CW00801346

TYPO-GRAPHIC FIRSTS

Adventures
in Early
Printing

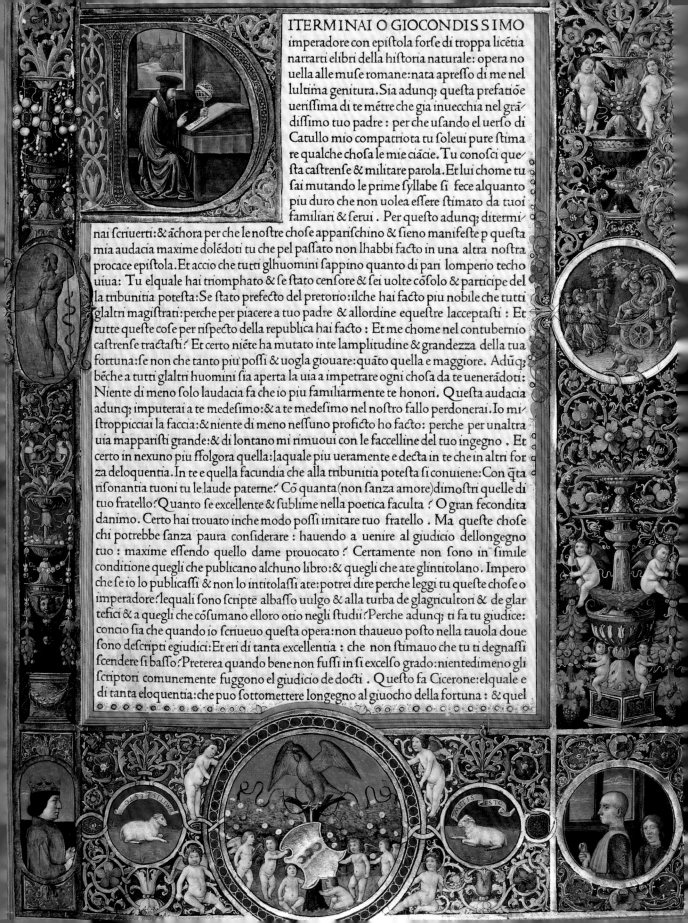

ITERMINAI O GIOCONDISSIMO
imperadore con epiſtola forſe di troppa licétia
narrarti elibri della hiſtoria naturale: opera no
uella alle muſe romane:nata apreſſo di me nel
lultima genitura.Sia adunq; queſta prefatióe
ueriſſima di te métre che gia inuecchia nel grā
diſſimo tuo padre : per che uſando el uerſo di
Catullo mio compatriota tu ſoleui pure ſtima
re qualche choſa le mie ciácie. Tu conoſci que
ſta caſtrenſe & militare parola. Et lui chome tu
ſai mutando le prime ſyllabe ſi fece alquanto
piu duro che non uolea eſſere ſtimato da tuoi
familiari & ſerui . Per queſto adunq; ditermi
nai ſcriuerti:& áchora per che le noſtre choſe appariſchino & ſieno manifeſte p queſta
mia audacia maxime dolédoti tu che pel paſſato non lhabbi facto in una altra noſtra
procace epiſtola.Et accio che tutti glhuomini ſappino quanto di pari lomperio techo
uiua: Tu elquale hai triomphato & ſe ſtato cenſore & ſei uolte cóſolo & participe del
la tribunitia poteſta:Se ſtato prefecto del pretorio:ilche hai facto piu nobile che tutti
glaltri magiſtrati:perche per piacere a tuo padre & allordine equeſtre lacceptaſti : Et
tutte queſte coſe per riſpecto della republica hai facto : Et me chome nel contubernio
caſtrenſe tractaſti? Et certo niéte ha mutato inte lamplitudine & grandezza della tua
fortuna:ſe non che tanto piu poſſi & uogla giouare:quáto quella e maggiore. Adūq;
béche a tutti glaltri huomini ſia aperta la uia a impetrare ogni choſa da te uenerádoti:
Niente di meno ſolo laudacia fa che io piu familiarmente te honori. Queſta audacia
adunq; imputerai a te medeſimo:& a te medeſimo nel noſtro fallo perdonerai. Io mi
ſtroppicciai la faccia:& niente di meno neſſuno proficto ho facto: perche per unaltra
uia mappariſti grande:& di lontano mi rimuoui con le faccelline del tuo ingegno . Et
certo in nexuno piu ffolgora quella:laquale piu ueramente e decta in te che in altri for
za deloquentia.In te e quella facundia che alla tribunitia poteſta ſi conuiene:Con q̃ta
riſonantia tuoni tu le laude paterne? Có quanta(non ſanza amore)dimoſtri quelle di
tuo fratello:Quanto ſe excellente & ſublime nella poetica faculta? O gran fecondita
danimo. Certo hai trouato inche modo poſſi imitare tuo fratello . Ma queſte choſe
chi potrebbe ſanza paura conſiderare : hauendo a uenire al giudicio dellongegno
tuo : maxime eſſendo quello dame prouocato? Certamente non ſono in ſimile
conditione quegli che publicano alchuno libro:& quegli che ate glintitolano. Impero
che ſe io lo publicaſſi & non lo intitolaſſi ate:potrei dire perche leggi tu queſte choſe o
imperadore:lequali ſono ſcripte albaſſo uulgo & alla turba de glagricultori & de glar
tefici & a quegli che cóſumano elloro otio negli ſtudii?Perche adunq; ti fa tu giudice:
concio ſia che quando io ſcriueuo queſta opera:non thaueuo poſto nella tauola doue
ſono deſcripti egiudici:Et eri di tanta excellentia : che non ſtimauo che tu ti degnaſſi
ſcendere ſi baſſo?Preterea quando bene non fuſſi in ſi excelſo grado:nientedimeno gli
ſcriptori comunemente fuggono el giudicio de docti . Queſto fa Cicerone:elquale e
di tanta eloquentia:che puo ſottomettere longegno al giuocho della fortuna : & quel

TYPOGRAPHIC FIRSTS

John Boardley

Adventures in Early Printing

Bodleian Library
UNIVERSITY OF OXFORD

First published in 2019 by the Bodleian Library
Broad Street, Oxford OX1 3BG
www.bodleianshop.co.uk

ISBN 978 1 85124 473 7

Cover design by Dot Little at the Bodleian Library
Typeset in DTL Elzevier and National
Printed and bound in China by C&C Offset Printing Co. Ltd.,
on 157 gsm Chinese Hua Xia Sun matt art FSC paper

MIX
Paper from
responsible sources
FSC® C008047

British Library Catalogue in Publishing Data
A CIP record of this publication is available from the British Library

Contents

Timeline

1452	Leonardo da Vinci: b. 15 April, Vinci, Florence	
1453	Fall of Constantinople to Mehmed II: 29 May	
1454		Dated, typographically printed indulgences
c. 1454–55		Completion of Forty-two-line Bible: Johannes Gutenberg, Mainz
1455	Pope Nicholas V: d. 24 March	
1457		Johann Fust and Peter Schoeffer's Mainz Psalter: first printed colophon; first printed bi-colour initials
c. 1460		Printing introduced to Strasbourg: Johann Mentelin
c. 1461		Thirty-six-line Bible printed in Bamberg
1462	Sack of Mainz: 28 October	First printer's device: Fust and Schoeffer's Latin Bible, Mainz
1463		First 'tentative' title-page: Fust and Schoeffer, Mainz
c. 1463		*Leiden Christi* fragments [printed in Italy?]; Ulrich Zell begins printing in Cologne
1464	Nicholas of Cusa: d. 11 August, Todi, Italy	
1465		First use of roman typeface: Subiaco
1466	Johann Fust: d. 30 October, Paris	
1467		Printing introduced to Rome: Ulrich Han and Konrad Sweynheym and Arnold Pannartz
1468		Johannes Gutenberg: d. 3 February, Mainz Printing introduced to Augsburg: Günther Zainer
1469		Johannes and Vindelinus da Spira publish first book in Venice Printing introduced to Nuremberg: Johann Sensenschmidt
1470		First printed foliation: Arnold Ther Hoernen, Cologne Nicolaus Jenson begins printing in Venice Printing introduced to France, Paris Printing introduced to Milan and Naples
1471		First Bible printed in roman type: Sweynheym and Pannartz, Rome Printing introduced to Padua: Clement of Padua, the first native Italian printer
1472		First printed map: Günther Zainer, Augsburg
c. 1472		Printing introduced to Spain: [Johannes Parix]
1473	Nicolaus Copernicus: b. 19 February 1473, Torun, Poland Pope Sixtus IV commissions Sistine Chapel	
c. 1473		First extant music notation printed: Southern Germany First book printed in English: William Caxton, Bruges
c. 1473–75		First books printed in Hebrew: [Spain/Italy]

c. 1474		First 'illustrated' Bible: Günther Zainer, Augsburg
1475	Michelangelo: b. 6 March, Caprese, Italy	
1476	Regiomontanus: d. 6 July, Rome	First decorative title-page: Ratdolt & Co., Venice
		First significant music printing: Ulrich Han, Rome
		First printing in Britain: William Caxton, Westminster
		First dated and signed book printed entirely in Greek: Milan
1477		First atlas with printed maps: Bologna
c. 1477–79		First printed advertisement in England
1478	Pazzi Conspiracy against Lorenzo de' Medici	First press at Oxford
	Spanish Inquisition begins	First printed notice of errata: Gabriele di Pietro, Venice
		First appearance of cast metal ornaments
1479	Treaty of Constantinople signed between	
	the Republic of Venice and the Ottoman Empire	
1480		Nicolaus Jenson: d. Venice
1481		Printing introduced to Munich: Johann Schauer
1482		First printing in gold: Erhard Ratdolt, Venice
c. 1482		Printing introduced to Denmark: Johann Snell
1483	Raphael: b. 6 April, Urbino, Italy	Printing introduced to Sweden: Bartholomaeus Ghotan
c. 1483		First English title-page
1484		First female printer to sign a colophon: Anna Rügerin
1485		First three-colour relief printing of images:
		Erhard Ratdolt, Venice
1486	Maximilian I elected King of the Romans: 16 February	First type specimen: Erhard Ratdolt, Venice
		First colour illustrations printed in books in England
1491		William Caxton: d. London
		First Cyrillic font
1492	Columbus' first voyage to the Americas	
	under the patronage of Ferdinand and Isabella of Spain	
1493		Brescia: introduction of running heads
1494	French invasion of Italy under Charles VIII	
1495		First Aldine roman 'Bembo' font cut by Francesco Griffo
1497	Hans Holbein the Younger: b. Augsburg	
1499		Earliest known illustration of a printing press: Lyons
1500		First use of italic type: Aldus Manutius, Venice
1501		First book typeset entirely in italic: Venice
1503		Peter Schoeffer: d. Mainz
		Robert Estienne: b. Paris
1505		First printed vine-leaf ornament: Erhard Ratdolt, Augsburg
1508	Beginning of the War of the League of Cambrai	Printing introduced to Scotland
1509		First Roman type used in England: Richard Pynson, London
1510	Sandro Botticelli: d. 17 May, Florence	
1514		First book printed in Arabic type: Fano, Italy
1515		Aldus Manutius: d. Venice
1518		Francesco Griffo: d. [Bologna]
1519	Leonardo da Vinci: d. 2 May, Amboise, France	Single-impression music printing: John Rastell, London

COMINCIA LA COMEDIA DI
dante alleghieri di fiorenze nella q̃le tracta
delle pene et punitioni de uitii et demeriti
et premii delle uirtu: Capitolo primo della
p̃ma parte de questo libro loquale sechiama
inferno : nel quale lautore fa prohemio ad
tucto eltractato del libro:·

EL mezo delcamin dinr̃a uita
mi trouai puna selua oscura
che la dir icta uia era smarrita
Et quanto adir q̃lera cosa dura
esta selua seluagia aspra eforte
che nel pensier renoua la paura
Tante amara che pocho piu morte
ma pertractar del ben chio uitrouai
diro dellatre cose chi úo scorte
I non so ben ridir come uentrai
tantera pien disonno insuquil punto
che la uerace uia abandonai
Ma poi che fui appie dum colle gionto
ladoue terminaua quella ualle
che mauea dipaura el cor compuncto
Guardai inalto et uidde le suoe spalle
uestite gia deraggi del pianeta
che mena dricto altrui perogni calle
Allor fu la paura un pocho cheta
che nellaco del cor mera durata
la nocte chio passi contanta pieta

Introduction

We know a thing largely by its cause and
it is obvious that knowledge of its genesis
is essential to an intelligent understanding
of its nature and end.
STANLEY MORISON[1]

For five and a half centuries it has educated, shocked and placated;
it has admonished through treatise and praised through poetry;
it has fomented war and promoted peace. Whether by letters of lead
alloy or wood or the intangible digital letters of font files, typography,
'the first agent of mass communication', revolutionized the way we
communicate.[2] The following 'typographic firsts' tell the story of
how such a revolution began.

THE ORIGINS OF TYPOGRAPHY and of books printed by
movable metal type are well known and often told, and for many
Johannes Gutenberg, Nicolaus Jenson and Aldus Manutius are familiar
names: a talented typographic trinity hailing from Germany, France
and Italy who irrevocably revolutionized communication, enriching
and broadening our cultural and intellectual horizons.[3] Gutenberg is
credited with the invention of a new mechanical mode of production
and with producing the very first printed books from the 1450s, Jenson
is renowned for his significant contribution to the aesthetic development
of the roman typeface, and Aldus for the first italic type, his early Greek
types (both with the punchcutter Francesco Griffo), and for his *libelli
portatiles*, small octavo-format classics, praised and pirated in equal
measure. In the story of typography, these names, together with that
of the German printer Erhard Ratdolt, crop up again and again.

But what was it that enabled the inventions of these men to prosper
in Renaissance Europe? Early experiments with movable types of clay,
wood and bronze in China and Korea had failed to be widely adopted.

1 Leaf from *editio princeps* of Dante
Alighieri's *Divine Comedy*, printed by
Johann Neumeister at Foligno, 1472.

Since the founding of universities in the eleventh and twelfth centuries (beginning with Bologna, Paris, Oxford and Salamanca), the expansion of grammar schools throughout the fourteenth and fifteenth centuries, and the attendant rise in literacy rates, manuscript book production had been increasing. European manuscript production rose 82 per cent from the fourteenth to fifteenth centuries, to an absolute figure of almost 5 million manuscripts (produced during the entire fifteenth century); the same century witnessed the production of about 12.6 million printed books.[4] Rising demand for books had prompted the introduction of the *pecia* system in Paris during the latter half of the thirteenth century, whereby the university stationer loaned out not entire manuscripts but sections or gatherings of unbound manuscript exemplars.[5] This ingenious (and in hindsight obvious) innovation facilitated the more rapid production of manuscript books. Paper, invented by the Chinese and introduced into Europe via the Iberian Peninsula in the eleventh century, was likewise a crucial ingredient of the typographic book's success. Fifteenth-century Europe witnessed a pronounced expansion of paper mills and a marked shift away from parchment (animal skins) to paper. In the fourteenth century about 34 per cent of manuscripts were written on paper; by the fifteenth century, that figure had risen to 72 per cent.[6] It was the confluence of these auspicious circumstances, from factors resulting in an increased demand for books to the ready availability of relatively inexpensive paper and a general spirit of intellectual curiosity, that made Renaissance Europe especially fertile soil for the typographic book.

The fifteenth century marks the beginning of a modern Europe unshackling itself from the medieval. Populations were finally recovering from the decimation wrought by the catastrophic Black Death in the fourteenth century and the years of debilitating famine that followed in its wake: 'The 15th century saw recovery become general throughout Europe: by its end totals were back to the 1300 level in nearly every area.'[7] The characters in the following pages are contemporaries of inventors and artists such as Da Vinci, Michelangelo, Raphael, Botticelli and Dürer; of architects such as Brunelleschi, Alberti and Palladio; of explorers Vasco da Gama and Columbus; of brilliant mathematicians and astronomers such as Regiomontanus (also a printer), Copernicus, Toscanelli and Pacioli. Europe witnessed too the death throes of feudalism, the expansion of banking and commerce, and the growth of cities and city-states. Planted

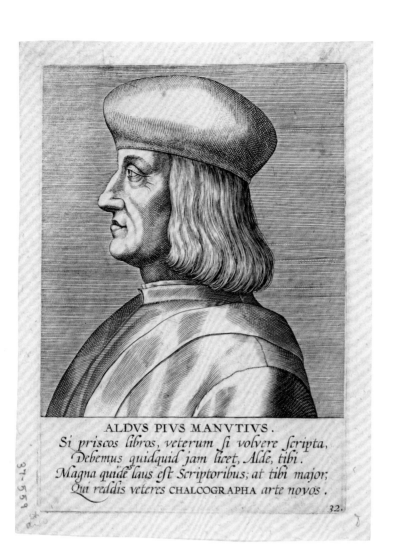

ALDVS PIVS MANVTIVS.
Si priscos libros, veterum si volvere scripta,
Debemus quidquid jam licet, Alde, tibi.
Magna quidé laus est Scriptoribus; at tibi major,
Qui reddis veteres CHALCOGRAPHA arte novos.

32.

in Florence, the seed of the Renaissance bloomed throughout Europe but its noblest aspects should not blind us to its attendant horrors: its tyrants and despots, frequent outbreaks of the plague and savage internecine wars. In the Italian Peninsula, Venice was at war with Milan and Genoa, Milan with Naples, Rome with Florence, and Florence with Pisa; elsewhere, Bohemia was at war with Hungary; in Germany, feuds culminated in the Sack of Mainz in 1462 that, incidentally but not insignificantly, led to the diaspora of German printers. These events are inseparable facets of the Janus-faced Renaissance: its dual nature was exemplified by the cruelty, self-indulgence and bellicosity of its patricians, politicians and

popes – who at the same time were generous and enthusiastic patrons of the arts and sciences including, perhaps most significantly, the printed book. The Renaissance, then, was not only a rebirth of the best of classical Graeco-Roman civilization, but a profound reimagining of the book, from handwritten and scarce to printed and ubiquitous.

3 Woodcut of a type-founder from *Das Ständebuch*: text by cobbler, singer and poet, Hans Sachs; illustrations by the prolific woodcut artist Jost Amman. Frankfurt, 1568.

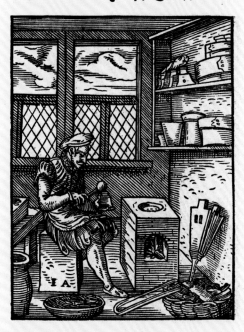

Der Schrifftgiesser.

Ich geuß die Schrifft zu der Druckrey
Gemacht auß Wißmat/Zin vnd Bley/
Die kan ich auch gerecht justiern/
Die Buchstaben zusammn ordniern
Lateinisch vnd Teutscher Geschrifft
Was auch die Griechisch Sprach antrifft
Mit Versalen/ Puncten vnd Zügn
Daß sie zu der Truckrey sich fügen.

E iij Der

From Manuscript to Print

Gutenberg's invention was a repurposing of existing technologies: a screw or wine press became a printing press, while pewter-casting techniques were used to produce durable and reusable pieces or sorts of metal type. Whether or not Gutenberg invented the handheld, adjustable type mould for casting type, and whether he used a temporary mould of sand or a permanent copper matrix, we cannot be sure, but his core innovation – individual letters of metal – remains. The other facets of bookmaking had been practised for the best part of a thousand years – bookbinding, rubrication (the addition of elements for textual articulation and emphasis, commonly in red) and decoration were elements of book production that, even after the advent of printing, long continued to be carried out by hand. Therefore, the earliest printed books resembled those penned by contemporary scribes.[8] This was not an attempt by printers to dupe their readers into believing that they were reading manuscript texts, but rather about producing the sorts of books with which readers would be familiar. Typography was not a reinvention of the book but a reinvention of how it was produced. And so it was that the first printed Bible was set in Gothic or blackletter type, modelled on contemporary German, formal Gothic book-hands, or Textualis Formata (*textura*). However, south of the Alps the more extreme angularity and lateral compression characteristic of the northern Gothic forms, or 'Northern Textualis', was resisted. A rounder Gothic script, Rotunda or 'Southern Textualis', came to be preferred in Italy and the Iberian Peninsula.[9] By the time printing had crossed the Alps, in 1464–5, with the establishment of Sweynheym and Pannartz's press at Subiaco, on the far eastern outskirts of Rome, the lighter and more open letterforms of humanistic script were preferred for manuscripts of classical and humanist texts. The inventors and promoters of this new script were the Italian humanist scribes of the Renaissance who looked back to the Caroline minuscule script of the ninth and tenth centuries, mistakenly attributing the hands to antiquity, thus the appellation, *litterae antiquae*. Therefore, the first extant books from the press of Sweynheym and Pannartz, classical texts by Cicero and Lactantius, employed types modelled on contemporary, formal humanistic book-hands that had been 'inspired by Coluccio Salutati, invented by Poggio Bracciolini [and] encouraged by Niccolò Niccoli'.[10] The demise of Gothic, or blackletter, and the ascendance of roman types (most notably in France from the

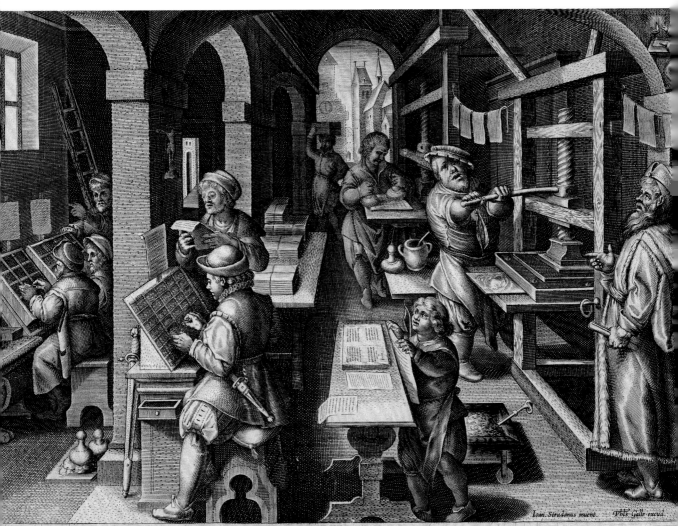

IMPRESSIO LIBRORVM.

Potest vt vna vox capi aure plurima: *Linunt ita vna scripta mille paginas.*

second quarter of the sixteenth century), can be attributed in large part to Jenson, who brought a more noble aesthetic to the roman minuscule, and to the late fifteenth-century Aldine roman of Aldus Manutius.

However, Gutenberg, Jenson and Aldus are just three of the thousands of printers who published millions of books, pamphlets and broadsides throughout hundreds of towns and cities. Many small towns saw the publication of just one or two editions, their printers either giving up the endeavour, or moving to one of the larger cities. Unsurprisingly, printing flourished in commercial centres with almost 60 per cent of all incunable editions printed in just nine cities: Venice (3,784), Paris (3,263), Rome (2,089), Cologne (1,629), Lyons (1,476), Leipzig (1,427), Augsburg (1,287), Strasbourg (1,241) and Milan (1,138).[11] But just as much is to be gleaned from the numerous anonymous printers, booksellers, bookbinders, artists, colourists (*Briefmaler*) and rubricators, and the owners and readers of the books themselves, who lived, worked and died throughout the Renaissance and Early Modern period – their legacy surviving in their books, or fragments of their books, the sole extant testaments to their existence.

The Business of Printing

Throughout most of the first half-century of printing, the market for books was burgeoning and unregulated, attracting countless eager entrepreneurs. Erasmus alluded to the unregulated nature of early printing, claiming that it was 'easier to become a printer than a baker'. Others, too, thought printing to be a quick and effortless way to make money. In the 1530s, the Basel printer Thomas Platter claimed, 'But when I saw Hervagius and the other printers had a good business and with little work made a good profit, I thought, "I should like to become a printer."' Johannes Herwagen (Hervagius), born in 1497, moved to Basel in 1528 and married Gertrud Lachner, widow of Johann Froben (see p. 103). He died *c.* 1558.[12]

But printing in those early decades was by no means easy. Johann Neumeister (*c.* 1435–*c.* 1512), who had probably been associated with Gutenberg in Mainz, initially had the good fortune to find a patron in the goldsmith Emiliano Orfini (Aemilianus de Orfinis), from whose home in Foligno Neumeister published several works. Despite a valiant effort, working at a number of presses across three countries, he struggled

5 Engraved portrait of
Christophe Plantin, showing
his motto, *Labore et Constantia*
('Work and Persistence').

to make a living, spending some time in jail for unpaid debts. By 1498
he was a pauper; despite being remembered as the printer of the very
first edition of Dante's *Divine Comedy*,[13] he died in destitute obscurity
in the first decade of the sixteenth century.

Many others involved in early printing struggled to make ends meet:
one printer pawned his wife's jewellery; another's bill was settled with
a bed-sheet. In Venice, the writer Nicolò Agostini implored his reader
not to loan his book to a friend but 'make him buy it so that I can recover
the money I spent on paper and printing'.[14] For others, however, the
business was booming. In the period 1471–2, the two firms of Nicolaus
Jenson and his associate Johannes de Colonia were responsible for half
of Venice's total book production.[15] More than a dozen other presses had
been established in the city, by the brothers Johannes and Vindelinus
da Spira, Christophorus Valdarfer, Adam de Ambergau, Clement of
Padua, Franciscus Renner, Bartholomaeus Cremonensis, Florentius
de Argentina and Gabriele and Filippo di Pietro, in addition to at least
half a dozen unassigned or anonymous presses. Perhaps dissuaded from
continuing his own printing experiments in Venice by high costs and
stiff competition from these nascent but burgeoning syndicates, in the
early 1470s Federicus de Comitibus decided to head south along the
eastern coast of the Italian Peninsula to Iesi.[16] Owing to outbreaks of
plague and raiding bandits from across the Adriatic, the picturesque
town of Iesi had been practically abandoned, prompting local authorities
to invite those from the surrounding region of Lombardy to settle there
with incentives of free land, tax breaks and supplementary benefits.
Federicus, the first and only printer in fifteenth-century Iesi, worked at
his press from about 1473 until the summer of 1476, publishing several
works, including a very early edition of Dante.[17] But even with such a
head-start, he wound up in the debtors' prison and, upon escaping,
found that his property, equipment and unsold inventory had been
seized. By the year's end, he was dead and guardians were appointed
for his orphaned children.

Christophe Plantin (*c.* 1520–89) was one of the most successful
printer-publishers of the sixteenth century. Originally from Tours in
France, by 1549 he had settled in Antwerp, which, during the first half of
the sixteenth century, was one of Europe's greatest economies. In 1562,
while away in Paris, where formerly he had learned to print, his pressmen,
according to Plantin, printed a banned book which subsequently came to

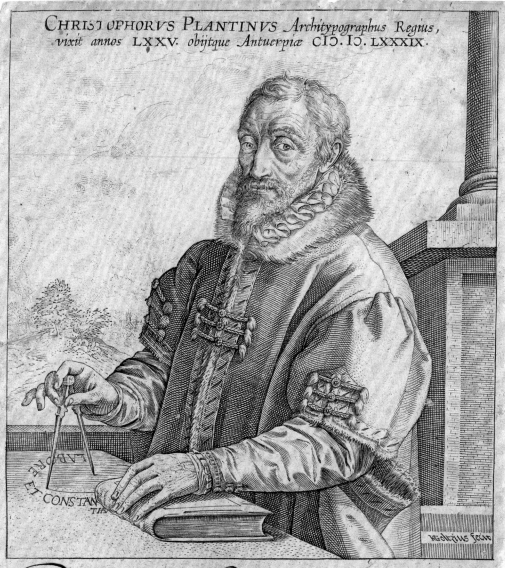

CHRISTOPHORVS PLANTINVS *Architypographus Regius,*
vixit annos LXXV. *obijtque Antuerpiæ* CIↃ.IↃ. LXXXIX.

Plantinum tibi, spectator, proponimus, vt cum
Nomine perpetuo viuat et effigies.
Sic vbi posteritas miracula tanta librorum
Eius et innumerum sera videbit opus;
Tune es Christophorus, tune ille es? dicat: in vnum
Et sua conijciens lumina fixa virum;
Musarum o pater, exclamet, dignissime salue:
Reddita sunt studio sæcula docta tuo.

I. BOCHIVS.

the attention of the local authorities, leading to Plantin's prosecution and the threat of imprisonment. Although he avoided prison by going into hiding, within two months all of his property and printing equipment was confiscated and auctioned off.[18] Upon his return to Antwerp Plantin was able to buy back some of his type and, despite his early setback, he recovered and prospered, so that by 1576 he employed twenty-two presses. We do well to note that even the great luminaries of typographic history were not invulnerable to the vicissitudes of printing in the fifteenth and sixteenth centuries. For every success story, every Aldus, Jenson or Ratdolt, there were dozens more who failed. Printing was not solely about craft. Unlike manuscript production, early printing was a chiefly speculative enterprise (the Florentine Vespasiano da Bisticci is a rare and late example of a seller of uncommissioned manuscript books), necessitating substantial capital investment and yielding slow and uncertain returns. Moreover, as the book trade expanded and local competition increased, or as local markets became saturated, it became necessary to market and sell books beyond their town of printing. This demanded considerable planning and necessitated the establishment of transnational networks of competent and trustworthy partners.

Even the inventor of the art struggled to make ends meet. Gutenberg's monumental *Biblia Latina,* or Forty-two-line Bible, took at least two years to complete and required several loans, including one from his cousin Arnold Gelthus, and two from his partner and financier Johann Fust. The loans, together with accrued interest from Fust alone, totalled 2,206 gulden, 'the equivalent in purchasing power to about four houses'.[19] Similarly, Sweynheym and Pannartz, despite the accolade of introducing the art of printing to the Italian Peninsula, were, in the space of a few years, left buried in unsold books.

First and Foremost

Typography, from the ancient Greek *typos* (impress) and *graphia* (writing), is described, in the broadest terms, by the eminent poet-typographer Robert Bringhurst as 'the craft of endowing human language with a durable visual form'.[20] More precisely it is the craft of using discrete, reusable and rearrangeable pieces of type – tangible or digital glyphs or characters – to produce, ideally, readable texts. The typographic firsts discussed in the chapters that follow originate in incunabula, a term

coined to describe the first decades of European printing from its introduction in about 1450 to the arbitrary but bibliographically convenient 1500.

There is an innate danger in employing superlatives. The oldest, the youngest, the best, the worst, the first, the last – these are invariably open to interpretation and revision. Sometimes it is impossible to point to an artefact and claim that it is, unequivocally, the first of its kind – sometimes the best we can do is claim it as the earliest surviving, or extant, example and it will remain so until, if ever, an even earlier example is discovered. To qualify every single statement about firsts, as though we were engaged in the preliminaries to a philosophical debate, is laborious and makes for tedious reading, so I have done my best to tread carefully, and where appropriate I have added caveats to my 'firsts' with modifying or comparative qualifiers. So, for example, to claim that Gutenberg's Forty-two-line Bible is the first book is obviously a falsehood. To claim it as the first typographically printed book is likewise untrue, but closer to the truth. However, it is the first *substantial* book to be printed in Europe and the first printed Bible. I hope that I have managed to find a compromise between flagrant laissez-faire and pernickety pedantry. Where possible I have provided notes for those seeking clarification and sources for those wishing to delve deeper. They also serve to credit the incunabulists, historians and bibliographers on whose shoulders I gratefully, proudly and unabashedly stand.

than
ue·ste
jai le
t filij
dras
aȝ in
er no=
men
ȝ sum
t uxo=
rimā
e filijs
enige
et fra=
·ȝ go
t eice
luo a
filijs
filijs
ȝ iehi
:heli
nael
itaȝ:

nai· matheth·azabeth· elpheleth· ier=
mai·manasses semei . De filijs bani·
maaddi· amram·ȝ huel·baneas·ȝ ba=
daias·cheliau·bannia·marimuth· et
heliasib·machanias·machanai·ȝ ia=
si· et bani· et bennui·semei· et salmias·ȝ
nathan· et adaias·mechnedabai·sysai·
sarai·ezrel· et selemau· et semeria·sellū·
amaria·ioseph . De filijs nebui · ahi=
hel machathias · zabeth·zabina· ied=
du· et iohel·ȝ banay·Omnes hij accepe=
rāt uxores alienigenas·ȝ fuerūt ex eis
mulieres ā peperāt filios. Expl'. liber es=
dre pm'. Incipit lib neemie ā e esdre se=

Erba nee eūd'. arȝ·j=
mie filij helchie · Et
factū est in mēse cas=
leu· āno uicesimo:
ȝ ego erā in susis ca=
stro. Et uenit anani
onus de fratribȝ meis·ipe et uiri iuda·
ȝ interrogaui eos de iudeis·qui reman=
serant et superant de captiuitate ȝ de

Prototypographer

The First Printing

A good book is the precious life-blood of a master
spirit, embalmed and treasured up on purpose to
a life beyond life.

JOHN MILTON[21]

1

ON THE ITALIAN PENINSULA, in the village of Vinci, in the
Tuscan hills outside Florence, a certain Leonardo was born in 1452.
Elsewhere in the early 1450s, Christopher Columbus, Francesco Griffo
and Filippo Giunti were born and Francesco Sforza seized Milan. In
England, Henry VI sat on the throne; in France, Charles VII; Alfonso
the Magnanimous, under whose reign the University of Barcelona was
founded in the autumn of 1450, ruled Spain. In the same year, hundreds
of thousands headed to Rome for the Jubilee pronounced by Pope
Nicholas V, while to the east, the Ottoman Turks were poised to bring
down the Byzantine Empire. Meanwhile, on the west bank of the river
Rhine, in Mainz, Germany, Johannes Gutenberg (c. 1400–1468), by now
in his early fifties, was perfecting his method of printing with movable type.

Indulgences, Grammars and Propaganda

Although Gutenberg is best known for printing the first substantial
typographic book, the Gutenberg Bible, also known as the Forty-two-line
Bible, or simply the B42, it was of course not the first printed matter to
be issued from his press. In addition to the ephemeral proof sheets for
the Bible, Gutenberg printed letters of indulgence, likely numbering in the
thousands – it was a lucrative business. It is impossible to know precisely
how many of these indulgences were printed. Estimates range from
'several thousand' to 'nearly 20,000'.[22] However, later in the century there
are reports of tens of thousands being printed. In late medieval Europe
indulgences were sold by a kind of holy hawker, or pardoner. They were

6 Detail of a decorated initial from
the Gutenberg Bible (Mainz, c. 1455),
taken from the prologue to the
Book of Nehemiah. In addition to
the initial, the rubrication (red text)
was added by hand.

Uniuerſis Criſtifidelibᵹ pūtes lřas inſpecturiſ **Paulinus** Chappe Cōſiliariᵹ Ambaſiatoʒ ʒ pcuratoʒ generaliſ Sereniſſi͂ Regiſ Cypri in hac parte Salm i͂ dño Cu̅ Sacřſſim̅ i xpo př ʒ dūs n̅ dñs Nicolauſ diuina puidētia p̄p quite affliction̅ Regni Cyp mi ſericorditer cōpatieſ cōtra pfidiſſioſ crucis xpi hoſteſ Theucroſ ʒ Saracenoſ gratis cōceſſit omibᵹ xpifidelibᵹ vbilibet oſtitut i ipoſ p aſpſioneͤ ſanguiſ dñi n̅ři ihū xpi pie exhortado qui infra trien̅ a prima die May Anni dñi Mccclj incipie͂du p defeſio͂e cath lice fidei ʒ regni pdicti de facultatibᵹ ſuiſ magiſ uel min̅ʒ pꝛut ipoꝛ videbitur oſcie͂tiis pcu̅toꝛibᵹ uel nūchs ſubſtitutiſ pie erogau rint ut oſeſſoꝛeſ ydonei ſeculareſ uel regulareſ p ipoſ eligedi oſſeſſionibᵹ eoꝛ auditiſ· p cōmiſſiſ etiā ſedi aplice reſeruatiſ exceſſi criminibᵹ atqᵹ delictis quatūcūʒ grauibᵹ p vna vice tātu debitā abſolutione͂ impede͂re ʒ penite͂tiā ſalutarem iniūgere Necn̅o ſi hu̅iliter petierit ipoſ a quibuſcūʒ excōicationum ſuſpenſionu ʒ interdicti aliiſqᵹ ſentenciis ce͂ſuriſ ʒ peniſ eccleſiaſticiſ a iure uel a hoie pmulgatis quibᵹ foꝛſan innodati exiſtu̅t abſoluere·Iniucta p modo culpe penite͂tia ſalutari uel aliis q̅ de iure fuerit iniu̅ged. ac eiſ vere penitentibᵹ ʒ oſeſſiſ·uel ſi foꝛſan propter amiſſione͂ loq̅le oſiteri n̅o poterit ſigna o͂triconis oſtede͂do plenıſſima oim pcto ſuoꝛ de quibᵹ oꝛe oſeſſi ʒ coꝛde o͂triti fuerint Indulgentia ac plenaria remiſſione ſemel in vita ʒ ſemel in moꝛtiſ articulo ipiſ u̅tiſ aplica o͂cedere valea͂t·Satiſfactione p eoſ facta ſi ſupuixerint aut p eoꝛ heredeſ ſi tu̅c trāſierit Sic tame͂ q̅p poſt indultu oceſſu͂ p vnu̅ annu ſinguliſ ſextiſ feriis uel quadā alia die ieiunet·legittimo impedime͂to eccleſie pcepto regulari obſeruatia pnia iniu͂cta voto uel aliaſ n̅o obſtau·Et ipiſ impeditiſ in dicto ā͂o uel eiuſ parte·anno ſequeti uel aliaſ quam primu̅ poterint ieiunabu͂t Et ſ in aliquo annoʒ uel eoꝛ parte dictu̅ ieiuniu͂ cōmode adimplere nequiuerit Confeſſor ad id electuſ in alia o͂mutare poterit caritati opa q̅ ipi facere etiā teneantur·Du̅modo tn ex oſidentia remiſſioniſ hu͂oi q̅p abſit peccare n̅o pſuma͂t Alioqui dicta o͂ceſſio quo ad plenaria remiſſione in moꝛtiſ articulo et remiſſio quo ad pcta ex oſidentia ut pmittitur oͤmiſſa nullius ſint roboꝛiſ uel momenti Et quia deuoti ⸺⸺⸺⸺⸺⸺⸺ ⸺⸺⸺⸺⸺⸺ ⸺⸺ iuxta dictum indultu̅ de facultatibus ſuiſ pie eroga⸺⸺ merito huiuſmodi indulgentiiſ gaudere debet·In veritatiſ teſtimoniu͂ ſigillu͂ ad hoc oꝛdinatu͂ pntibᵹ lřis teſtimonialibᵹ eſt appenſum Datu̅ ⸺⸺⸺⸺ Anno dñi Mccccliiii die vero ⸺⸺⸺ menſiſ ⸺⸺⸺

Forma plenıſſime abſolutioniſ et remıſſioniſ in vita

Miſereatur tui ꝛc Dūs noſter iheſuſ xpſ p ſuā ſanctıſſimā et piiſſimā mia͂ʒ te abſoluat Et auctoͤ ipiꝰ beatoꝛu̅ q̅ʒ petri ʒ pauli aploꝛ eiuſ ac auctoͤ aplica michi o͂miſſa ʒ tibi oceſſa Ego te abſoluo ab omibᵹ pctis tuiſ o͂tritiſ oſeſſis ʒ oblitiſ Etiā ab omibᵹ caſibᵹ exceſſibᵹ criminibᵹ atqᵹ delictiſ quatūcūʒ grauibᵹ ſedi aplice reſeruatiſ Necn̅o a quibuſcūʒ excoicationū ſuſpenſionū ʒ interdicti aliiſqᵹ ſentenciiſ cenſuriſ ʒ peniſ eccliaſticiſ a iure uel ab hoie pmulgatiſ ſi quaſ incurriſti dando tibi plenıſſimā oim pctoꝛ tuoꝛ indulgentiā ʒ remıſſione͂ Inquatu̅ claueſ ſancte matriſ eccle in hac parte ſe extendu͂t·In noie patriſ ʒ filii ʒ ſpirituſ ſancti Amen

Forma plenarie remıſſioniſ in moꝛtiſ articulo

Miſereatur tui ꝛc Dūs noſter ut ſupꝛa Ego te abſoluo ab omibᵹ pctis tuiſ o͂tritiſ oſeſſiſ et oblitiſ reſtituendo te vnitati fideliu̅ ʒ ſacrame͂tiſ eccleſie Remittendo tibi penaſ purgatoꝛii quaſ propter culpaſ ʒ offenſaſ incurriſti dando tibi plenariā oi͂m pctoꝛ tuoꝛ remıſſione· Inquantu̅ claueſ ſancte matriſ eccle in hac parte ſe extendu͂t·In noie patriſ ʒ filii ʒ ſpirituſ ſancti Amen

7 Letter of indulgence issued to support a military campaign against the Turks, issued on 27 February 1455. There are thirty lines to the page.

sold to raise income for everything from the repair of a local church or cathedral to waging a crusade. Ostensibly, these papal letters of indulgence were receipts for the remission of the punishment for sins in this life and in purgatory. In 1452, Pope Nicolas V issued a plenary indulgence, valid until 30 April 1455. A proportion of the funds raised were promised to King John II of Cyprus, for the island's defence against the Turks, specifically for rebuilding the walls of the capital, Nicosia.[23] As had been the custom since the first indulgences of the mid-eleventh century, they were handwritten by scribes.[24] In 1454, someone, perhaps the archbishop of Mainz, Dietrich Schenk von Erbach, commissioned printed letters of indulgence from Gutenberg's nascent print shop, at a time when printing of the monumental Forty-two-line Bible was undoubtedly well underway. Gutenberg's indulgences were printed on vellum, with spaces left for the handwritten insertion of the pious

recipient's name, the place of purchase and date. The earliest extant example of a printed indulgence is completed with a handwritten date of 22 October 1454, making it the earliest precisely datable piece of typographic printing in Europe.[25] However, it is plausible that with the involvement of Nicholas of Cusa, whom Pope Nicholas V had sent throughout Northern Germany and the Netherlands to preach the Jubilee indulgence and to promote the crusade against the Turks, indulgences were printed as early as 1452.[26] Single-side broadside indulgences were quick to typeset and print and thus became a mainstay of jobbing printers until the Reformation. 'For the years 1488–90 surviving copies of printed letters of indulgence for the Crusade in Germany prove the existence of more than thirty editions a year,

8 *Türkenkalender* (*Eyn Manung der Christenheit Widder die Durken*): a polemical tract of six leaves, set in the type of the Thirty-six-line Bible, between 6 and 24 December 1454, in Mainz.

produced by presses which extended from Antwerp to Passau and from Lübeck to Memmingen; and the print-run in each case could well have reached 20,000.'[27] It has been suggested that it was the demand for indulgences that got Gutenberg thinking about a method of mass-producing the written word.[28] In addition to indulgences, Gutenberg also printed a long-popular beginner's guide to Latin grammar, Aelius Donatus's *Ars minor.*[29] Numerous fragments of at least two dozen editions have survived, printed with Gutenberg's types, with at least three editions printed before completion of the Forty-two-line Bible.[30] Then there is the so-called *Türkenkalender*:[31] a propaganda piece, a short polemical tract of six leaves, it was both a warning and a rallying call to the leaders of Christendom to lead a crusade against the Turks in retaliation for the sack of Constantinople in the spring of 1453. It was very likely printed by Gutenberg in December 1454 (fig. 8).

Although the indulgence is the earliest dated piece of typography to survive from the Gutenberg press, a unique and small fragment of a single leaf, just eleven lines, now at the Gutenberg Museum in Mainz, is conceivably even earlier. The *Sibyllenbuch* fragment, from a book of fourteenth-century German poetry containing prophecies about the fate of the Roman Empire, is printed with a very early, if not the earliest, set of Gutenberg's DK types (see p. 35) and is tentatively ascribed to 1452–3. By extrapolating from the known length of the poem, the typesetting and the watermark position, D.C. McTurtie estimated that the pamphlet comprised thirty-seven leaves (seventy-four pages).[32]

The Gutenberg Bible

At the close of the fourth century there were numerous widely divergent translations of the Bible. Pope Damasus I tasked Eusebius Hieronymus (Saint Jerome) with producing an authoritative text of the Bible in Latin translation. For the subsequent 1,000 years, Saint Jerome's Latin Vulgate, or *Biblia Sacra Latina*, remained the standard Latin translation of the Bible. In the thirteenth century, not only was there a significant increase in the number of Bibles produced but their format changed to text set in two columns and the division of the entire Bible into numbered chapters. Chapter numbers were long attributed to Stephen Langton, *c.* 1203, who lectured in theology at the University of Paris until 1206. The division of chapters into verses was first introduced in 1551 by Parisian printer

extraordinaire, Robert Estienne (Robertus Stephanus).[33] The same century witnessed the introduction of the smaller, portable Bible bound into a single volume or pandect Bible. For Gutenberg, who was printing single-side broadsheets and small Latin grammars of just dozens of pages, an imposing, large-format royal folio, two-volume, 700,000-word, 1,282-page Latin Vulgate Bible was by no means an obvious choice.[34]

The Forty-two-line Bible (fig. 9) is one of the most intensely and thoroughly analysed books of all time. The type, paper stocks, inks, bindings, illumination, rubrication, manuscript marginalia and doodles, watermarks, gatherings and quire structure – and even the minute registration pinholes – have been the focus of detailed study.[35] Although the Bible contains no colophon, or imprint information, it was almost certainly completed no later than 1455. In 1454, sheets from the Bible were seen by Aeneas Silvius Piccolomini, Pope Pius II from 1458 until his death in 1464 but at that time still in the employ of Emperor Frederick III. In a letter dated 12 March 1455 and addressed to the Spanish cardinal, Juan de Carvajal, in Rome, Aeneas writes,

> What was written to me about that marvellous man seen at Frankfurt is entirely true. I have not seen complete Bibles but only a number of quires of various books [of the Bible]. The script is extremely neat and legible, not at all difficult to follow. Your grace would be able to read it without effort, and indeed without glasses. Several people told me that 158 copies have been finished, though others say there are 180. I'm not certain of the exact number but I'm in no doubt that the volumes are finished, if my informants are to be trusted. Had I known your wishes I should certainly have bought you a copy – some quires were actually brought here to the emperor. I shall try and see if I can have a copy for sale brought here which I can purchase on your behalf. But I fear that won't be possible, both because of the length of the journey and because buyers were said to be lined up even before the books were finished. I can imagine your grace's great desire to know how matters stand from the fact that the messenger you sent was quicker than Pegasus! But that's enough joking.[36]

The 'marvellous man seen at Frankfurt' could have been Gutenberg himself, though might just as well have been Johann Fust, Peter Schoeffer or a trusted representative. The Frankfurt Fair was held twice a year, in spring and autumn. Only from about the mid-1470s would it become established as a book fair.[37] In 1454 the Frankfurt autumn fair coincided with the Diet of Frankfurt held in October. From the evident early

9 (overleaf) Opening from the Gutenberg Bible: the prologue and opening to St John's gospel (fol. 235r). Mainz, c. 1455.

vidit lintheamina sola posita:z abijt
secu mirans qd factum fuerat. Et ecce
duo ex illis ibant ipsa die in castellu
quod erat in spacio stadiox sexagita
ab iherusale nomine emmaus: et ipi
loquebant ad inuicem de hijs omni-
bus que acciderant. Et factu est dum
fabularentur et secu quererent: et ipse
ihesus appropiquans ibat cu illis. Ocu-
li aut illox tenebantur- ne eum agno-
scerent. Et ait ad illos. Qui sut hij ser-
mones quos cofertis ad inuicem am-
bulantes:et estis tristes? Et respondes
un9 cui nome cleophas: dixit ei. Tu so-
lus peregrin9 es i iherusale z no cogno-
uisti que facta sunt in illa hijs diebz?
Quibz ille dixit. Que? Et dixerut. De
ihesu nazareno qui fuit vir ppheta:
potens in opere z sermone-coram deo
et oi plo. Et quomo eu tradiderut
summi sacerdotes z principes nostri in
damnatione mortis: et crucifixerut eu.
Nos aut sperabam9:quia ipe esset re-
demptur9 israhel. Et nunc sup hec o-
mnia tercia dies est hodie:qp hec facta
sunt. Sed z mulieres quedam ex nris
terruerut nos- que ante lucem fuerunt
ad monumentu:z no inuento corpo-
re ei9- venerut dicentes se etia visione
angelox vidisse:qui dicut eum viuere.
Et abierunt quidã ex nris ad monu-
mentu:z ita inuenerut sicut mulieres
dixerut:ipm vero non inuenerunt. Et
ipse dixit ad eos. O stulti z tardi corde
ad credendu in oibus q locuti sunt
prophete. Nonne hec oportuit pati
cristu: et ita intrare in gloria sua? Et
incipiens a moyse z omibus ppheris:
interpretabat illis in omnibz scriptu-
ris que de ipo erãt. Et appropinqua-
uerut castello quo ibant:z ipe se finxit
longius ire. Et coegerut illu dicentes.

Mane nobiscu quoniam aduespe-
scit:z inclinata est ia dies. Et intrauit
cum illis. Et factu est dum recumber-
cum eis accepit pane:z benedixit ac fre-
git: z porrigebat illis. Et apti sunt o-
culi eox:z cognouerut eu:z ipe euanu-
it ex oclis eox. Et dixerunt ad inuicem
nonne cor nrm ardens erat i nobis- du
loqueretur in via:z aperiret nobis scri-
pturas? Et surgentes eadem hora re-
gressi sunt in iherusale: z inuenerunt
cogregatos undecim-z eos qui cu illis
erant dicentes qp surrexit dns vere: z
apparuit simoni. Et ipi narrabant que
gesta erãt i via:z quomo cognouerut
eum in fractione panis. Dum autem
hec loquuntur:stetit ihesus in medio eo-
rum z dixit. Pax vobis. Ego su:no-
lite timere. Conturbati vero z coterriti:
estimabant se spiritu videre. Et dixit
eis.Quid turbati estis: z cogitationes
ascendut in corda vestra? Videte ma-
nus meas z pedes:quia ego ipe sum.
Palpate z videte:quia spiritus carni-
et ossa no habet- sicut me videtis ha-
bere. Et cum hoc dixisset- ostendit e-
is manus z pedes. Adhuc aut illis
no credentibus et mirantibus pre gau-
dio-dixit. Habetis hic aliquid quod
manducet? At illi obtulerut ei partem
piscis assi:z fauu mellis. Et cu madu-
casset coram eis:sumens reliquias de-
dit eis. Et dixit ad eos. Hec sunt verba
q locut9 su ad vos cu adhuc essem vo-
biscu:quonia necesse est impleri oia
que scripta sunt in lege moysi et pphe-
tis z psalmis de me. Tuc aperuit illis
sensum-ut intelligeret scripturas: z di-
xit eis. Quonia sic scriptu e-et sic opor-
tebat cristu pati z resurgere a mortuis
tercia die:z pdicare in nomine ei9 peni-
tentia z remissione peccatox i omnes

gentes:incipientibus ab iherosolima.
Uos aut testes estis horu. Et ego mit
tam pmissum patris mei i vos: vos
aut sedete in ciuitate quoadusq indu
amini virtute ex alto. Eduxit aut eos
foras in bethaniam: z eleuatis mani
bus suis benedixit eis. Et factu est du
benediceret illis recessit ab eis:z fereba
tur in celum. Et ipsi adorantes regres
si sunt in iherusalem cum gaudio ma
gno: et erant semper in templo lau
dantes et benedicentes deum amen.
Explicit euangeliu secundu luca. Incipit
prologus i euangeliu secundu Johanne

Hic est iohannes euange
lista vn9 ex discipulis dni
qui virgo a deo electus e:
que de nuptijs volentem
nubere vocauit deus. Cui virginitatis
in hoc duplex testimoniu datur in eu
angelio:q et pre ceteris dilectus a deo
dicit:et huic matrem sua de cruce com
mendauit dns:ut virgine virgo serua
ret. Deniq manifestans in euangelio
q erat ipe incorruptibilis verbi opus
inchoans:solus verbu carne factum
esse:nec lumen a tenebris comprehensu
fuisse testatur:primu signu ponens qd
in nuptijs fecit dns ostendens q ipe
erat:ut legentib demonstraret q ubi
dns inuitatus sit deficere nuptiaru vi
num debeat:et ueteribus immutatis
noua omnia que a cristo instituunt
appareat. Hoc aut euangeliu scripsit in
asia:postea qj i pathmos insula apo
calipsim scripserat:ut cui i principio ca
nonis incorruptibile principiu pnotat
in genesi: ei etia incorruptibilis finis
p virgine i apocalipsi redderet dicere
cristo ego sum alpha et o. Et hic e io
hannes:qui sciens superuenisse diem re
cessus sui. Conuocatis discipulis suis

in ephesi:per multa signoru experimen
ta pueniens cristu descendens i defossu
sepulture sue locu facta oratione · po
situs est ad patres suos:tam extrane9
a dolore mortis q a corruptione car
nis inuenitur alienus. Tamen post om
nes euangeliu scripsit: z hoc virgini
debebat. Quoru tame uel scriptoru tepo
ris dispositio·uel libroru ordinatio ido
a nobis per singula non exponitur:
ut sciendi desiderio collato et queren
tibus fructus laboris: z deo magiste
rij doctrina seruetur. Explicit prologus
Incipit euangeliu secundu iohannem.

In principio erat verbu: z verbu erat
apud deu: et de9 erat verbu. Hoc erat
in principio apud deu. Omnia p ipm
facta sunt: z sine ipo factum est nichil.
Quod factu est in ipo vita erat: z vita
erat lux hominu: et lux in tenebris lu
cet: z tenebre eam no comprehenderut. Fu
it homo missus a deo: cui nome erat io
hanes. Hic venit i testimoniu ut testi
moniu phiberet de lumine: ut omnes
crederent p illu. No erat ille lux: sed ut
testimoniu phiberet de lumine. Erat
lux vera: que illuminat omne homi
nem venientem in hunc mundu. In mu
do erat: z mudus p ipm factus est: et
mudus eu non cognouit. In propria ve
nit: z sui eu no receperut. Quotqt aut
receperut eu: dedit eis potestatem filios
dei fieri: hijs qui credut in nomine ei9.
Qui no ex sanguinib neq ex volun
tate carnis · neq ex volutate viri: sed
ex deo nati sunt. Et verbu caro factum
est:et habitauit in nobis. Et vidimus
gloria ei9·gloriam quasi unigeniti a
patre:plenu gratie z veritatis. Johan
nes testimonium phibet de ipo· z cla
mat dicens.Hic erat que dixi: q post
me venturus est · ante me factus est:

24

resetting of some pages, it is clear that Gutenberg increased the print-run.[38] Producing 180 copies would likely have taken about three years – this includes the time to cast type, typesetting and the presswork itself, which during the latter stages employed six presses.[39] This compares to about two to three years for the production of a single manuscript copy. Once printing was completed, every leaf of every single copy required finishing by hand: decorated and illuminated initials, rubrication, book headings, chapter numbers, Psalm *tituli* (labels or titles used to introduce the psalm or identify the speaker) and other rubrics. Only then could the sheets, comprising 643 leaves (1,286 pages), be bound into two volumes. Copies of the Forty-two-line Bible now in Munich and Vienna are of special interest in this regard as they are supplemented by eight-page printed guides to rubrication, or *tabula rubricarum*, for the book-finishers to follow.[40] Doubtless the rubrication guides were supplied with all copies, but it is to be expected that most were discarded or recycled once they had served their purpose. Some surviving copies of the Bible follow the rubrication guide very closely, while others, like the paper and vellum copies held at the British Library, ignore it entirely. The style of decoration in surviving Forty-two-line bibles ranges from the elaborate and luxurious, like the Burgos, Göttingen and Vienna copies, to the plain but graceful reservation of the vellum copy at the British Library, which besides rubrication and some sober yet finely decorated initials, contains no other embellishments. The British Library's paper copy is similarly undecorated but for three pages: for example, the opening to volume two (Proverbs, folio 1r), with scrolling foliage, exotic birds, a monkey in the lower margin and a historiated initial featuring King Solomon. Although the Bible is not without its errors – one of the best-known examples being an oversight on the part of the compositors to add space, or a line-break, for the chapter number, in Matthew 22[41] – it is nevertheless an impressive book and a truly remarkable typographic first. The very even line-endings in the two columns of text were achieved by inserting metal spacing material, variant punctuation marks, ligatures or contractions. What is more, the 2,563 columns of text always end with a full word – a word is never broken or hyphenated across pages or columns, apart from two exceptions, one in each volume: the first in Psalm 104 towards the end of volume one; the second in 1 Timothy 1:2, in volume two.[42]

The greatest capital investment was in paper and vellum. It is estimated that the cost of vellum and paper alone ran to 1,000 gulden,

10 Bull's head watermark from the Forty-two-line Bible, *c.* 1455. The watermark identifies the origin of the paper as Caselle in Northern Italy. The paper is fine quality, made from linen rags.

the equivalent of the cost of two houses.[43] Add to that the cost of hiring compositors to set type and labour to operate the six printing presses and ink the formes, materials for casting type, production of inks – expenses that had to be covered for some two to three years while the Bible was being produced. The water-based inks that had long been used by scribes were wholly unsuited to printing as they would fail to adhere evenly to the metal type. Gutenberg needed a relatively stiff or sticky ink, more akin to oil paint, but one which would dry quickly to avoid inadvertent smudging. His ink comprised a varnish, either walnut oil or linseed oil, in addition to rosin (distilled turpentine) and lampblack, or fine soot. Gutenberg's ink recipe coincided with significant developments in the art world and the broad adoption of oil-based paints over water-based tempera (pigments with egg yolk added as a binding medium), championed by the likes of early Netherlandish painters Jan van Eyck and Rogier van der Weyden. Moreover, this new oil-based ink worked

equally well for printing using metal type and woodblocks. When it came to sourcing paper, Gutenberg avoided the local paper mills in Germany and instead imported high-quality stocks made from linen rags – from Caselle in Piedmont, Northern Italy,[44] evidenced by watermarks that reveal the use of four different paper stocks from the region: the four unique watermarks comprised two varieties of grape clusters and two of an ox (fig. 10).[45]

For Gutenberg, 1455 was undoubtedly a bittersweet year. The Forty-two-line Bible was either completed or nearing completion, but Johann Fust, who had twice made loans to Gutenberg in about 1449 and 1452, brought legal action against him for immediate repayment of this money. Fust claimed that Gutenberg had not paid interest on the loans, further accusing him of using some of the funds to finance his personal projects – perhaps a reference to Gutenberg's grammars, calendars and indulgences.

Despite the lawsuit against Gutenberg, there is no evidence to suggest that he was bankrupted or that he lost all of his printing equipment to Fust as a result. On the contrary, it appears that the dispute was resolved and the dissolution of their partnership was nothing other than amicable. Gutenberg continued to run his press independently, while Fust continued to print in partnership with Peter Schoeffer. Such temporary partnerships, often established for a set period of time, or even a single edition, were especially common in the early days of printing – often between a merchant or financier, a printer and perhaps a lawyer or academic. In 1465, Gutenberg was granted special dispensations by the Archbishop of Mainz, including exemption from all taxes and an annual stipend, in perpetuity.[46]

Esther and the French Cardinal

Of the 180 copies of his Bible that Gutenberg finished printing in about 1455, forty-nine complete, or substantially complete, examples have survived. The last time a complete Gutenberg Bible went up for sale was in 1978. It sold for $2.2 million and is now in Stuttgart. In 1987, in New York, a single volume sold for $5.4 million to a Japanese bookseller. In 1996 that copy was acquired by Keio University Library in Tokyo, the only copy of the Gutenberg Bible in Asia. If you wish to save up, in expectation of a copy coming onto the market, then you will likely need

tens of millions of dollars. If a complete copy is beyond your means, you might want to know that in 2015, eight leaves, the entire Book of Esther, sold at auction for $970,000; in 2014, a single leaf was sold for a mere $55,200.

Whether complete copies or fragments, the story of their provenance and survival is often as marvellous as the books themselves. For example, the perfect paper copy of the Gutenberg Bible in the Bodleian Library, Oxford University has travelled an especially interesting journey.[47] About 1475, the mayor of Heilbronn, some 140 kilometres to the south-east of Mainz, bequeathed it to the city's Carmelite monastery. In 1632, during the Thirty Years' War, the monastery was destroyed and the Bible came into the possession of the Swedish general Axel Oxenstierna. It subsequently found its way into the library of the French cardinal Étienne Charles de Loménie de Brienne, and was purchased by the Bodleian Library in 1793 for £100, a year before de Brienne died in prison, of apoplexy or poisoning.

The Harvard copy also has an especially interesting and comprehensively recorded provenance. After its printing in Mainz it made its way to Utrecht Cathedral in the Netherlands. In the seventeenth century it returned to Germany, where it remained until the beginning of the nineteenth century when it arrived in Paris. Shortly afterwards it went to England, then on to New York at the close of the nineteenth century. Thereafter it was purchased by the Widener family in Pennsylvania, who later donated it to Harvard College Library in Cambridge, Massachusetts in May 1941.[48] In 1969, a young man who aspired to own his own copy of the legendary Bible hid in a bathroom on the top floor of Harvard's Widener Library, where he patiently waited until closing time. He then climbed out of the bathroom window, making his way to the roof, from where he rappelled down into the room in which the Bible was on display. However, the two volumes of the priceless Bible, now in his knapsack, weighed seventy pounds and hindered his progress back up the rope. He fell six stories to the ground, where he was discovered the following morning with a concussion and a fractured skull. The Gutenberg Bible had broken his fall, but suffered only minor damage. It was both his downfall and his saviour.

Punch, Strike, Justify, Cast

The First Fonts

2

> This noble book . . . has been printed and accomplished without the help of reed, stylus or pen but by the wondrous agreement, proportion and harmony of punches and types.[49]

OUT WALKING AMONG THE DUNES with his children, a father picked up a piece of bark and for no other reason than to entertain them proceeded to carve from it a letter. Upon completion it fell from his hands, face down, leaving its impression in the soft sand. In this happy accident Laurens Coster of Haarlem in the Netherlands saw the entire typographic process clearly before him. Despite the apocryphal nature of this origins tale, it elucidates the fundamental component of typography – an alphabet of discrete cast or moulded letters, inked and then printed.

The Latin alphabet of just twenty-three letters readily lent itself to typographic reproduction – certainly more easily than the thousands of ideographs of the Far East, where there had been early experiments with movable types of baked clay, ceramic, wood and, in thirteenth-century Korea, bronze (these methods were not widely adopted).[50] Gutenberg's invention was entirely independent of those in the East. We do not know what led to Gutenberg's decision to produce metal type, but he had begun experimenting while in Strasbourg around the same time that he had gone into business making pilgrim mirrors for the upcoming pilgrimage to Aachen, one of medieval Europe's most important centres of pilgrimage, famed for its reliquary that held, among other relics, the loin cloth worn by Jesus at his crucifixion. The mirrors were used by pilgrims to capture a glimpse of the relics and something of their sacred aura, which could then be taken home. The mirrors were traditionally set in a metal alloy of lead and tin (not dissimilar to pewter casting of the time that was used to make, among other things, cutlery

and tableware) – the metals, in addition to antimony, that Gutenberg used for casting his types: 'about 83 per cent lead, 9 per cent tin, 6 per cent antimony and one per cent each of copper and iron'.[51] Lead was a relatively inexpensive metal, but too soft; the addition of antimony resulted in a harder, more durable, metal type. However, the piece of metal type was the end result of a long process. The manufacture of metal type began with the fabrication of a letter punch.[52] A punchcutter, working with gravers, files and counterpunches, would fashion each tiny letterform in high relief on the end of a small bar of steel. A steel counterpunch was used to strike or form counters, the area enclosed in letters like *o*, *p* and *q* or partially enclosed in letters like *n*, *m* and *h*. During this painstaking process, the punchcutter would, from time to time, make smoke proofs from a punch held in the flame of a candle to coat it in soot. The punchcutter would continue through the alphabet of upper- and lowercase letters, ligatures, numerals and punctuation until the entire character set or font was completed. It is estimated that between one and four punches might be produced each day, so a complete set of punches, numbering about 120, would take between one and four months to fashion.[53] Once the punches were completed, they were hardened or tempered, then struck into a softer metal, such as copper. The resulting copper matrix now bore an impression of the letterform; however, the act of striking the punch into the copper would deform the matrix, so before it could be used to cast letters, it required levelling and squaring, a process called justification; to minimize distortion the punch might also be pressed into the copper via screw pressure.[54] Justification of the matrices ensured that letters remained centred and perpendicular, so they would not produce uneven or 'dancing' lines when combined for printing. A matrix for a single character was then placed at the bottom of a handheld mould, which was adjustable to cater for letters of different widths from the widest *M* and *W* to the narrow *I* or a comma, for example.[55] The molten alloy of lead, tin and antimony was poured into the top of the mould, cooling and hardening very quickly (the correct proportions of alloyed metals ensured that it did not significantly expand or contract upon cooling). The resulting single piece of cast-metal type, or sort, was removed from the mould, cleaned and was then ready to use in printing.[56] This process would have been repeated thousands of times. Gutenberg likely had at least 100,000 pieces of type cast for the production of the Forty-two-line Bible.[57] A document of 1474 references the casting of a

font of 80,000 letters for use in a newly established press at the Benedictine monastery of SS Ulrich and Afra in Augsburg.[58]

The First Gothic Fonts

Just as the Gutenberg Bible was not the first typographic matter produced, so its font, the B42 type, a formal Gothic typeface modelled on the manuscript book-hand Textualis Formata, was not the first typeface ever produced.[59] In fact, by the time that Gutenberg and Fust completed the Forty-two-line Bible in about 1455, at least four fonts were in existence: in addition to the B42 type (fig. 12), there was the so-called Donatus-Kalender (DK) type, named after its early use in Donatus's grammars and the so-called Astronomical Calendar, and two smaller Gothic cursives or *bastarda*.[60] Of these, the DK type was the earliest as it appears in the *Sibyllenbuch* fragment printed in about 1452–3.[61] In an improved form, it reappeared in the second printed Bible, the Thirty-six-line or Bamberg Bible, most likely also printed by Gutenberg.[62] Like the Forty-two-line Bible type, the DK type was a very formal Gothic *textura*. The two other Gothic cursive fonts, 130 and 131, appeared in letters of indulgence printed in 1454, and were named after the number of lines in the two principal variants (fig. 13). In the 30-line letter of indulgence an early version of the Gutenberg Bible type was used as a titling font; the slightly larger Gothic cursive in the 31-line indulgence was accompanied by the DK type. After its use in the indulgence, the 130 type was never seen again. However, the 131 type was used on no fewer than four more occasions, including in an abridged Latin–German dictionary and an opusculum of Thomas Aquinas,[63] printed by Nicolaus Bechtermüntze in Eltville, a short distance from Mainz, as well as in two broadsides issued in 1480, one an invitation to crusade,[64] the other an altogether more secular invitation to a crossbow meet.[65]

The two Gothic indulgence types, 130 and 131, were similar in design but were most easily differentiated by their capitals, most notably in the forms of *C*, *D* and *T* which in 130 sported perpendicular hairlines. There were fewer significant differences in the lowercase alphabets of the two indulgence fonts but perhaps the most notable was *g*: note how the lower loop or bowl in 131 has an unenclosed lower counter; moreover, 130 includes many more ligatures and contractions.[66]

12 Specimen of в42 type.

13 (opposite) The 130 and 131
indulgence types, 1454–55.

The First Roman

Renaissance letterforms reach far beyond the Italian Renaissance to antiquity. In ancient Rome, Republican and Imperial capital letters were joined by rustic capitals, square capitals (Imperial roman capitals written with a brush), uncials and half-uncials that featured more rounded forms which had developed from the first century, in addition to a more rapidly penned cursive for everyday use. From those uncial and half-uncial forms evolved minuscule letterforms and a new formal book-hand practised in France at the height of the Carolingian empire, which spread rapidly throughout medieval Europe.[67]

LIB SALOMONISIDĒPA
RABOLAEEIVSSECVNDŪ
HEBRAICĀVERITATĒTR
ANSLAT̄E ABEVSEBIO
HIERONIMOPRBROPE
TENTECHROMATIOET
HELIODOROEPĪS HIER°M

UNCAT EPISTOLA QUOS.IUNCIT SACER
dotuum immo carta non diuidat quos xp̄i
Nectat amor. Commentarios in osee
amos zacchariam malachiam. quae
posceris scripsissem silicuisset pracualitu
dine mittitis solacia sirauu notarios ħros
et librarios sustentatis. Ut uobis potissimū
Nostrum desuderinzenium. Et ecce exla
tere frequens turba diuersa poscentium
quasi aut aequum sit me uobis esurientibus
et aliis laborare autin ratione data etac
cepta cuiquam praeter uos obnoxius sim. Itaq;

plebis· NoN ad auctoritatem ecclesiastico
rum dozmatum confirmandam. sicut sane
septuazinta interp̄tum mazis editio placet
habet eam a nobis olim emendatam. Neq;
enim sic Noua condimus ut uetera destrua
mus. et tamen cum dilizentissime lezerit
sciat mazis Nostra intellizi quae Non in
tertium uas transfusa coacuerint. sed statim
de praelo purissime commendata testae
suum saporem seruauerint

EXPLICIT PRAEFATIO;

INCIPIUNT CAPITULA LIBRI PROUERBIO
De parabolis salomonis· I
Affectum patris alloquitur filium blanditur II
 peccatorum non adquiescere
Non ambulandum cum impiis III
Sapientia id e xp̄s loquitur foris id e inluce palam IIII
 ut relicta infantia malitia paruuli simus·
Sapientia hortatur conuerta ad dn̄m et profert sp̄m· V
Sapientia comminatur contemtoribs suis VI
Sapientia hortatur suscipere sermones suos sapientia et prudentia VII
Sapientia docet non ee obliuiscendi legem sua et p̄cepta VIII
Habenda mess̄e fiduciam ad dn̄m· et non haesitandum VIIII
 in oratione· nec confidere prudentiae propriae
Sapientia hortatur ne eloquia dni neglegantur· X
Sapientia docet non ee hominem malū imitandū nec uias eius XI

14 Alcuin of York was responsible for introducing the notion of a hierarchy of scripts from old to new: roman capitals, uncials and Caroline minuscule, with capital forms reserved for display purposes, as seen on this page from a Latin Bible. Manuscript made at Tours, Abbey St Martin, c. 820–30.

This Carolingian script flourished throughout the eponymous empire during the eighth and ninth centuries. However, from the beginning of the eleventh century until about 1225, the open, rounded forms of Caroline minuscule evolved into a squarer, more angular and laterally compressed script. Increasingly the space between certain pairs of letters decreased and the bows, or rounded parts of letters (e.g. in *b, d, o, p*), began to join or 'fuse'.[68] By the twelfth century, this distinctive dark, condensed, ligature-ridden Gothic script, with numerous national and local variations, was fully developed and adopted throughout Europe. The causes of the transformation of Carolingian script into PreGothic, or the 'Gothicizing' of Carolingian script, have been debated for a long

time and the discussion has virtually come to an end without any one explanation gaining general acceptance.[69] Scripts evolved for a number of reasons in addition to sometimes deliberate attempts to devise and popularize new styles.[70] For example, a rigid and formal, constructed script, if written more rapidly will appear less formal, more cursive. Moreover, the kind of pen used and the angle at which it is held all affect the overall designs of letterforms. Other factors include the size, importance or influence of particular monastic scriptoria. A large scriptorium employing dozens of scribes in a university town was more likely to influence the evolution of national scripts than a lone scribe in the countryside.

By the fourteenth century, significant changes were afoot. Coluccio Salutati (1331–1406), humanist Chancellor of Florence, championed a new semi-Gothic script that evolved into the humanist minuscules of Poggio Bracciolini (1380–1459) and Niccolò Niccoli (1364–1437).[71] Renaissance humanism, an intellectual and cultural movement born in Florence, saw in classical antiquity a civilized and civilizing cultural legacy. The art historian Jacob Burckhardt describes the early Italian humanists as 'mediators between their own age and a venerated antiquity'.[72] A great deal of their enthusiasm was focused on restoring the best of classical civilization, most manifestly embodied in its language and literature. Therefore, they scoured the earth for manuscripts, and transcribed, translated and copied them in earnest. But just as the philological reforms of early humanists had sought to reclaim Latin from its medieval adulterations, so too with its script. Late medieval Gothic scripts simply could not be vehicles of classical literature, no more than late Medieval Latin could adequately convey the works of Cicero or Livy. In the course of unearthing manuscripts of classical literature throughout the monastic scriptoria of Europe, the humanists discovered that a number of their venerated classical authors were penned in a rounder, lighter, more open script. What they were seeing were medieval copies of the classics penned in Caroline minuscule but they mistakenly attributed the script to antiquity, hence the term *litterae antiquae*, or antique letters. By 1465, around the time two dusty and tired German clerics arrived in Subiaco in the quiet seclusion of the Sabine Hills east of Rome, the humanist script, a resurrection and reinterpretation of the Caroline minuscule, was fully evolved, and already a natural choice for reproducing the classics.

15 The very first roman type.
Detail from Augustine's *De civitate
Dei* ('The City of God'), printed by
Sweynheym and Pannartz in
Subiaco, 12 June 1467.

Sweynheym and Pannartz

Printing had spread from Mainz in the mid-1450s to Strasbourg, Bamberg, Eltville and Cologne. However, despite the close economic and cultural ties between Germany and Italy, a decade would pass before typography crossed the Alps, surfacing not in Europe's most cosmopolitan city, Venice, nor even in Rome, but rather in the quiet sanctuary of the Benedictine monastery of Santa Scolastica at Subiaco, some 70 kilometres east of Rome. A century before, in 1364, Pope Urban V, dismayed by its 'incorrigible monks', ordered Abbot Bartholomew to dismiss them. Many of their replacements came from Germany, a fact that subsequently was to attract yet more German immigrants, including two lower-order clerics, Konrad Sweynheym and Arnold Pannartz. At the Subiaco monastery, during the fourteenth and fifteenth centuries, foreigners outnumbered Italian monks. Of the approximately 280 monks recorded by name from 1360 to 1515, more than a third (110) were from Germany. Sweynheym had perhaps been employed in Mainz with Peter Schoeffer, and Pannartz was from Cologne. (Pannartz was not, as so many sources have wrongly repeated, from Prague.) Sweynheym and Pannartz's first colophon (Rome, 1467) states they are 'comrades from the German nation'. Their petition of 1472 addressed to Pope Sixtus IV states unequivocally that they are from the dioceses of Mainz and Cologne.[73] So the two cleric-printers would likely have felt quite at home, surrounded as they were by so many of their compatriots.

While in Subiaco, Sweynheym and Pannartz printed four works: Cicero's *De oratore* ('On the Ideal Orator'), Augustine's *De civitate dei* ('The City of God'), Lactantius's *Opera* ('Works') and a Latin grammar by Donatus. The Donatus has not survived but we may safely assume that it was printed in the same roman type employed for the other three. Just as the first printers in Germany looked to contemporary German manuscript exemplars for their Gothic types, so Sweynheym and Pannartz in Italy modelled their letterforms on familiar, contemporary Italian manuscript book-hands, or humanistic scripts. There is no single exemplar for their typeface, just as there is no single humanistic script. It existed in many forms, with local variations, further differentiated by the idiosyncrasies of individual scribes.

The capitals of the Subiaco type are roman, although they are clearly a fifteenth-century scribal interpretation of antique square capitals. *A* is

Incipiut nomi libri rubrice
de ciuitate dei August.Epi.

relatively wide with no serif at the apex; *H* is among the most peculiar of the capitals, with its broken right stem, although this form was not a fanciful invention by Sweynheym and Pannartz but is to be found in early fifteenth-century specimens.[74] Capital *I* has a spur protruding from the left-centre of the stem. The diagonal stroke of *N* meets the right stem mid-way – a form not uncommon in humanistic hands. In addition to long *s* (*ʃ*), short *s* is included for word endings only.

Furthermore, there is a lack of unity between the upper- and lowercase alphabets. For example, the stress and axis (the distribution of weight in the stroke) in the capitals is sometimes almost perpendicular, while in the lowercase it is oblique. Moreover, the treatment of serifs is rather haphazard. As the print historian Stanley Morison notes, the type includes several sorts of *d*, *l* and *m* – perhaps concessions to calligraphic variation.[75] Overall, there is little contrast in the letterforms (little variation between thick and thin strokes). The principal difference between the lowercase of the Subiaco roman and contemporary humanistic scripts is how narrow many of the lowercase letters are cut. This feature, combined with tight spacing, makes for a relatively dark colour (the overall shade of a block of text).

It is somewhat peculiar that the Benedictine monks of Subiaco did not continue with their own press.[76] In 1471, four years after Sweynheym and Pannartz left for Rome, Benedictus de Bavaria (Benedikt Zwink), a monk at Sacra Speco, a sacred grotto just above Santa Scolastica, wrote to Laurentius, the abbot of the Benedictine abbey of Göttweig in Austria, offering to print a breviary, but there is no evidence that Subiaco produced a single title after the departure of the prototypographers Sweynheym and Pannartz.

> We have all the equipment for printing and also the people who know how to use it … all books, whatever the number required, could be printed and distributed to all the monasteries which in their turn would have joined the congregation, with the equipment which is available on the spot, and with the help of five brethren who could be instructed in this technique.[77]

The letter also suggests that they could print 200 copies. A specimen leaf from Sweynheym and Pannartz's edition of *De civitate Dei* was enclosed with the letter, suggesting perhaps that the Subiaco monks inherited the font upon Sweynheym and Pannartz's departure for Rome, although it

appears that they never got the opportunity to use it. However, Benedictus de Bavaria's letter makes it abundantly clear that the monks must have been intimately involved with the Subiaco press.

The other strong candidate for the first typographic printing on the Italian Peninsula is the *Leiden Christi*, a fragment of an edition of the *Passione di Cristo*,[78] which has been tentatively dated to as early as *c.* 1462 and tentatively attributed to either Ulrich Han (by Konrad Haebler) or to Damianus de Moyllis in Parma; if it does not belong to Northern Italy, then it originates in Southern Germany. Its fragmentary nature makes conclusive dating problematic. Felix de Marez Oyens attributes the watermark to a North Italian paper mill, although this in itself does not establish the book's Italian provenance.[79]

Typography at its core comprises discrete and movable, or rearrangeable and reusable, pieces of metal type. Moreover, from their invention to the end of the hand-press age in the early nineteenth century, very little changed, both in the way type was manufactured and used. Today's metal, wood or digital fonts still share those same modular, reusable characteristics. Of Gutenberg's innovations, his pieces of movable type were the most consequential. The choice of roman or Gothic forms was not a technical decision but a cultural one. The eventual domination of roman types is, in addition to their evident clarity, down to the enthusiasm and influence of Florentine humanists and the reforms and successes of the Italian Renaissance, which from the first years of the fifteenth century championed the humanistic minuscule, the model for the very letterforms that you are reading now.

Che la diritta uia era smarrita:

E t quanto a dir qual era, è cosa dura

 Esta selua seluaggia et aspra et forte; esta .

 Che nel pensier rinuoua la paura.

T ant'è amara; che poco è piu morte.

 Ma per trattar del ben, ch'i ui troudi;

 Diro de l'altre cose, ch'i u'ho scorte.

I non so ben ridir, com'i u'entrai;

 Tant'era pien di sonno in su quel punto,

 Che la uerace uia abbandonai. uerace.

M a po ch'i fui al pie d'un colle giunto pie.

 La, oue terminaua quella ualle,

 Che m'hauea di paura il cor compunto;

G uarda'in alto; et uidi le sue spalle

 Vestite gia d'e raggi del pianeta,

 Che mena dritt'altrui per ogni calle.

A llhor fu la paura un poco queta; queta.

 Che nel lago del cor m'era durata lago del co

 La notte, ch'i passai con tanta pièta.

E t come quei; che con lena affannata simil.^{do} pièta . i. la

 Vscito fuor del pelago alla riua lena . i.

 Si uolge a l'acqua periglosa, et guata; elito. guata.

C osi l'animo mio, ch'anchor fuggiua,

 Si uols'a retro a rimirar lo passo; retro.

 Che non lascio giammai persona uiua.

P o c'hei posat'un poco'l corpo lasso; hei . i. habui.

 Ripresi uia per la piaggia diserta deserta

Saint Catherine and the Pirates

The First Italics

3

> We have printed, and are now publishing, the Satires of Juvenal and Persius in a very small format, so that they may more conveniently be held in the hand and learned by heart (not to speak of being read) by everyone.
>
> ALDUS MANUTIUS[80]

WHILE GUTENBERG WAS EXPERIMENTING with movable type in Mainz, the Manuzio family gave birth to a son, Aldo (latinized as Aldus Manutius). Born in about 1450 in the small hill town of Bassiano some 65 kilometres to the south-east of Rome, Aldus Manutius would go on to become one of the greatest printer-publishers of all time. In Rome he studied under Gaspare da Verona and worked as a tutor to the aristocratic nephews of Giovanni Pico della Mirandola, the elder of whom, Alberto Pio, prince of Carpi, became one of Aldus's financial backers in Venice.[81] In Ferrara he completed his studies in Greek under the humanist scholar Battista Guarino. By the summer of 1490, Aldus was in Venice embarking on a new career and busying himself collecting manuscripts, seeking backers and familiarizing himself with the business of printing and publishing. Prior to setting up his own press, he commissioned Andreas Torresanus (Andrea Torresani), formerly associated with Jenson in the 1470s, to publish his own Latin grammar in March 1493.[82] By the following year his press was established, in partnership with Torresanus, with the first book rolling off the press in 1495.

Initially Aldus printed the Greek classics, works by Aristotle, Herodotus, Sophocles and Thucydides, then turned his attention to Latin authors and works in the vernacular. The folio *Hypnerotomachia Poliphili* ('Poliphilo's Battle of Love in a Dream'), published in December 1499, commissioned by Leonardo Grassi of Verona and attributed to the Dominican priest Francesco Colonna, is an eccentric, near-unreadable allegorical prose romance, adorned with 172 woodcuts, and one of the most famous of all incunabula (see pp. 75–7).[83] While Michelangelo

16 Aldine italic from an early edition of Dante Alighieri's *Inferno*, 1502.

was in Florence beginning work on his *David*, Aldus was preparing
to print the first in his series of small-format octavo classics, or *libelli
portatiles*, books that could be held comfortably in the hand. Contrary to
an oft-repeated misconception, their novelty lies not in their size – small
octavo-format books were not invented by Aldus, but had existed for
centuries prior, in manuscript form, often used for devotional texts like
the book of hours, for example; the ISTC lists some 3,000 editions
printed in the octavo format prior to 1500, or approximately 10 per cent
of the total incunabula editions. Neither did their originality lie in their
subject matter – the Latin classics were among the first books published
in Italy by the prototypographers Sweynheym and Pannartz. Nor, as
some have claimed, were they particularly inexpensive – Isabella d'Este,
Marchesa of Mantua, complained about the cost of some luxury vellum
copies of Latin classics she had ordered from Aldus. Plain paper copies
sold for a by-no-means-inexpensive quarter of a ducat, comparable to the
cost of some of the larger quarto editions.[84] The Aldine octavo-format
editions were not cheap, but they were considerably smaller than the
quarto and folio editions, which were accompanied by exhaustive
commentaries by the likes of Donatus, Landino and Mancinelli. The new
small-format Aldine editions, by contrast, omitted those commentaries.
It was this omission, rather than the new italic type, that afforded the
greatest space saving, and a smaller format book with far fewer pages was
indubitably less expensive to produce. Thus, the popularity and novelty
of the Aldine *libelli portatiles* is attributable to the successful synthesis
of these individual features.

 Although the Virgil of 1501 was the first book in which the new
Aldine italic was used throughout, it had made an appearance in the
preceding year – albeit in a minor supporting role – in Aldus's folio edition
of the *Letters of St Catherine of Siena*, where a mere five words of Latin are
set in the newly cut italic writ across the open book – *iesu dolce | iesu amore*
– and heart – *iesus* – held aloft in the frontispiece woodcut depiction
of Saint Catherine (fig. 18).[85] Incidentally, this book was commissioned
by publisher Margherita Ugelheimer, widow of Peter Ugelheimer, former
business partner and close friend to Nicolaus Jenson. This new italic
type appeared again in February 1501, months before the Virgil, in the
preface to the second edition of Aldus's Latin grammar.

In a preface to his 1514 edition of Virgil, Aldus explains that inspiration for his *libelli portatiles* or *enchiridion* (handbook) came from books in the library of his friend, Bernardo Bembo, small-format manuscripts written in a humanist cursive script. Just as roman type was modelled on formal humanistic book-hands of the fifteenth century, Aldus's italic type was based on the more rapidly penned cursive humanist script, or *littera humanistica cursiva,* like that used by the scribes at the papal chancery throughout the fifteenth and sixteenth centuries (fig. 19). Indeed, his very first italic might well have been modelled on the hand of Paduan scribe and illuminator, Bartolomeo Sanvito (1433–1511).[86]

Counterfeits

In an era before legal copyright, Aldus was quick to protect both his newly designed italic type and the editions in which those types appeared from the pirates and counterfeiters the best way he could. In 1502 he was granted 'privileges' (the exclusive right to print a work or class of works for a specific period) by two decrees issued from the Senate and the Doge of Venice. The ten-year privilege granted by the Senate threatened counterfeiters with fines and confiscation. (In 1496, Aldus had been granted a similar twenty-year privilege for his Greek types, and by extension his Greek books.[87]) However, there is no evidence to suggest that such privileges afforded much real protection against counterfeit editions – it was not long before his italic type and entire books were copied. In the very same year in which the Senate granted Manutius protection, a pirated edition of his Dante was published in Lyons.[88] Although unsigned, it is usually attributed to Barthelemy Trot, who ironically referred to himself as 'the honest book-seller'. Trot, in another counterfeit from his press, was brazen enough to reprint Aldus's all-caps warning, 'Whoever you are, whatever way you misuse this edition will cause your condemnation as a criminal by the illustrious Venetian senate. Don't say you haven't been warned. Watch out!'[89] That so many early pseudo- or counterfeit editions were unsigned suggests that they were intended for export to Italy to compete with genuine Aldine editions. When Aldus learned of the pirated editions, on 16 March 1503 he

17 An Aldine press octavo edition of Juvenal, printed on vellum. Venice, 1501.

IVNII IVVENALIS AQVINA
TIS SATYRA PRIMA.

EMPER EGO AVDITOR
tantum? nunquám ne reponam
Vexatus toties rauci theseide
Codri?
Impune ergo mihi recitauerit ille
togatas?
Hic elegos? impune diem consumpserit ingens
Telephus? aut summi plena iam margine libri
Scriptus, et in tergo nec dum finitus, Orestes?
Nota magis nulli domus est sua, quam mihi lucus
Martis, et æoliis uicinum rupibus antrum
Vulcani. Quid agant uenti, quas torqueat umbras
Aeacus, unde alius furtiuæ deuehat aurum
Pelliculæ, quantas iaculetur Monychus ornos,
Frontonis platani, conuulsáq; marmora clamant
Semper, et assiduo ruptæ lectore columnæ.
Expectes eadem a summo, minimóq; poeta.
Et nos ergo manum ferulæ subduximus, et nos
Consilium dedimus Syllæ, priuatus ut altum
Dormiret. stulta est clementia, cum tot ubique
Vatibus occurras, perituræ parcere chartæ.
Cur tamen hoc libeat potius decurrere campo,
Per quem magnus equos Auruncæ flexit alumnus,
Si uacat, et placidi rationem admittitis, edam.
Cum tener uxorem ducat spado, Meuia thuscum
Figat aprum, et nuda teneat uenabula mamma,
Patricios omnes opibus cum prouocet unus,

iesu
dolce

iesu
amore

Dulce signum charitatis
Dum amator castitatis,
Cor mutat in Virgine.

iesus

COR MVNDVM

CREA IN ME DEVS

SANCTA CATHARINA DESENIS.

18 (left) *The Letters of St Catherine of Siena*, printed by Aldus Manutius in 1500. This is the first appearance of Aldus's new italic type, written across the open book and the heart.

19 (right) A fifteenth-century manuscript example of Paduan scribe Bartolomeo Sanvito's hand from Ovid's *Ex Ponto.* Such letterforms, italics or chancery cursive, were models for the first italic types.

published a broadside warning or 'Monitum' in protest, in which he not
only castigated the pirates, but lists the ways in which the counterfeit
Lyonnais editions were inferior (fig. 20):

> These fraudulent volumes, printed and sold under my name prejudice
> friends of letters to my sorrow and discredit. The paper is inferior,
> and even has a foul odour; the type characters are defective, and the
> consonants do not align with the vowels. It is by their imperfections
> that you may distinguish them.[90]

And, taking a sideswipe at *les faussaires Lyonnais,* he describes their
typography as exuding a certain 'Frenchiness'. However, the savvy Lyons
printers did not miss a stride: they promptly noted Aldus's corrigenda,
using them to emend and improve their own counterfeit editions.
By 1510 the Lyonnais had put out no fewer than fifty italic-type editions.
Pirated editions were also issued from 1503 by the Florentine press of
Filippo Giunti, who claimed that his texts had been corrected by one
Aldus Manutius, when in fact they were almost exact copies of the 1502
Aldine editions. Martin Lowry makes a case for suggesting that the
lawsuit in which Aldus was involved in 1507 was with the Giunti press
over its pirated editions.[91]

The first italic types comprised a gently inclined cursive-style
lowercase paired with upright roman capitals.[92] This was not a typographic
innovation, but a convention imitating manuscript exemplars. It is worth
noting that italic scripts and types are not inclined by definition – italic
refers to its place of origin rather than its aesthetic. Moreover, the roman
capitals in Aldus's italic fonts were smaller and, in some respects, might
be considered precursors to small capitals (capitals that are the same
height as the lowercase letters). The shift from upright to inclined capitals
was gradual. Inclined italic capitals begin to appear with increased
frequency during the 1530s. The so-called Froben italic of 1537, likely
cut by Peter Schoeffer the younger (the second son of Gutenberg's former
partner), is described by Hendrik Vervliet as the first successful attempt
at allying inclined or sloped roman capitals with a cursive italic lowercase.
Some italic types designed by Robert Granjon at the close of the 1540s
were supplied with both upright and inclined capitals, demonstrating
that not all audiences were ready for the latter.[93] However, by the
mid-sixteenth century, the inclined italic capital was becoming the
normative form, with its later ubiquity perhaps most attributable to the

Cum primum cœpi suppeditare studiosis bonos libros: id solum negocii fore mihi existimabã: ut optimi quiq; librí & Latini:& Græci exirent ex Neacademia nostra quã emendatissimi:omnes q; ad bonas literas:bonas q; artes:cura:& ope nostra excitarentur:Verum longe aliter euenit.Tantæ molis erat Romanam condere linguam. Nam præter bella:quæ nescio quo infortunio eodem tempore cœperunt:quo ego hanc duram accepi prouinciam:atq; in hunc usq; diem perseue rant:ita ut literæ iam septénium cum armis quodammodo strenue pugnare uideant:quater iam in ædibus nostris ab ope ris : & stipendiariis in me conspiratum est : duce malorum omnium matre Auaritia: quos Deo adiuuante sic fregi:ut ual de omnes pœniteat suæ persidiæ. Restabat:ut in Vrbe Lugduno libros nostros & mendose excuderent:& sub meo nomi ne publicarent:in quibus nec artisicis nomen:nec locum,ubi nam impressi fuerint,esse uoluerunt:quo incautos emptores fallerent:ut & characterum similitudine:& enchiridii forma decepti:nostra cura Venetiis excusos putarent . Quamobrem ne ea res studiosis damno:mihi uero & damno:& dedecori foret:uolui hac mea epistola oẽs:ne decipiantur,admonere:in frascriptis uidelicet signis. Sunt iam impressi Lugduni(quod scierim)characteribus simillimis nostris:Vergilius.Horatius Iuuenalis cum Persio.Martialis.Lucanus.Catullus cum Tibullo:& Propertio.Teretius.In quibus oĩbus nec est impresso ris nomen:nec locus:in quo impressi:nec tẽpus,quo absoluti fuerint. In nostris uero omnibus sic est : Venetiis in ædibus Aldi Ro. illo:uel illo tẽpore. Item nulla in illis uisuntur insignia. In nostris est Delphinus anchoræ inuolutus:ut in fra licet uidere. Præterea deterior in illis charta:& nescio quid graue olens.Characteres uero diligentius intuenti sapiũt: (ut sic dixerim)gallicitatem quandam. Grandiusculæ item sunt perquãdeformes. Adde q uocalibus cõsonátes non cõ nectuntur:sed separatæ sunt. In nostris plerasq; omnes inuicè connexas:manum q; mentientes:operæpretium est uide re. Ad hæc hisce:quæ inibi uisuntur:incorrectionibus:non esse meos,facile est cognoscere. Nam in Vergilio Lugduni impresso in fine Epistolii nostri ante Bucolicoꝝ Tityrum, perperam impressum est: optimos quousq; autores : pro opti mos quosq;. Et in fine librorum Aeneidos:in prima Epistolæ nostræ semipagina ad Studiosos extremo uersu male im pressum est: maria omnie cirtm:pro maria omnia circum.ubi etiam nulli accentus obseruantur:cum ego eam epistolam propterea composuerim:ut ostenderem:quo nam modo apud nostros utendum sit accentiunculis. In Horatio:in mea Epistola:secundo uersu sic est excusum : Imprissis uergilianis operibus : pro impressis. Et tertio sic: Flaccum aggrssi:pro aggressi. Grandiusculæ præterea literæ ante primam Oden primo:& secundo uersu sunt impressorio atramento supra: & infra:quasi linea conclusæ pturpiter. In Iuuenale in mea Epistola:tertio uersu est pubilcamus:pro publicamus. Et de cimo uersu: Vngues quæ suos : pro ungues q; suos. Item in prima semipagina: Semper & assiduo ruptæ rectore: pro lectore. In eadem. Si uacat:& placidi rationem admittitis:eadem : pro edam. Et paulo post. Cum tenet uxorem:pro te ner. Item inibi: Eigat aprum:pro figat. In Martiale statim in principio primæ semipaginæ est impressum literis gran diusculis sic AMPHITEATRVM : pro AMPHITHEATRVM . Et in eadem. Quæ tam se posita : pro seposita. Item in Libro secundo ad Seuerum deest græcum ἐϱωτοϰαλιϰόϊ· Et in Candidum:ubiq; deest græcum:idest ϰοινὰ Φίλων πάντα. Et in fine : ϰοινὰ Φίλων. In Lucano nulla est epistola in principio:at in meo maxime. In fine Ca tulli eam:quæ in meo est:epistolam prætermiserunt.Quæ etiam possunt esse signa Lugdunĩne:an Venetiis mea cura im pressi fuerint. Terentium etsi egò nondum curaui imprimendum:tamen Lugduni una cum cæteris sine cuiusquam no mine impressus est:Quod ideo factum est:ut emptores meum erte:& libri paruitate:& characterum similitudine existĩmã tes:deciperentur. Sciunt enim quem nos in pristinam correctionè:seruatis etiam metris:restituẽdum curamus:in summ a esse expectatione:& propterea suum edere accelerarunt:sperãtes ante eum uenũdatumiri:q̃ emittatur meus. Sed q̃ ill emẽ datus exierit:uel hinc cognosci pốt:q̃ statim in principio sic est impressum:EPITAPHIVM TER MT pro Terentii. Item Bellica prædia sui : pro præda. Et : Hæc quunq; leget:pro quicunq;. Præterea in principio secunda: char tæ. Acta ludis Megalensibus. M. Fuluio ædilibus.&.M.Glabrione.Q .Minutio Valerio curulibus:pro.M. Glabrione. Qu. Minutio Valerio ædilibus curulibus.Quod etiam putates esse argumentũ:impresserũt. ARGVMENTVM. ANDRIAE. Ante etiam Sororem falso est.TERENTII ARGVMENTVM.cũ argumenta omnia Comœdiarũ Teretii : non Teretius:sed Sulpitius Apollinaris cõposuerit.Sic enim in uetustissimis habetur codicibus.C.Sulpitii Apol linaris periocha. Metra etiam confusa sunt omnia.Versus enim primæ scenæ:quæ tota trimetris constat:sic tanq̃ chaos in elementa:separati ab inuicem in suum locum sunt restituendi.

Si. Vos istæc intro auferte.abite.Sosia
 Ades dum:paucis te uolo. So. Dictum puta.
 Nempe:ut curentur recte hæc. Si. Immo aliud. So. quid est:
 Quod tibi mea ars efficere hoc possit amplius?&c.

Item secunda scena:cuius tres primi uersus sunt trimetri.Quartus tetra meter. Quintus dimeter:& cæteri omnes quadrati : sic esse debet.

Si. Non dubium est : quin uxorem nolit filius.
 Ita Dauum modo timere sensi:ubi nuptias
 Futuras esse audiuit. sed ipse exit foras.
Da.Mirabar hoc si sic abiret:& heri semper lenitas
 Verebar quorsum euaderet.
 Qui postquam audiuit non datumiri filio uxorem suo:
 Nunquam cuiquam nostrum uerbum fecit:neq; id ægre tulit.
Si. At nunc faciet:neq;(ut opinor)sine tuo magno malo.
Da.Id uoluit:nos sic opinantes duci falso gaudio:
 Sperantes iam amoto metu:interea oscitantes obprimi:
 Ne esset spatium cogitandi ad disturbandas nuptias.
 Astute.Si.Carnifex quæ loquit?D Herus est:neq; puideram &c.

Qua in re quantus sit mihi labor:cogu at:qui intellegũt . Certe pluri mum die:noctu q; elaboramus.

Hæc publicãda iussimus:ut q libellos enchiridii forma excusos emptu tus est:ne decipiatur:facile.n.cognoscet:Venetiis:ne in ædibus nostris impressi fuerint:an Lugduni. Vale. Venetiis.xvi.Martii.M.D.III.

likes of Granjon from about 1543.[94] From the mid-sixteenth century, in addition to capitals inclined to match the slope of the italic lowercase, the slope steepened, and the sharpness or angularity of the original Aldine italics made way for smoother forms and transitions. During the 1550s the so-called old-face italic had all but replaced the chancery and Aldine forms.[95] Not until about 1560, some forty-five years after Aldus's death, was the italic capital adopted by the Aldine press itself. The italic first appeared in England in 1528, in two works from the press of Wynkyn de Worde in London.

Murder in Italic

It appears that Griffo had cut most, if not all, of Aldus's types up to the year 1500, including romans, Greeks and possibly the Aldine Hebrew;[96] and, of course, the first italic. Aldus had heaped praise on Griffo, going as far as to compare him, in the preface to his octavo-format Virgil, to the godlike artisan Daedalus, of Homeric legend.[97] However, it appears that Griffo was unhappy that he was not receiving enough credit or recompense for these new typefaces. Shortly after the publication of the Virgil, Griffo left Aldus to work in Fano for Gershom Soncino, for whom he cut new italic punches; Griffo appears to have been excluded from the Venetian territories by legal action on the part of Aldus.[98] Soncino sided with Griffo, and in the dedication of his 1503 Petrarch, he praised Griffo and criticized Aldus for his treatment of him – in particular Aldus's efforts to seek what amounted to a kind of patent on Griffo's type designs. In 1516, soon after the death of Aldus, Griffo returned to his native Bologna to set up his own print shop. In the first book issued from his press, Petrarch's *Canzonier*, the preface, written a decade after their split, in addition to reasserting Griffo's authorship of the Aldine italics, took a jab at the recently departed Aldus: '[Aldus] had not only come into much wealth, but had assured himself of immortal fame and posterity.'[99] Fame and prosperity that, undoubtably, Griffo felt were owed to him, rather than Aldus.

However, Griffo's career as an independent printer was short-lived. During an altercation in the family home with his son-in-law, Cristoforo De Risia, husband to his daughter Caterina, Griffo allegedly beat him to death with a metal bar. Griffo disappears from records in 1518, some

claiming that he was found guilty of his son-in-law's murder and breathed his last at the end of a hangman's noose. Within a century of Griffo's death, typographic fashions had demoted the italic to a supporting or secondary role. In English text it was used for quotations in Latin. By the seventeenth century italic was rarely employed to set entire books, its role subordinated – for *emphasis*, loan and foreign words and sometimes quotations – in much the same way as it is today.

Making Haste Slowly

Aldus's motto was the classical adage, *festina lente*, or 'make haste slowly', exemplified in his printer's mark, a dolphin entwined around an anchor (see p. 98, fig. 43). This apparent oxymoron, attributed to ancient Greece, conveys a simultaneous desire to act with urgency while taking time to reflect, to be meticulous – hurry without being slipshod, so to speak. It is evident that Aldus indeed worked by this motto. His sense of urgency or haste is evidenced by the ambitiousness of his publishing programme, and by the fact that right up until his death, while in poor health, he was still working and planning future books. In the preface to his Cicero of 1514, he complains of the numerous interruptions from visitors to his workshop, writing that as a deterrent to would-be time-wasters and gawkers, he posted a notice above his door that read, 'Whoever you are, state your business as briefly as possible and be gone.' It is rather fitting that Aldus's final book, completed just weeks before his death in February 1515, was another *enchiridion*, Lucretius's *De rerum natura* ('On the Nature of Things'), set in italic and dedicated to his former student and long-time benefactor, Alberto Pio, prince of Carpi.[100] It was Lucretius who famously penned the words 'life is one long struggle in the dark' – a darkness gloriously illuminated by the genius of a visionary Venetian publisher and a bellicose Bolognese punchcutter.[101]

Against All Odds
The First Female Typographers

For most of history, Anonymous was a woman.[102]

THE MIDDLE AGES witnessed the establishment of universities and a concomitant flourishing of formal education, but few supposed that women could benefit from these developments, even from reading and writing. Women were not admitted to universities and few, bar those in the higher social classes, were even sent to school. The predominant view was that women were inferior to men, morally and intellectually (for hadn't the first woman been responsible for man's expulsion from paradise?) and that they should eschew vanity, ambition and literature in favour of so-called female labours, chastity and prayer. Fifteenth-century women had little time left over from their quotidian obligations to pursue a formal education, let alone a career.

Perhaps Victorian romanticism is responsible for painting a rather idealized picture of women during the Middle Ages: maidens in pretty gowns with princely suitors – something more akin to Disney than the prosaic and harsh historical facts. The prospects of medieval and early Renaissance women might more accurately be summarized as 'marriage, monasticism and prostitution'.[103] For those who did not join a convent, marriage came early: 'an unmarried girl of sixteen or seventeen was a catastrophe.'[104] Young women from wealthier or patrician families fared marginally better, although, once the family's dowry fund had been exhausted on the eldest daughters, the youngest girls would be enthusiastically persuaded to 'take the veil', to enter a convent as a nun. But even in the convent, the best positions were, for the most part, open only to women of high birth. Others might join as lay sisters, where much of their

21 Vittore Carpaccio, *The Virgin Reading*, c. 1505.

day-to-day work consisted of domestic chores. In Venice alone, during the 1480s, there numbered some 2,500 nuns in fifty convents; an estimated 15,000 women – one-fifth of the total female population – worked as prostitutes and courtesans.

A further danger to women in this period was the craze of torturing and burning 'witches', the beginnings of which coincided with Pope Innocent VIII's so-called Witch-Bull of 1484, sanctioning the inquisition to pursue any means necessary to prosecute and execute witches, who were mostly female. Printing played a part in this brutal and prolonged episode. The book *Malleus Maleficarum* ('Hammer of Witches') by the inquisitor Heinrich Kramer had a key role in promoting the murder of women. It is true that Innocent later disavowed the book, but print allowed it to become a bestseller throughout Europe – he had lit a fire that he was powerless (or unwilling) to extinguish. Historian Malcolm Gaskill estimates that 40,000–50,000 witches (mostly women) were executed over a period of 300 years.[105]

Scribes and Copyists

Notwithstanding such a wholly inauspicious and frequently hostile environment, a number of women became printers, publishers and typographers. Prior to the introduction of printing in the mid-fifteenth century women had sometimes been involved in the production of manuscript books. The history of women working as scribes can be traced back to the early days of the Church, with Eusebius (263–339) mentioning that women were employed as copyists.[106] Notable too are the female monastic scribes of Schäftlarn, Admont and Wessobrunn in twelfth-century Bavaria.[107] It is difficult to trace the scale of the involvement of women in medieval monastic scriptoria, as scribes and copyists, whether men or women, seldom signed their work, even where the manuscript contained a colophon.

Other women were involved in the book trade, directly or tangentially. In France, Mahaut, Countess of Artois (1268–1329), was an avid book collector and patron of the arts. Margaret Beaufort, Countess of Richmond, was a leading patron of William Caxton, who printed the first books in England. Isabella d'Este, patron of Aldus Manutius, one of the most notable women of the Italian Renaissance, commissioned numerous volumes, including beautiful and lavishly illustrated editions

of books of hours from the great Venetian printer-publisher, and reportedly had them all checked for errors, threatening to return copies that did. She was also crucial in procuring vellum from Mantua for the Aldine press after an apparent shortage.[108] Then there were the miniaturists and illuminators such as Jeanne de Montbaston in Paris in the mid-fourteenth century (fig. 22), and professional scribe Clara Hatzlerin, who worked in Augsburg during the third quarter of the fifteenth century.[109]

22 Self-portraits of husband and wife illuminators, Richard and Jeanne de Montbaston, from a fourteenth-century French manuscript.

Husband and Wife Partnerships

From 1476 to 1484, the Dominican nuns of San Jacopo di Ripoli in Florence were printing a mix of classical, educational and religious books. A diary or logbook of the convent press was discovered in the eighteenth century and contains the earliest record of a female compositor, a nun, who in 1481/82 typeset a folio edition of *Il Morgante*, a work by Italian poet Luigi Pulci (1432–84).[110] In Mantua, Northern Italy, around 1476, Estellina Conat, wife to physician and printer Abraham Conat, was involved in typesetting one of the earliest printed Hebrew books, a small octavo edition of *Behinat Olam*.[111] In the colophon she writes:

I, Estellina, wife of my master my husband the honoured Rabbi Abraham Conat, may he be blessed with children and may his days be prolonged. Amen! wrote this book 'Investigation of the World' with the aid of the youth Jacob Levi of Provence of Tarascon, may he live.[112]

She printed with her assistants in the newly built clock tower, overlooking the Piazza delle Erbe, designed by the famed Florentine architect and contemporary of Da Vinci, Luca Fancelli.

It was not uncommon for the wife of a craftsman to work alongside her husband. The atelier and the living quarters of the fifteenth-century print shop merged into one, so that even if the wife were not directly working at printing she would undoubtedly become very familiar with the workings of the business – and would no doubt be well acquainted with compositors, editors, visiting authors and the host of other skilled and unskilled labourers who busied themselves around the press. Wives were allowed to join the same guilds as their husbands, something that in most instances was not permitted for women not already associated through marriage and familial connections. Madonna Paola, daughter of the painter Antonello da Messina, married four times, the last three times to printers. After the death of her first husband, Bartolomeo di Bonacio da Messina, she married Venice's prototypographer, Johannes da Spira, then Johannes de Colonia (associated with Jenson), and lastly to Rinaldus of Nijmegen. The usual trajectory was a three- or four-year apprenticeship; however, as women were not permitted to apprentice as printers, for a women to run a printing business demanded a rare configuration of circumstances. First, she had to be a widow with no male heirs. Second, she must be educated, not only in reading and writing, but also with a knowledge of Latin (almost three-quarters of fifteenth-century books were published in Latin). Third, she would require familiarity with business practices and be possessed of a network of contacts.

Making a Mark

Estellina Conat, in her modesty, referenced her involvement in the typesetting of the book, but does not claim directly the printing as hers. The very first woman to add her name as its printer to the colophon of a printed book was Anna Rügerin, who published two folio editions in the summer of 1484 in the imperial city of Augsburg in Southern Germany.

Hye endet ssch der sachsenspiegel mitt ozdnung des rechten den der erwirdig in got vater vnd herr Theodoricus von bockß dozf bischof zů neůnburg săliger gecozrigiert hat. Gedzuckt vñ volendt von Anna Rügerin in der keyserlichen stat Augspurg ăm aftermontag năchst voz Johannis. do man zalt nach Cristi gepurt. M·CCCC·lxxxiiij·jar·

Upon the death of her husband, Thomas, it appears that Anna took full control of the print shop. Anna employed the Gothic type (1:120G) of Johann Schönsperger, who continued using it until 1492. Interestingly, Sheila Edmunds identifies Schönsperger as Anna's brother. In fact, Anna's mother, Barbara Traut Schönsperger, remarried in 1467/68 (when printing was first introduced to Augsburg by Günther Zainer) to the Augsburg printer Johann Bämler, marking 'the beginning of an extensive family network actively engaged in Augsburg's book trade'.[113]

In the sixteenth century many more women were involved in book production. Helen Smith estimates that 'between 1550 and 1650, at least a hundred and thirty-two women were actively involved in the production or sale of books aimed at the British market' alone.[114] Most worked in publishing and bookselling rather than printing and, of those who were involved in printing, very few signed their books, remaining anonymous or simply referring to themselves as heirs or widows to the master printer. One of the few exceptions was Girolama Cartolari, a native of Perugia who, upon the death of her husband in 1543, ran her print shop in Rome right up until 1559.[115]

Not that attitudes towards women printers and typographers had changed much between the centuries. In 1569, Henri II Estienne wrote:

> But beyond all those evils which have now been brought on by the ignorance of printers, male and female (for this only remains to add to the disgrace of the art, that even the little ladies have been practising it), who will doubt that new evils are daily to be expected?[116]

Moreover, it appears that most printers' widows did not assume control of their deceased husbands' print shops. A survey of sixteenth-century

23 Colophon from the medieval law book *Sachsenspiegel* by Eike von Repgow. Printed in Augsburg by Anna Rügerin, 22 June 1484.

S. Bernardus.

Véni ad me oés

S. Malachias.

¶ Joannes Egidius Nu-
ceriensis ad lectorem.

Dat tibi mellifluus fecunda volumina doctor
 Inter preclaras candide lector opes.
Omnia nunc vno clauduntur opuscula libro
 Singula que varijs sparsa fuere locis.
In quib⁹ ampla patet nitidorū semina morū,
 Fertile si vigili corde legatur opus.
Ob tam frugiferos gratissima dona labores
 Debetur sancto gratia magna viro.
Qui primus fecit magni pia iussa tonantis:
 Post docuit fratres illa ferenda suos.
Sepe feros homines dulci sermone trahebat
 Letior ad clare splendida claustra domus.
Diuitias spreuit, nullos amplexus honores:
 Supposuitq̃ suo colla superba iugo.
Flexit ꝛ ignaras ad olympica gaudia turbas:
 Tantus in ardenti pectore feruor erat.
Deniq̃ tanta fuit placidi clementia patris,
 Esset vt etatis gloria prima sue.
Si cupis ergo bonos mores vitamq̃ perennè,
 Hec lege Bernardi scripta probata pij.

¶ Ad librum.

I nunc, ꝛ tandem totum Bernarde per orbem
 Protinus exilias: ne tua fama cadat.
Diuinasq̃ tuis sermonibus exprime leges:
 Crimina fac homines deseruisse velint.
Vade precor, cūctis Bernarde legare suauis:
 Flecte ad virtutes pectora dura pias.
Tu quēcūq̃ iuuat sanctos cognoscere patres:
 Bernardum relegas inclyta scripa colens.
Frigida iamdudum feruescet amore volūtas:
 Et mens doctrine dulcia mella feret.

¶ Joannes Egidius Nu-
ceriensis iterum ad librum.

I pede precipiti totum Bernarde per orbem:
 Horret adire tuos lingua canina libros.
Hec tua magnificas monumēta ferāt i vrbes
 Ne pereat turpi candida fama situ.
Postulat hoc grauiū prudentia clara virorū:
 Quos trahit ad supos mēs generosa lares

Parisian contracts indicates that only one in ten widows chose to inherit and run the family print shop. Some opted to forgo their husband's legacy because inheriting the business meant inheriting its debts, too.

Perhaps the most notable and prolific of early female printers is Charlotte Guillard, whose first husband, Berthold Rembolt, had worked with Ulrich Gering, who had been a printer at France's first press at the Sorbonne in Paris.[117] Berthold and Charlotte married in 1502 and ran a successful print shop in Paris until his death in late 1518 or early 1519. She continued printing for several years as a widow until her second marriage to bookseller Claude Chevallon. After the death of her second husband in 1537, she assumed full control of the business, continuing to print under her own imprint and with her own printer's mark. During the subsequent two decades, she published no fewer than 150 editions, concentrating on works of the Church Fathers and jurisprudence (canon and civil law). Well into her seventies she ran both the bookshop on rue St-Jean-de-Latran and four or five presses housed in two buildings just around the corner on rue St-Jacques, just a few minutes' walk from the Sorbonne. She was a successful and respected publisher of scholarly works, with a career spanning some five decades: Luigi Lippomano, Bishop of Verona, was so impressed with her work that he had her press print his first two books.

24 (opposite) Woodcut from Bernard of Clairvaux's *Opera omnia*, printed in Paris, 1527, by Claude Chevallon, husband to Charlotte Guillard. The three figures on the right are Claude, Claude's daughter Gillette and Charlotte.

25 Charlotte Guillard's 'orb and four' printer's mark incorporating her late husband's initials, C. C. (Claude Chevallon, d. 1537), on the title page of *Insigne commentariorum opus, in psalmos omnes Davidicos* by Denis the Carthusian. Paris, 1542.

From Blockbooks to Pliny

The First Illustrated Printed Books

5

> Your pen will be worn out before you can fully describe
> what the painter can represent forthwith by the aid of
> his science. And your tongue will be parched with thirst
> and your body overcome by sleep and hunger before you
> can demonstrate with words what a painter is able to
> demonstrate to you in an instant.
>
> LEONARDO DA VINCI[118]

THE EARLY HISTORY OF printed illustrations centres on the
woodcut, a technique wherein the background to an image is carved
away from a block of wood, leaving the surface to be printed raised,
or in relief. This of course limited the type of illustration that could be
reproduced. By the time Gutenberg had begun experimenting with
metal type, such woodcuts were used to print standalone single-sheet
prints, while at the same time xylographic books or blockbooks made
their first appearance.

Blockbooks and Woodcuts

Needless to say, woodcuts long pre-date the mid-fifteenth-century
introduction of movable type to Germany. They had been used exten-
sively in the printing of textiles many hundreds of years before in Europe
and are known in China from the seventh century and Japan from at least
the eighth century. The very earliest extant and dated illustrated printed
book, the *Diamond Sutra*, from ninth-century China, comprises a series
of pasted-together woodblock prints. Prior to their use in books,
woodcuts were used in the production of playing cards, most notably in
Augsburg and Nuremberg in Southern Germany, during the first half
of the fifteenth century. Hand-printed woodcuts were also used in the
creation of devotional images – images of the saints or other holy figures
that might be used as aids to prayer – pasted on religious calendars,
or carried as a kind of charm.

26 *Samson Rending the Lion.*
Woodcut by Albrecht Dürer,
Nuremberg, *c.* 1497–98.

draco eſt dyabolus qui uirtute ſuam
quã totã mola ẽ beſtie ueſt anꝥps
dabitur illo habitabit et peu
qui quid ueſtigia dyaboli
eſco cogitari poteſt opabitur

Septẽ capita eñꝥps
ſuãt ur̃ uiċa pincipa
ba et pcipit qꝯ nouoc
cabi ſed quaſi occiſũ uẏuſ
eſt blaſphurna pñuiſlam
terrã peccores ligit

Et dant illi draco uir
tute ſuã et pꝼatem
magnã et mũ uuũ
de capittbus liueqã
ſi occiſuu ut morte et
plaga mortis eiꝯ ca
rata eſt et adiurabte
eſt uniſa terra
poſt beſtiam

Et adorauerũt draconẽ qꝯ dedit
pꝼatem beſtie et uel dracone i dyabo
lũ adorabut que nõ uidebut ſꝫ a
dorabũt autꝥpm qui pteram deſig
natur i aꝥꝥpo dyabolu diceres
nullũ ẽ anꝥpm ſilem uec ẽ
qui eius fortitudini poſſit equari

The woodcut is an ideal counterpart to movable type. Both are relief processes, meaning that woodblocks and type could be set in the same forme and printed at the same time. Yet none of the early books from the presses of Gutenberg, Fust or Schoeffer was illustrated, beyond some experiments with woodcut initials. The beautiful initials in Gutenberg's Forty-two-line Bible of 1455 are the work of scribes or illuminators, each one skilfully penned and painted in each individual copy, just as they had been for centuries in decorated and illuminated manuscripts.

Blockbooks, wherein entire pages of text and illustration were carved in relief, were a logical outgrowth of woodcut illustrations. However, carving thousands of words of text in reverse in wood was no mean feat and mistakes were not easily rectified. What is more, the finer details of a woodcut are especially prone to damage. Although it is easy to imagine these technologically lesser books as forerunners to the typographically printed books, the evidence points to them as contemporaneous techniques. Most blockbooks were printed in the Low Countries and Southern Germany during the 1450s and 1460s.[119] Among them are the popular *Ars moriendi* ('The Art of Dying'), the *Biblia pauperum* ('Pauper's Bible') and *Apocalypse*, a late-medieval picture-book version of Saint John's revelatory hallucinations on the island of Patmos.[120] Of these early blockbooks, a relatively large number have survived – some 600 copies in 100 editions.

Pioneers: Pfister, Zainer and Han

The very first illustrated typographic books were published by the cleric-printer, Albrecht Pfister (*c.* 1420–70), in Bamberg.[121] Very little is known about him, outside of his printed books, other than that he was secretary to Bishop Georg I von Schaumberg. A total of nine editions are ascribed to Pfister, with all but one illustrated with woodcuts, and all produced during the 1460s. Pfister's *Der Edelstein* ('The Jewel'), a book of fables by the fourteenth-century Dominican monk Ulrich Boner, is not only the first dated illustrated book produced in Europe (on 14 February 1461), with 101 woodcut illustrations, but is also the very first to be printed in the German language.[122] Of this book just a single example remains, in the Herzog August Library, in Wolfenbüttel, Germany. Of the three editions of an illustrated Bible, *Biblia pauperum*, that Pfister published between 1462 and 1463, two were in German and one in Latin. Prior to

27 *Apocalypse* blockbook from a late-medieval tradition of manuscript picture-books. Top illustration shows the dragon giving his power to the beast with seven heads (Revelation 13:2); lower illustration shows humanity worshipping the dragon (Revelation 13:4).

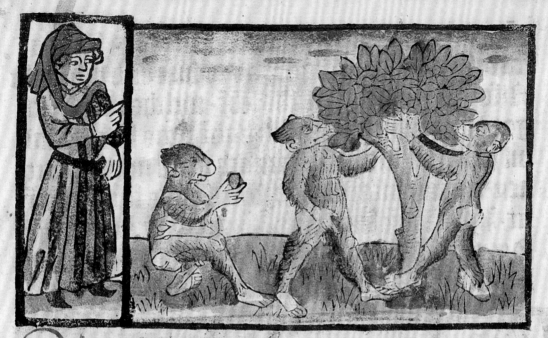

Ins mals ein affe kam gerät·Do er vil guter
nusse vant·Der hette er gessē gerne·Im was
gesagt von dem kerne·Der wer gar lustiglich vn
de gut·Geswert was sein thümer mut· Do er der
pitterkeit entpfāt·Der schalē darnach zu hant·Be
greiff er der schalē herrikeit·Von der nussen ist mir
geseit·Sprach er das ist mir worden kunt·Si ha
ben mir verhonet meinen munt·hyn warff er sie
zu der selben fart·Der kerne der nusse im nye wart·
Dem selben affen sein gleich·Geide iung arm vnd
reich·Die durch kurze pitterkeit·Verschmehē lan
ge susikeit·wenne mā das feuer enzunte wil·So
wirt des rauches dick zu vil·Der thut einem in dn
augen we·wenn man darzu bleset mee·Bis; es en-

its typographic appearance, the *Biblia pauperum* had already proven popular as a blockbook. Pfister's woodcuts were not printed in-forme (on the press alongside the type), but separately and by hand. In fact an impression from a woodcut can be achieved without the use of a press. Hand-burnishing the back of the paper is quite adequate to transfer the inked impression to the paper.

Pfister's Bible is not technically the first illustrated Bible. In fact, it cannot really be called a Bible at all, but rather a compendium of texts highlighting parallels between the Old and New Testaments (typology). The woodblock versions of the fifteenth century are based on fourteenth-century manuscript exemplars. Moreover, these books were generally only forty to fifty pages long; Gutenberg's Bible ran to 1,286 pages, bound in two volumes. The first illustrated and unabridged Bible was printed in German by Günther Zainer, and, although undated, a reference to it in a reprint suggests that it was issued no later than 1474. It was illustrated with seventy-three historiated, or pictorial, woodcut initials. A second edition followed in 1477.

Shortly after the introduction of print to Italy, the German printer Ulrich Han, working in Rome, published the first illustrated book in the Italian Peninsula. In 1467 he published Cardinal Torquemada's *Meditationes, seu Contemplationes devotissimae* ('Meditations, or the Contemplations of the Most Devout'), illustrated with thirty-three woodcuts. Again, the woodcuts were not printed in-forme but separately. Evidence of this is to be found in variations in the registration (alignment) between text and illustration throughout the four extant copies and also in slight variations in the shade of ink between the two elements. With the exception of a full-page woodcut, the entire series of illustrations, one for each chapter, is approximately half the height of the text block, to make planning for their insertion a relatively simple matter. In 1473, Ulrich Han reprinted *Meditationes*, only this time he managed to print both the type and woodcuts in the same forme, at the same time.

During his relatively brief career, cut short by his untimely death in 1478, Günther Zainer published no fewer than eighty titles, about one-fifth of them illustrated. His brother (or relative) Johann Zainer is best known for introducing the art of printing to the city of Ulm in 1473. Ulm and Augsburg became leading centres in the publication of woodcut-illustrated books. However, when Günther Zainer arrived in Augsburg with his press, he was not met with open arms, parades and

28 A page from *Der Edelstein*, the first typographic book to be printed with both text and illustrations. Printed by Albrecht Pfister, 14 February 1461.

℞es stupenda et omni plena pietate: ecce ꝙ pro
reconciliatōne humana paceꝗ cōponenda inter
omnipotentem deū offensū · �7 reū homiñe · inscrutabilis
altitudo diuini consilij matrimoniū contrahendū inter
dei filiū · �7 humanā naturam mira dispensatione stabi-
liunt. Simile ꝗdem ē regnū celoꝝ · homini regi qui fecit
nuptias filio suo · quas tunc pr celestis rex uniuerse crea-
ure filio suo fecit · quando eū in utero uirginis humane
n ature coniūxit. Ait gregorius. Et qñ consensus efficit
matrimoniū · mittitur a patre luminū · patre misericor-
diarū · nūtius celestis · s · angelus. ꝫabriel · ad uirgiñe
noie ꟿariam · que gēmis ornata uirtutū · �7 donis sub-
limata diuinis icōpabilis erat uniuersis ꝗ tam pie tāꝗ
salutari diuini dispositioni in totius nature huāe psone
preberet consensū. O admiranda legatio · �7 ex omni pte

confetti. His arrival from Strasbourg, where he likely worked under the city's first printer, Johann Mentelin, was met with suspicion and then outright conflict. The local woodcutters' guild, fearing that Zainer's newfangled printed book – containing woodcuts no less! – would put them out of business, or at the very least put a dent in their monopoly, attempted to prevent him from printing. Similarly, in 1441, Venice had sought to protect its woodblock printers by banning the importation of printed cloth and playing cards. As the Venetian chronicler and biographer Tommaso Temanza reports, the Venetian card-makers complained of 'the injury they sustain by the daily importation of Cards and printed figures which are made out[side] of Venice; by which their art is brought to total decay.'[123] Those cards were probably coming from nearby Padua and even Augsburg in Germany. In Augsburg, after a rather lengthy standoff, and thanks to the intervention of the abbot of the monastery of SS Ulrich and Afra (later home to its own print shop), a compromise was finally reached: Zainer was permitted to produce books with woodcut illustrations on the condition that he employ only woodcutters from the local woodcutters' guild. No doubt owing to this dispute, Zainer's first book of 1468, *Meditationes vitae domini* ('Meditations on the Life of Our Lord') contains no woodcut illustrations, not even woodcut initials: in the copy at the Bavarian State Library, Munich, the initials are Lombardic initials from the hand of a scribe or rubricator. Zainer's first book to contain woodcut illustrations was Jacobus de Voragine's medieval bestseller, *Legenda aurea* ('Golden Legend'), printed in 1471 – Augsburg's very first illustrated book.

Albrecht Dürer

One cannot write about the woodcut without pausing to mention one of its greatest and most masterful proponents, Albrecht Dürer (1471–1528), arguably the greatest printmaker, not only of the Northern Renaissance, but of all time. Dürer was apprenticed to the local Nuremberg painter and printmaker Michael Wolgemut, whose workshop later produced a large number of woodcut illustrations for print publishers. Dürer's extraordinary woodcuts were, for the most part, designed as independent or standalone prints, although a significant number of his designs were used to illustrate books (fig. 26). Dürer's series of *Apocalypse* woodcuts was published in 1498 by the famed Nuremberg printer Anton

29 *Meditationes, seu Contemplationes devotissimae.* Printed by Ulrich Han in Rome, 1467.

Koberger, who incidentally was also Dürer's godfather.[124] Dürer brought the complexity and sophistication of the engraving to the woodcut and his style was to prove remarkably influential on succeeding generations of European artists and printmakers. Dürer even became his own publisher, in partnership with Hieronymus Hölzel, when he first published his series of *Passion* woodcuts as a book in 1511.[125] His woodcuts appear in books printed and published outside Germany too, including, for example, Sebastian Brant's hugely popular *Das Narrenschiff* ('Ship of Fools'), printed by Johann Bergmann de Olpe in Basel.[126]

Colouring

Prior to the emergence of polychromatic printing (see Chapter 6), it was, of course, not practical to hand-colour books before their sale. Just imagine a book containing, say, fifty woodcut illustrations, and a modest print run of 500 copies. Now imagine how long it would take even a skilled colourist to colour those 25,000 illustrations by hand. Some incunabula are very crudely coloured, suggesting that their owners all too frequently tried their hand at a job that was better suited to a professional artist or colourist. Conversely, there are numerous fine examples of hand-coloured and decorated typographic books that rival their illuminated manuscript forebears. A vellum copy of the *Historia naturalis* ('Natural History') by Pliny the Elder (23–79 CE) in Italian translation, printed by Nicolaus Jenson in Venice in 1476 and illuminated, over the course of four years, by one or both of the brothers Gherardo and Monte di Giovanni di Miniato for the wealthy Florentine banker Filippo Strozzi (1428–91), is a breathtaking example of two overlapping traditions and undeniably one of the most magnificent illustrated books of the fifteenth-century.[127] In addition to richly decorated borders, miniatures and decorated initials, each of its thirty-seven chapters, or books, opens with a luxurious gilded historiated initial, the first book (folio 5r), a dedication to Titus Vespasian (39–91 CE), depicting Pliny himself at his writing desk holding an armillary sphere (fig. 31).

At the start of the sixteenth century, French books of hours were among the most notable and magnificent examples of the illustrated typographic book. Sumptuous borders, vignettes and initials combined to produce some of the most beautiful and luxurious printed books of all time – some, like those printed in Paris by the likes of Jean du Pré,

et biderant: sicut dictum est ad il=
los.Credo.Offer.Deus enim firma
uit orbem terre qui non cõmouebit .
parata sedes tua deus extunc a secu
lo tu es . 　　　　Secreta.

Vnera nostra quesum⁹ do=
mine natiuitatis hodierne
mysteriis apta proueniant: vt si=
cut homo genitus idem refulsit
deus : sic nobis hec terrena substã
tia conferat quod diuinum est.

De sancta anastasia.

Accipe quesumus domie mu
nera dignãter oblata: ⁊ bea
te anastasie suffragantibus meri
tis ad nostre salutis auxiliũ puei
re concede.Per dñm. 　Prefacio.
Quia per incarnati.Et.Cõmuni
cantes. vtsupra. Cõio. Exulta filia
syon lauda filia hierusalē ecce rex tu⁹
venit sctũs ⁊ saluator mũdi. postcõ.

Dius nos dñe sacramēti sē
per nouitas natalis instau
ret:cui⁹ natiuitas singularis hu
manam reppulit vetustatem .

De sancta anastasia. 　　postcõ

Aciasti dñe familiã tuã mu
neribus sacris. eius q̃s sem
per iteruentione nos refoue : cui⁹
solennia celebramus . Per dñm.

Ad magnam missam . Introitus.

Uer natus est
nobis . et fil⁹
batus est no=
bis cuius im=
perium super
humerum ei⁹.
et vocabit no=
men eius ma=

gnt consilii angelus. ps. Cantate do=
mino. canticum nouũ quia mirabilia

fecit. 　Glia patri.Sicut. 　kyrie k.
Gloria in excelsis. 　　　　Orõ.

Oncede quesumus omnipo
tens deus: vt nos vnigeniti
tui noua per carnē natiuitas libe
ret. quos sub peccati iugo vetusta
seruitus tenet. Qui tecũ. Memo
nulla. Lectio isaye pphete. 　lii.

Hec dicit dominus deus. Pro
pter hoc sciet populus meus
nomē meũ i die illa: quia egoipse
qui loquebar ecce adsum. Quam
pulchri super mõtes pedes annũ
ciantis et predicantis pacem: an
nunciantis bonum . predicantis
salutem: dicentis spon . regnabit
deus tuus. Vox speculatorum tu
orum leuauerunt vocē: simul lau
dabunt quia oculo ad oculum vi
debunt.cũ conuerterit dñs spon.
Gaudete et laudate simul deserta
hierusalem:quia cõsolatus est do
minus populũ suum . et redemit
hierusalem.Parauit dñs brachiũ
sanctum suum:in oculis oim gē
tium. Etvidebunt omēs fines ter
re:salutare dei nostri. 　Lectio epi
stole bi pauli apli Ad hebreos .i.ca.

Fratres. Multipharie multis
q̃ modis olim deus loquēs
patribʒ in prophis.nouissie diebʒ
istis locutus est nobis i filio : quē
constituit heredem vniuersorum
per quem fecit ⁊ secula . Qui cum
sit splendor glorie ⁊ figura substã
tie eius . portansqʒ omnia verbo
virtutis sue purgationem pctõ
faciens : sedet ad dexterã maiesta
tis in excelsis. Tãto melior ãgelis
effect⁹ : quãto differenti⁹ pre illis
nomē hēditauit.Cui ei dixit aliqñ

LIBRO PRIMO DELLA NATVRALE HISTORIA DI. C.
PLINIO SECONDO TRADOCTA IN LINGVA FIOREN
TINA PER CHRISTOPHORO LANDINO FIORENTI
NO AL SERENISSIMO FERDINANDO RE DI NAPOLI.
PREFATIONE

ITERMINAI O GIOCONDISSIMO
imperadore con epistola forse di troppa licétia
narrarti elibri della historia naturale: opera no
uella alle muse romane:nata apresso di me nel
lultima genitura. Sia adunq; questa prefatiōe
uerissima di te métre che gia inuecchia nel grā
dissimo tuo padre: per che usando el uerso di
Catullo mio compatriota tu soleui pure stima
re qualche chosa le mie ciácie. Tu conosci que
sta castrense & militare parola. Et lui chome tu
sai mutando le prime syllabe si fece alquanto
piu duro che non uolea essere stimato da tuoi
familiari & serui. Per questo adunq; ditermi
nai scriuerti:& áchora per che le nostre chose apparischino & sieno manifeste p questa
mia audacia maxime dolédoti tu che pel passato non lhabbi facto in una altra nostra
procace epistola. Et accio che tutti glhuomini sappino quanto di pari lomperio techo
uiua: Tu elquale hai triomphato & se stato censore & sei uolte cósolo & participe del
la tribunitia potesta: Se stato prefecto del pretorio:ilche hai facto piu nobile che tutti
glaltri magistrati:perche per piacere a tuo padre & allordine equestre lacceptasti: Et
tutte queste cose per rispecto della republica hai facto: Et me chome nel contubernio
castrense tractasti? Et certo niéte ha mutato inte lamplitudine & grandezza della tua
fortuna:se non che tanto piu possi & uogla giouare:quáto quella e maggiore. Adūq;
béche a tutti glaltri huomini sia aperta la uia a impetrare ogni chosa da te uenerádoti:
Niente di meno solo laudacia fa che io piu familiarmente te honori. Questa audacia
adunq; imputerai a te medesimo:& a te medesimo nel nostro fallo perdonerai. Io mi
stroppicciai la faccia:& niente di meno nessuno proficto ho facto: perche per unaltra
uia mapparisti grande:& di lontano mi rimuoui con le faccelline del tuo ingegno . Et
certo in nexuno piu sfolgora quella:laquale piu ueramente e decta in te che in altri for
za deloquentia. In te e quella facundia che alla tribunitia potesta si conuiene:Con qta
risonantia tuoni tu le laude paterne? Có quanta(non sanza amore)dimostri quelle di
tuo fratello? Quanto se excellente & sublime nella poetica faculta? O gran feconditá
danimo. Certo hai trouato inche modo possi imitare tuo fratello . Ma queste chose
chi potrebbe sanza paura considerare : hauendo a uenire al giudicio dellongegno
tuo : maxime essendo quello dame prouocato? Certamente non sono in simile
conditione quegli che publicano alchuno libro:& quegli che ate glintitolano. Impero
che se io lo publicassi & non lo intitolassi ate:potrei dire perche leggi tu queste chose o
imperadore:lequali sono scripte albasso uulgo & alla turba de glagricultori & de glar
tefici & a quegli che cósumano elloro otio negli studii?Perche adunq; ti fa giudice:
concio sia che quando io scriueuo questa opera:non thaueuo posto nella tauola doue
sono descripti egiudici:Et eri di tanta excellentia : che non stimauo che tu ti degnassi
scendere si basso?Preterea quando bene non fussi in si excelso grado:nientedimeno gli
scriptori comunemente fuggono el giudicio de docti . Questo fa Cicerone:elquale e
di tanta eloquentia:che puo sottomettere longegno al giuocho della fortuna : & quel

Antoine Vérard and Philippe Pigouchet, might even be said to surpass their illuminated manuscript forebears.

But of all fifteenth-century illustrated books, the best examples were to be found in Italy, especially during the last quarter of the century. Some of the most exquisite were printed in Renaissance centres such as Venice, Florence and Milan. In Venice, examples included those by Jenson, Erhard Ratdolt and Aldus Manutius, whose famed and glorious *Hypnerotomachia Poliphili* of 1499 was a consummate congruence of type and illustration. In Florence, Lorenzo Morgiani and Johannes Petri produced a large number of illustrated books, including an edition of *Epistolae et Evangelii* (1495) – one of the very finest Florentine examples of fifteenth-century typographic books. Not until technological developments in colour printing in the eighteenth century did hand-colouring finally begin to decline, and it still continued into the early twentieth century: for example, in Great Britain a hand-colouring department was established in 1902 at the mapmakers Ordnance Survey to meet increased demand for colour maps.

Some 550 years have passed since printers like Pfister introduced Europe to the illustrated typographic book. By the mid-sixteenth century the woodcut was increasingly being replaced by intaglio printing – a technique that was more durable and permitted finer detail. In intaglio the ink sits not on the surface of a block but in the engraved or etched lines in a metal plate. The pressure required to transfer the ink from those grooves to the paper or parchment was considerably more (several tons, in fact) than could be achieved in a flat-bed press designed for relief printing, and a separate roller press was used.

Over the centuries printing techniques for illustrated books have continued to evolve and improve, from drypoint techniques like mezzotint in the mid-seventeenth century, lithography in the late eighteenth century, through the invention of the rotary press in the mid-nineteenth, shortly followed by offset and hot-metal type, or mechanical typesetting, in the late nineteenth century, and the dawn of electronic printing in the twentieth.

31 (left and right) The 'Douce Pliny'. Pliny's *Natural History*, printed by Nicolaus Jenson in Venice, 1476. Illuminated by hand for the Florentine banker and statesman Filippo Strozzi (1428–91).

32 (overleaf) *Hypnerotomachia Poliphili* ('Poliphilo's Battle of Love in a Dream'), adorned with 172 woodcuts, is one of the most famous of all incunabula. Printed by Aldus Manutius in Venice, 1499.

ce ligatura alla fistula tubale, Gli altri dui cū ueterrimi cornitibici co
cordi ciascuno & cum gli instrumenti delle Equitante nymphe.

Sotto lequale triūphale seiughe era laxide nel meditullo, Nelq̃le,
rotali radii erano infixi, deliniamento Balustico, graciliscenti sepo
negli mucronati labii cum uno pomulo alla circunferentia. Elqua
Polo era di finissimo & ponderoso oro, repudiante el rodicabile erug
ne, & lo'incēdioso Vulcano, della uirtute & pace exitiale ueneno. Sum
mamente dagli festigianti celebrato, cum moderate, & repentine
riuolutiōe intorno saltanti, cum solemnissimi plausi, cum
gli habiti cincti di fasceole uolitante, Et le sedente so
pra gli trahenti centauri. La Sancta cagione,
& diuino mysterio, inuoce cōsone & car
mini cancionali cum extre
ma exultatione amo-
rosamente lauda
uano.

⁂

EL SEQVENTE triúpho nó meno mirauegliofo đl primo. Impo
che egli hauea le q̃tro uolubile rote tutte, & gli radii, & il meditullo defu
fco achate, di cãdide uéule uagaméte uaricato. Ne tale certaṁte geftoe re
Pyrrho cũ le noue Mufe & A polline ĩ medio pulfáte dalla natura ípffo.

Laxide & la forma del dicto q̃ĩe el primo, ma le tabelle erão di cyaneo
Saphyro orientale, atomato de fcintillule doro , alla magica gratiffimo,
& longo acceptiffimo a cupidine nella finiftra mano.

Nella tabella dextra mirai exfcalpto una infigne Matróa che
dui oui hauea parturito, in uno cubile regio colloca
ta, di uno mirabile pallacio, Cum obftetrice ftu
pefacte, & multe altre matrone & aftante
NympheDegli quali ufciua de
uno una flammula, & delal-
tro ouo due fpectatiffi
me ftelle.

✱ ✱
✱

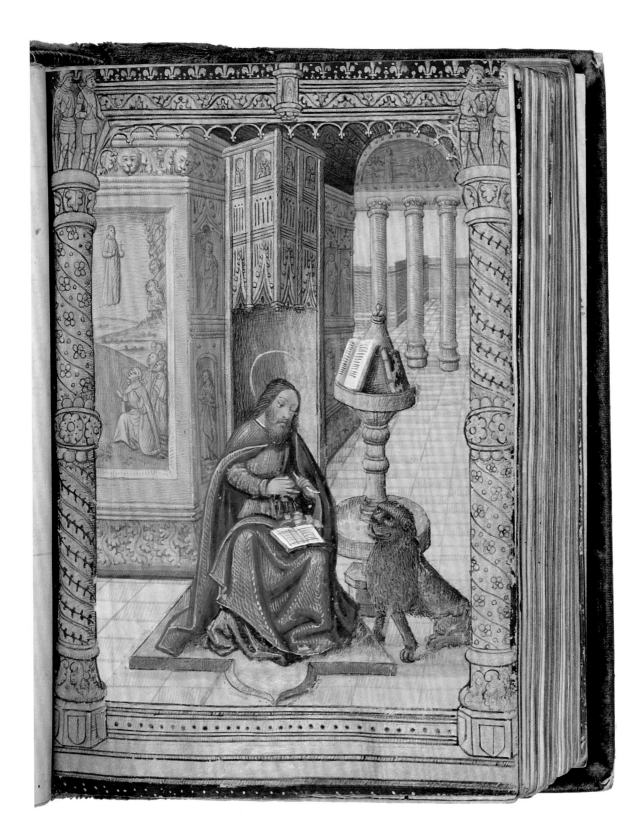

Printed Polychromy
The First Colour Printing

How wrong are those simpletons of whom the world
is full, who would rather look at a green, a red, or some
other high colours than at figures which show spirit
and movement.[128]

6

FOR TENS OF THOUSANDS OF YEARS, humans have manufactured
colour pigments. Colour was used in ancient Egyptian papyri and in
Graeco-Roman antiquity.[129] But the proliferation of colour in books
coincided with the transition from papyrus roll to parchment codex
and signalled the beginnings of Western manuscript illumination.[130]
For a thousand years, coloured inks and paints were used by scribes and
rubricators to highlight and articulate; and by miniaturists to illustrate
and decorate manuscript books. The term 'rubrication' is derived from
rubrico, the Latin for 'to colour red'; the additional text elements or
'rubrics' were typically penned or painted in red (from a red form of
lead oxide, in Latin called *minium*). From this the word 'miniature'
is derived: etymologically it bears no relation to size, although later
associated with diminutive painted portraiture.

As manuscripts were the exemplars of the first printed books, it
was only natural that fifteenth-century printers should seek to emulate
their polychromy. But many of the ingredients for pigments were toxic
to those who manufactured and used them:[131] they included azurite,
a copper carbonate used to make blues; malachite for greens; lead white
created by submerging strips of lead in vinegar and storing that mixture
in earthenware jars buried for several months in fermenting dung (a
hazardous process used until the 1880s); and red lead, produced by
heating white lead. Also dangerous were verdigris derived from copper
strips corroded by contact with vinegar, curdled milk or urine and
identified as a pigment used in ancient Egyptian papyri; vermilion from
the sulphide mineral cinnabar, used as a cosmetic since antiquity and in

33 Manuscript illumination depicting
Saint Mark the evangelist with a quill
pen and a manuscript. France,
second half of the fifteenth century.

Roman times prohibitively expensive (and not to be confused with the *cinnabaris* of Pliny, the 'mingled blood of the elephant and the dragon'); and yellows from orpiment, a sulphide containing 60 per cent arsenic, thus Italian Renaissance painter Cennino Cennini's judicious caution, 'Beware of soiling your mouth with it, lest you suffer personal injury.'[132] Other pigments came from distant lands and were correspondingly expensive, such as ultramarine from the precious stone lapis lazuli, mined in the Kokcha River valley in north-eastern Afghanistan.

Coloured Ephemera

As we have seen in the preceding chapter, printed woodcuts pre-date printed books. Single-leaf woodcut prints were often coloured by hand with water-based paints and many thousands of those single-sheet parchment and paper prints were the materials of Renaissance recycling. Parchment and paper were expensive commodities, so once a calendar or an indulgence had expired, or the print had been discarded for some other reason, it might be repurposed, often finding its way into the binding material of books. Therefore, relatively few of these ephemeral single-sheet prints have survived; of those that have, the devotional images have one of the best survival rates, as they were afforded protection when sometimes they were pasted into books. One of the earliest European examples is such a hand-coloured devotional woodcut that survived thanks to its repurposing as an endpaper to a manuscript book dated 1417 (fig. 34). The image, Saint Christopher carrying the child Christ over a stream, bears the date 1423, though possibly was printed and coloured several decades later: rather than referring to its year of production the date might be commemorative, or the woodcut itself may be a later copy of an earlier dated print.[133]

In 1449, Anna Jäck, scribe, translator and prioress of the convent of Inzigkofen, a little north of Lake Constance, completed a manuscript by pasting in a number of pre-coloured woodcut prints.[134] The colours were mostly laid down as washes with a familiar palette of carbon black or azurite, lake (organic) pigments and even *Zwischgold*, a laminate of gold and silver leaves, used in combination with other pigments in the nimbi of holy figures.[135] Similarly, woodcuts in typographically printed books were sometimes coloured by hand, either by a professional colourist or by the book's owner, with mixed results and varying degrees of artistic merit.

34 The St Christopher woodcut, *c.* 1423. It is preserved as an endpaper in a manuscript, the *Laus Virginis*, dated 1417 from Bohemia.

Rubrication

There were no technical barriers to adding colour to a manuscript but the typographic book posed new challenges. The first and principal obstacle to printing in colour was cost. The addition of just one colour, say red, in addition to the black for text, could almost double the time required to print a book, as each colour typically required a separate pass through the press. Second, especial care would be required so that the separately printed red and black elements were in precise register, that is, aligned perfectly. So when it came to replicating the traditionally

coloured features of manuscript books, printers faced a choice: either they find an economically viable typographical solution or abandon the feature entirely.[136] In early printing the most common second colour was red, as it was used for rubrication.[137] The addition of such red elements was not decorative in intent but was an integral constituent of textual articulation; for example, underlining, strikethrough and ticks through capital letters or red printing for woodcut initials, running heads or titles.[138] The numerous monochrome incunabula with unfilled spaces left for initials demonstrate that decoration, rubrication and the addition of colour in illustrated books were optional extras to be added by hand at the discretion of one's taste and purse. During the fifteenth century about half of all books were hand-rubricated. By the sixteenth century, monochrome typographic solutions – italic type, all-caps, small capitals and varying type sizes – increasingly substituted for the red of the rubricator's pen.

During the first half-century of printing, the genres most commonly printed in two colours were legal and liturgical books. In legal books, especially prior to printed foliation (page numbering), red was essential for signposting and organizing lengthy and complex texts. Liturgical works made up the greatest proportion of two-colour printed books, with red used for calendars, prologues and music.

35 Illustration of the two-piece Mainz Psalter jigsaw initial. Each part is inked separately, or *à la poupée*, reassembled and printed.

The first known example of colour printing in relief is to be found in Gutenberg's Forty-two-line Bible (*c.* 1454–55), in which rubrics on a handful of folia are printed in red, making it the first book with text printed in red.[139] Gutenberg abandoned this attempt to mimic contemporary scribal practice in favour of adding the rubrics by hand, in what was already a substantial undertaking – a large royal folio Bible of 1,286 pages. His decision is undoubtedly evidence that printed rubrics requiring a second, precisely superimposed impression were simply too impractical and expensive. Not long after Gutenberg's first experiment with colour, his heirs, Fust and Schoeffer, printed bi-colour initials in some copies of their Mainz Psalter of 1457. These so-called jigsaw initials comprised two interlocking metal components (fig. 35).[140] Each piece of the initial was inked separately, or *à la poupée*, so that the bi-colour initials (usually red and blue) could be printed in a single impression, or in one pass through the press. This technique solved any difficulties with registration as, once assembled, the jigsaw would print in perfect registration. Although the Mainz Psalter initials were used on and off for another three decades (last appearing in a Benedictine psalter printed by Peter Schoeffer in 1490) this method of colour printing in the fifteenth century is very rare.[141]

Stencils

The earliest coloured woodcuts were painted freehand in familiar late medieval palettes. The use of stencils in early polychromatic printing is rather well documented, but stencils were not a medieval invention.[142] In fact, their use dates back to antiquity;[143] as well as illuminated manuscripts they were used to decorate church walls and textiles, and perhaps used in the production of playing cards too.[144] By the middle of the sixteenth century colouring prints with stencils was not uncommon. A woodcut illustration in Jost Amman's *Das Ständebuch* or 'Book of Trades' features a *Briefmaler* (colourist) applying colour through a stencil to a printed woodcut illustration with a broad brush (fig. 36).[145] Ironically, the accompanying poem, in rhyming couplets, reads, in part, 'I look with disdain on stencilling; / It makes for poor workmanship.'[146] As a simple, quick and inexpensive technique, the stencil proved a popular method for colouring printed illustrations right through to the eighteenth century.[147]

Der Brieffmaler.

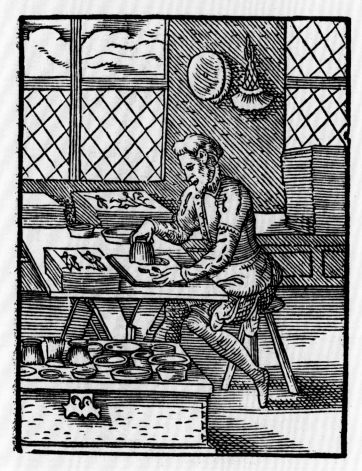

Ein Brieffmaler bin aber ich/
Mit dem Pensel so nehr ich mich/
An streich die bildwerck so da stehnd
Auff Papyr oder Pergament/
Mit farben/vnd verhöchs mit gold/
Den Patronen bin ich nit hold/
Darmit man schlechte arbeit macht/
Darvon auch gringen lohn empfacht.

Der

The most common method of colour printing involved a type of stencil called a frisket. From the earliest days of the hand press period frisket-sheets were used to mask or protect the margins of a sheet. They were also used to mask areas that would be printed in a second colour (fig. 37).[148] For example, a forme could be inked in red but the areas of a sheet intended for printing in black would be masked off by use of a frisket-sheet; holes cut in the frisket would expose only the areas to print red. The sheet was printed, and the type that had been printed in red was removed from the forme and replaced with quads, or spacing material. Then the remaining type would be inked in black for the second impression, without the frisket in place.[149] Scraps of paper or parchment manuscript leaves were appropriated for use as friskets in colour printing, and a number were later reused as binders' waste in early modern books.

36 (opposite) A *Briefmaler*, or professional print colourist, using a broad brush to apply colour to printed woodcuts through a stencil. From *Das Ständebuch*: text by cobbler, singer and poet Hans Sachs; illustrations by the prolific woodcut artist, Jost Amman. Frankfurt, 1568.

37 (above) A frisket-sheet used to print text and initials in red while masking unprinted areas. Once printed, the red elements were removed from the forme, and the remainder was printed separately in black.

38 Colour woodcut of Saint
Valentine, Saint Stephen and Saint
Maximilian. Woodcut by Hans
Burgkmair. Printed by Erhard
Ratdolt, 1494 and 1498.

Ratdolt and Relief Colour Printing

The earliest known colour intaglio illustrations in a typographic book
are to be found in a volume on astronomy printed by Nicolaus Götz in
Cologne in 1476.[150] The book contains a number of woodcuts of eclipses
in monochrome black, but in some of the ten extant copies there are
two engravings of astronomical instruments printed in red and black.
As we have seen (p. 75), intaglio cannot be printed on a press designed
for letterpress or relief printing as it requires substantially more pressure
to transfer the ink to the sheet.[151] Prior to the invention of the rolling
press, therefore, metal intaglio plates were printed by rubbing the back
of the paper.[152]

For the emergence of colour images printed in relief, we must
fast-forward more than a decade to a German immigrant working in
Venice. In 1474, following an argument with his brother, Erhard Ratdolt
(1447–1527/8) left his hometown of Augsburg for Venice, likely arriving
there some time in 1475; Ratdolt had been a teenager in Mainz, escaping
shortly before the troops of Archbishop Adolf II sacked the city in 1462.[153]
He published his first book along with two German compatriots,
Bernhard Maler and Peter Löslein, the following year. Ratdolt was
an especially innovative printer and produced many impressive books,
including a considerable number of first editions. The first extant
colour images printed in Italy were the red and black eclipses printed
by Ratdolt in Venice in 1482 in the *Kalendarium* of Regiomontanus
(Johannes Müller von Königsberg, 1436–1476).[154] The first tri-colour
printing, in red, black and yellow, followed in 1485 with the publication
of the *Breviarium Augustanum*,[155] then, in the same year, in an edition of
Johannes de Sacrobosco's *Sphaera mundi* ('Sphere of the World').[156] Upon
his return to Augsburg, at the invitation of two successive bishops, Ratdolt
printed predominantly liturgical works and continued his experiments in
colour printing. It is Ratdolt's press, more than any other of the fifteenth
century, that is most associated with polychromatic printing.

Prior to becoming an independent master, Hans Burgkmair (1473–1531),
the famed Augsburg printmaker, appears to have been apprenticed to Ratdolt
in Augsburg. Quite possibly their collaboration began as early as 1493. Hans
Burgkmair was one of the very first proponents of the chiaroscuro woodcut,
a technique whereby several blocks are cut and inked with different tones
of the same colour to produce subtle gradation (see p. 95), something
that until then could only be achieved by hand via washes.

Typographic Firsts

The five-colour woodcut of Saints Valentine, Stephen and Maximilian, which served as title-page for a Passau missal (fig. 38), though not signed by Burgkmair, is certainly his. These polychromatic prints were once believed to have been coloured with stencils. However, more recent investigation reveals that they were in fact printed with woodblocks, one for each colour: black, red, yellow, blue and olive green. Colour-printed woodcuts and metalcuts of several colours are very rare in the fifteenth century. One particularly unusual example is the first book printed in England to contain printed colour illustrations. *The Book of Hawking, Hunting and Heraldry* by an anonymous schoolmaster printer in St Albans, and better known as 'The Book of St Albans', was printed in 1486 or shortly thereafter and is illustrated with 117 woodcuts of coats of arms, dozens of them printed in up to four colours: black, red, blue and green, with yellow or gold added by hand.[157] According to Joseph Dane, 'it is clear that the ambition of this printer far outstripped the technical resources available';[158] and, according to Ad Stijnman and Elizabeth Savage, 'it is the only recorded example of printing in more than two colours in Tudor England.'[159]

That elements of colour printing proved a significant technical challenge for some time is evidenced by two Nuremberg printers, Johann Sensenschmidt and Andreas Frisner, who had wished to print red underlining, in imitation of manuscript rubrication, but had failed and issued an apology to that effect in their preface to the *editio princeps* of Peter Lombard's commentaries on the Psalms, printed in 1478.[160] To the best of my knowledge, printed underlining in red does not occur in any book of the fifteenth century.

Dr Christopher de Hamel, one of the world's foremost experts on medieval manuscripts, wrote that 'probably the most visible difference between any manuscript of the Middle Ages and later printed books is that the majority of manuscripts are in more than one colour.'[161] Erasmus, who had much to say about many things, claimed that the addition of colour to fine prints was at best superfluous – at worst, injurious. Of Albrecht Dürer's work, he writes, 'so alive it is to the eye that if you were to add colour you would spoil the effect.'[162] However, he conceded that colour might be employed in mitigation of lesser works. Notwithstanding Erasmus' selective chromophobia, polychromy in relief and intaglio printing multiplied, and from the beginning of the sixteenth century we witness a concomitant decline in hand-coloured prints.

Two hundred years would pass before Jacob Christoff Le Blon's trichromatic technique was developed at the beginning of the eighteenth century, the forerunner of lithography and chromolithography.[163] Yet another century would pass until colour printing became commercially viable. Until these relatively late technological developments, colour printing was always something of an expensive compromise, with aesthetic criteria and expectations shaped by those very limitations.[164]

Magnificat aïa
mea dominum.
Et exultauit spûs et̃
Require in off̃ domi
nıca ad vesperas Añt
Omne quod dat mihi
pater ad me ueiet: et eũ
qui uenit ad me nõ eici
am foras. Pater nr̃. Secto
Et ne nos. R̃ Sed librã
Lauda anima r̃s
mea dñm: lauda

bo dominum in uita me
a: psallam deo meo q̃ diu
fuero. Nolite confidere
i principibus neq̃ infili[j]
hominũ: iquibus nõ est
salus. Exibit spûs cius,
et reuertet in tẽram suã:
in illa die pibunt omẽs
cogitationes eor̃ . . et
atus cius deus iacob ad
iutor cius: spes cius in
dño deo ipius: qui fecit

Printed Illuminations
The First Gold Printing

7

In a pot ... place nine lizards in the milk, put on the cover, and bury it in damp earth. Make sure the lizards have air so they do not die. Let it stand until the seventh day in the afternoon. The lizards will have eaten the brass ... and their strong poison will have compelled the brass to turn to gold.[165]

THE ANCIENT ROMAN AND GREEK historians Pliny and Herodotus both mention gilding – the latter writing that the Egyptians gilded wood and metal. Gold has been used in the decoration of ceramics and in art for millennia, and from at least the fifth century in the production of illuminated manuscripts. In his prologue to the Book of Job, Saint Jerome is critical of writing in gold in manuscripts of the gospels, their owners more concerned with their luxury than the accuracy of their texts. In his *Letters* he writes, 'parchments are dyed purple, gold is melted for lettering, manuscripts are decked with jewels: and Christ lies at their door naked and dying.'[166] But the wealthy purveyors of deluxe, illuminated manuscripts were not to be discouraged. In addition to writing in gold, 'chrysography', gold leaf was used to decorate or illuminate manuscripts. Although the term 'illuminated manuscript' is often used to describe all decorated manuscripts, strictly speaking it refers to those ornamented with gold and silver. The metals reflect light and therefore literally illuminate the page. If gold was to be used in a manuscript, it was applied before other colours, as the burnishing, for adhesion and shine, risked damaging already painted areas.[167] Of the millions of medieval manuscripts produced, most were rather plain, with only a very small proportion decorated or written in gold. However, their splendid and expensive decoration often assured their survival in disproportionate numbers.

39 A fifteenth-century Italian manuscript book of hours penned in gold. MS. Canon. Liturg. 287.

Erhardus ratdolt Augustensis impres-
sor Serenissimo Uenetiarum principi
Principi Joanni Mocenico. S.

Solebam antea Serenissime Princeps mecum ipse cogitans admi-
rari quid causae esset:q, in hac urbe praepotenti z tanta urbe cu uarie
auctorum uereru nouorúq, uolumina quotidie imprimerent. In
hac mathematica facultate uel reliquarum disciplinarú nobilissima
aut nihil: aut parua quaedam z friuola in tanta impressorú copia qui
in tua urbe agunt: uideretur impressa. Haec cum mecú saepius dispu-
tarem: aduertebam id difficultate operis accidisse. Non enim adhuc
quo pacto schemata geometrica: quibus mathematica uolumina sca-
tent: ac sine quibus nihil i his disciplinis fere intelligi optime potest
excogitauerant. Itaq, cum hoc solum tantúmodo communi omnium
utilitati que ex his percipitur obstaret: mea industria nõ sine maximo
labore effeci: ut qua facilitate litterarum elementa imprimuntur: ea
etiam geometricae figurae conficerent. Quamobrem ut sphero hoc
nostro inuento hae disciplinae quas mathemata graeci appellant:
uoluminú copia sicut reliquae scientiae breui illustrabút. De quaru
landibus z utilitate possem multa impraesenti adducere ab illustribus
collecta auctorib9: nisi studiosis iam omnib9 haec nota essent. Illud
etiam plane cognitú est caeteras scientias sine mathematib9 imper-
fectas ac ueluti mancas esse. Neq, hoc profecto negabút Dialectici
neq, Philosophi abnuent: in quoz libris multa reperiunt: quae si-
ne mathematica ratione minime intelligi possunt. Quam diuin9 ille
Plato noere ueritatis arcanú: ut adipisceretur cyrenas ad. Theo-
dorum summum eo tempore mathematicuz z ad egyptios sacerdotes
enauigauit. Quid q sine hac una facultate uiuendi ratio nõ perfecte
constat. Nam ut de musice taceam: quae nobis munera ab ipsa natu-
ra ad perferendos facili9 labores ptceila uidetur: ut astrologiã prae-
teream qua exculti coelum ipsum ueluti scalis machinisq, quibusda
conscendentes uerum ipsius naturae argumentum cognoscimus: sine
arithmetica z geometria: quaruz altera numeros altera mẽsuras do-
cet: ciuiliter comodeq, uiuere qui possum9? Sed quid ego i his mo-
ror quae iam omnibus ut dixi: notiora sunt q̃ ut a me dicantúr. Eu-
clides igitur megarensis serenissime princeps qui. xv. libris omnem
geometriae rationem psummatissime complexus est: quem ego sum-
ma z cura z diligentia nullo praetermisso schemate imprimenduz cu-
raui: sub tuo nomine tutus foelixq, prodeat.

Typographic Gold

Although the use of gold in manuscript books was an obvious added expense, its application, practised over centuries, was not such a technical challenge. However, printing in gold was another matter entirely. The German printer Erhard Ratdolt, a native of Augsburg in Southern Germany, was undoubtedly one of the greatest innovators in printing during the fifteenth century. In addition to being the very first to use a decorative title-page and among the first to experiment with printing in multiple colours (see pp. 86, 109), he also appears to have been the first to print in gold. In some copies of his *editio princeps* of Euclid's *Elements*, printed at Venice in 1482, translated from the Arabic by the twelfth-century scholar Adelard of Bath, and famed for its early use of more than 400 printed geometric diagrams, he printed the dedication to the incumbent Doge of the Republic of Venice, Giovanni Mocenigo, in gold.[168] Of approximately 300 surviving copies, at least seven have their dedications printed in gold, including the copy at the British Library.

In fact, during the fifteenth century, Ratdolt was only one of two printers who experimented with printing in gold; the other being the Cretan printer and former scribe Zacharias Callierges, renowned for his Greek press in Venice.[169] In July 1499, he printed a folio edition of a Byzantine Greek dictionary, *Etymologicum Magnum Graecum*, for Nicolaus Blastus and Anna Notaras.[170] It appears that the partnership with Blastus was initiated solely for the production of this dictionary. Anna Notaras, daughter of the last duke of Constantinople, Loukas Notaras, is credited for being instrumental in bringing Blastus to the project. This very fine book, which was five years in the planning and making, was the first to issue from Callierges' press. In most copies the white-line initials (where the letterform is cut away from the surface of the woodblock, so appears white against a darker background) and headings are printed in red but in some copies the headers and initials are printed in gold.[171] Whereas the illuminators of medieval manuscripts prepared their liquid gold ink, or shell gold (named after the receptacles in which it was prepared), by combining flaked gold with gum arabic, it appears that Ratdolt first dusted the paper or parchment with a powdered adhesive and then applied gold leaf to the surface of heated type. With this process, upon impression the heated type melted the adhesive and the gold leaf was left adhered to the page, whereupon the excess was

40 Euclid's *Elements*, printed on 25 May 1482 in Venice, by Erhard Ratdolt. The dedication addressed to Giovanni Mocenigo, the Doge of Venice, is the first extant example of printing with gold.

dusted off. This was rather tricky. Overheat the type and one risked scorching the paper or parchment; under-heat it, and the gold would fail to adhere to the page. The fact that gold leaf rather than gold ink was used is apparent from the specks of gold that are clearly visible across the entire page under magnification – remnants from the brushing away of excess gold leaf. Ratdolt again printed in gold on his return to Augsburg, in the preface to two vellum copies of Johannes de Thwrocz's *Chronica Hungarorum*, issued in 1488, although apparently with a form of gold ink rather than gold leaf.[172] He used gold a third and last time in the colophon of Conrad Peutinger's slim volume of Roman lapidary inscriptions discovered in and around Augsburg, *Romanae vetustatis fragmenta*, in 1505.[173] (Augsburg had been founded by the Romans as Augusta Vindelicorum in the first century BCE.) This was the first example of this genre in print.[174]

Gold had appeared in printed books prior to Ratdolt's edition of Euclid. In some copies of the first printed edition of Dante's *Divine Comedy*, printed at Foligno by Johann Neumeister in 1472, the first page contains borders and letters in gold.[175] However, the underlying letterforms have been printed in ink, then over-painted with gold pigment. An even earlier example of gold is to be found in a Cicero of 1465 from the Mainz press of Johann Fust and Peter Schoeffer, where, in some copies, the headings are handwritten in gold.[176]

Shortly after the publication of Ratdolt's last example of gold printing in Peutinger's book of inscriptions, another Augsburg native, Lucas Cranach the Elder (1472–1553) – the famed painter, engraver and friend to Luther, early proponent of polychromatic printing and the chiaroscuro woodcut – was also experimenting with gold. Chiaroscuro, from the Italian meaning 'dark and light', was the term used to describe the Renaissance drawing technique of drawing and painting highlights on coloured papers. Chiaroscuro woodcuts achieved a similar effect with overlapping tone blocks that 'were superimposed over one another, with the overlaying line block, to achieve an interlocking pattern of shading and highlights'. One of the best-known examples of very early chiaroscuro woodcut is Hans Burgkmair's three-block (a black line block and two red tone blocks) *The Lovers Surprised by Death*.[177] Cranach's *St George* woodcut is printed with two blocks, a key block for the black, printed first, and a second block for the printing of gold, using gold ink (fig. 41). Adding to the very small corpus of early gold printing is a commemorative

41 A colour woodcut of St George made from two blocks. Printed by Lucas Cranach the Elder, 1507.

woodcut of a young Charles V, whose German coronation took place in October 1519. It was printed in Augsburg by the Flemish artist Jost de Negker, and detailed x-ray and microscopic analysis reveals that gold ink (gold powder suspended in a liquid medium) was employed.

Presentation Copies

During the fifteenth century, when the manuscript tradition was still relatively strong, printing in gold was performed for the same reasons and for the same clientele as gold in illuminated manuscripts. Such manuscripts would, in addition to making a statement about their owner's wealth and status, also reflect their devotion. Ratdolt's own limited printing in gold served a similar purpose. His books were intended as presentation copies to honour and impress the Emperor and the Doge of Venice. Ratdolt's last use of printed gold in the preface of Johannes de Thwrocz's *Chronica Hungarorum* was dedicated to none other than the learned patron of the arts, Matthias Corvinus, King of Hungary and Bohemia. A book with a page printed in gold (at that time unique) was also perhaps Ratdolt's answer to the question, what does one give to someone who has everything?

Only a handful of examples of gold printing exist prior to the eighteenth century,[178] when a patent for gold printing – not in books but on wallpaper – was granted to Joachim Andreas Bähre for his method of sizing paper to be printed upon in gold and silver.[179] In the seventeenth century Joseph Moxon, in addition to his descriptions of type-founding and printing, describes the common technique for applying gold to printed books, not in the press but by hand with varnish and gold leaf.[180]

Gold-coloured inks were not always made from gold. A yellow tin sulphide, or mosaic gold,[181] was a less expensive substitute, its preparation described in the early fourth century by the Chinese,[182] who also used it as an elixir; in Europe a recipe of mercury and sulphur is described by Cennino Cennini; others include the implausible sixteenth-century recipe of brass, nine lizards and a quart of goat's milk, or the equally dubious combination of mercury and fresh hen's eggs.[183] These days, gold inks seldom contain gold – or mercury or goat's milk – but are commonly made from powdered aluminium or brass, an alloy of copper and zinc.

Carl von gottes gnaden, Römischer König, zu Castillien Aragon Leon/bayde Sicilien Hierusalem Nananen Granaten Valencien Gallicien Maioricanum Hispalen Sardinien Cordube Corsicen Murcien Giennen Algarbien Algeren Sibralearen/auch der Insule Cana ie Jndien vnd des Lands Oceanischñ Moers, König, Erzherzog zu Osterreich, zu Burgundien/Lotrach, Brabant Steyr Kernthen Crain Limburg Lutelburg Geldren Calabrien Athenarum Neopatrien, Grave zi Flandern Hapspurg Tyrol Barzalon Arthois vnd burgundien, Pfalzgrave zu Henegaw land Seland Vhyet Roburg Namur Rosilio Lentthani vnd Zurphen, Landgrave am Elsas, Margrave zu Burgaw istanien vnd Goctan, des heyligen rey hs fürst zu Cathalonie, Schwaben vnd Asturien, herre d Frie land/Visch, ay Volinaen auff der Windischen marck zu Portenaw Salins vnd Mulhelm, Jost de Negker zu Aua

ERASMI ROTERODAMI ADAGIORVM CHILIADES TRES, AC CENTV-RIAE FERE TOTIDEM.

ALD. STVDIOSIS. S.

Quia nihil aliud cupio, q̃ prodeſſe uobis Studioſi. Cum ueniſſet in manus meas Eraſmi Roteroda-
mi, hominis undecunq̃ doctiſs. hoc adagiorũ opus eruditum. uarium. plenũ bonæ frugis,
& quod poſſit uel cum ipſa antiquitate certare, intermiſſis antiquis autorib. quos pa-
raueram excudendos, illud curauimus imprimendum, rati profuturum uobis
& multitudine ipſa adagiorũ, quæ ex plurimis autorib. tam latinis , quàm
græcis ſtudioſe collegit ſummis certe laborib. ſummis uigiliis , &
multis locis apud utriuſq̃ linguæ autores obiter uel correctis
acute, uel expoſitis erudite. Docet præterea quot modis
ex hiſce adagiis capere utilitatem liceat, puta quē-
admodum ad uarios uſus accõmodari poſ-
ſint. Adde, qd̃ circiter decẽ millia uer-
ſuum ex Homero. Euripide, & cæ.
teris Græcis eodẽ metro in
hoc opere fideliter, &
docte tralata ha
bẽtur, præ
ter plu
rima
ex Pla-
tone, De-
moſthene, & id
genus ali
is. An
autem uerus ſim,
ἰδοὺ ῥόδος, ἰδοὺ καὶ τὸ πήδημα.
Nam, quod dicitur, αὐτὸς αὐτὸν αὐλεῖ.

Alchemy and Antimony

The First Printers' Marks

8

> For the head of the Dolphin is turned to the left, whereas
> that of ours is well known to be turned to the right.
>
> ANDREAS TORRESANUS[184]

FOR CENTURIES PRIOR TO GUTENBERG, books were the products
of scribes and copyists. Theirs was slow and laborious work and yet most
remained anonymous, their names seldom appearing in the colophons
of medieval manuscripts. The *Rule of Saint Benedict* warned that monks
who boasted of their craftsmanship risked dismissal.[185] However, just
as the illuminator would from time to time stray into the margins to draw
the grotesque and profane, so too scribes sometimes took to the margins
and colophons to complain about their working conditions, their aching
backs and sore fingers, or to express contrition for pages penned too
quickly, or too poorly, with the typically self-deprecating refrain, 'Alas,
I finished badly because I didn't know how to write well.'[186] In medieval
Germany, some female convent scribes, though leaving most of their
work unsigned, did add their names to some of the more challenging
commissions, such as antiphonals and graduals, especially difficult texts
'requiring special professional-level training to copy', owing, in part, to
the music they contained.[187] From late medieval times, with the decline of
monastic scriptoria, the scribal colophon was more consistently concerned
with bibliographic details, and as such was a fitting antecedent to the
printer's colophon.

Gutenberg never saw the need to complete his books with a colophon.
The first printed book to contain one was the Mainz Psalter of 1457,
produced by Gutenberg's heirs, Johann Fust and Peter Shoeffer: 'The
present copy of the Psalms, adorned with beauty of capital letters, and
sufficiently marked out with rubrics, has been thus fashioned by an
ingenious invention of printing and stamping without any driving of
the pen, And to the worship of God has been diligently brought to

43 Aldus Manutius's printer's mark:
the dolphin and anchor.

completion by Johann Fust, a citizen of Mainz, and Peter Schoeffer of Gernsheim, in the year of the Lord 1457, on the vigil of the Feast of the Assumption.'[188] A feature that was soon to join the colophon but had no direct parallel in the manuscript tradition was the printer's mark, an emblem or symbol akin to the trademark. In France printers' devices were afforded some legal protection when, in 1539, François I passed an ordinance requiring all booksellers and printers to have their own marks. Elsewhere in Europe, for the most part, printers' devices were not legally protected until the end of the sixteenth century.[189] In 1462, in addition to publishing a number of broadside indulgences in the spring, Fust and Schoeffer published a Latin Bible in the autumn,[190] the first book to appear with a printer's device. Fust and Schoeffer's device had appeared earlier, printed in red in a single surviving copy of the Mainz Psalter of 1457. However, it was most likely stamped into the Psalter at a later date, probably at some time after its use in the 1462 Bible.[191] The Fust and Schoeffer device comprised two heraldic shields suspended from a branch. The shields bore a saltire, a diagonal cross and a chevron surrounded by three stars. Perhaps these were based on Fust's and Schoeffer's individual coats of arms,[192] though it is also reasonable to assume that the cross and chevron represented the Greek letters X and Λ, for Christ and Logos. So why did Fust and Schoeffer use such a mark? Schoeffer claimed, 'By signing it with his shields Peter Schoeffer has brought the book to a happy completion.' The device, then, was a seal of completion, a mark of a craftsman's pride in his work.[193]

The Fust and Shoeffer device was imitated by a number of fifteenth-century printers, including Gerard Leeu in Antwerp, Johann Veldener in Louvain, Michael Wenssler and Nicolaus Kesler in Basel, and Peter Drach in Speyer. The heraldic device became a popular motif north of the Alps, particularly in Germany and the Low Countries, while printers throughout the Italian Peninsula preferred the adroit symbolism of the *globus cruciger*, or 'orb and cross', popular in Christian iconography from the early Middle Ages, with the cross representing God's dominion over the globe.[194] The 'orb and cross' or 'Jenson device' associated with Nicolaus Jenson (*c.* 1420–1480) in Venice was never used in his lifetime. It first appeared in April 1481, some six months after his death, in a book bearing the imprint 'Johannes de Colonia, Nicolaus Jenson et Socii' (the short-lived firm that was set up just months before Jenson died).[195] It was much imitated in the late fifteenth and early sixteenth century through-out Italy. In France, too, the orb and cross was a popular motif, though

early in the sixteenth century such simple devices were frequently subsumed in architectural frontispieces or drowned out by borders and a cornucopia of disparate graphic accoutrements.[196] These 'orb and cross' and 'orb and four' printers' marks and their variants were the direct descendants of the merchant's mark. Appropriately, the circle and cross is also the alchemical symbol for antimony which, when alloyed with lead and tin, contributes to the hardness and durability of type metal.

Konrad Sweynheym, Arnold Pannartz and Ulrich Han, the earliest printers in Italy, used no printer's device. Not until the final decades of the fifteenth century do we witness Italian printers adopting their own devices. Sixtus Riessinger was among the first to use a printer's mark in Italy; his device, a stick of wood pierced through with an arrow, took two forms; in Naples in 1478 it appeared on an escutcheon held by the mythological Sibylla Persica;[197] and from 1481, upon his return to Rome, the stick and arrow motif appeared alone. In the more complex device there was a banderole bearing the initials S.R.D.A., standing for 'Sixtus Riessinger de Argentina'.[198]

William Caxton went many years without using a printer's device; Caxton used his printer's mark in only about 10 per cent of his books.[199] Even after returning to England, where in 1476 he was the first to print

44 A variety of printers' marks: (top row, left to right) Andrea Wechello; François Regnault; Johann Froben; Lucantonio Giunti; (bottom row, left to right) Johannes de Colonia, Nicolaus Jenson et Socii; Sébastien Gryphius; Melchior Sessa; William Caxton.

on British soil,[200] it would be another decade before his own device appeared in a Sarum missal.[201] Caxton's device was preceded by the cross and orb of the St Albans Press, employed from about 1483.[202] To this day, Caxton's printer's device remains something of an enigma.[203] Do the initials S.C. in the border stand for 'Sancta Colonia' (a reference to Cologne; see p. 147) or simply for 'Caxton's Seal' (*sigillum Caxtoni*)?

Most Modest Mercury

Most fifteenth-century printers' marks were relatively small and usually appeared on a title-page or accompanying a colophon at the end of the book. One of the largest fifteenth-century examples of a standalone printer's device belonged to the German printer, Erhard Ratdolt. His mark was first used from about 1494 in a Latin and German psalter, long after he had left Venice and returned to his native Augsburg in Southern Germany. An entire page was devoted to his device, which was always printed in two colours, black and red. Centre stage is naked Mercury, a well-placed star representing the eponymous planet and affording him some dignity. (In medieval and Renaissance astronomy the planets and stars were all labelled as stars, although they were separated into two groups: the fixed stars – what we would today call stars – and the

45 Erhard Ratdolt's full-page, two-colour, woodcut Mercury printer's device.

wandering stars or planets.) He holds aloft a staff entwined by serpents, a caduceus. The Greek god Hermes, son of Zeus (in Roman mythology, Mercury), was generally depicted holding the caduceus. In addition to being messenger to the gods, Mercury, at least for the Romans, was also the god-patron of commerce and the merchant, thus lending his name to 'mercantilism'. The caduceus held aloft by the hand of God emerging from the clouds was employed as a printer's mark by Johannes Tacuinus in Venice from about 1505, and in Basel by the printer-publisher Johann Froben (*c.* 1460–1527) from about 1516.

Fraudulent Dolphins

Arguably the most familiar of printers' devices is associated with one of the greatest printer-publishers of all time, Aldus Manutius. He chose not to employ any printer's device until his dolphin and anchor emblem appeared for the first time in the second volume of *Poetae Christiani veteres* ('Ancient Christian Poets'), dated June 1502.[204] Over the next seven decades the dolphin and anchor mark of Aldus Manutius, Andreas Torresanus (Aldus's partner) and their familial heirs would appear in almost fifty variants.[205] In the preface to the 1518 edition of Livy's *Decades*,[206] Torresanus wrote of competitors pirating the Aldine device:

> Lastly, I must draw the attention of the students to the fact that some Florentine printers, seeing that they could not equal our diligence in correcting and printing, have resorted to their usual artifices. To Aldus's *Institutiones Gramaticae*, printed in their offices, they have affixed our well known sign of the Dolphin wound round the Anchor. But they have so managed that any person who is the least acquainted with the books of our production, cannot fail to observe that this is an impudent fraud. For the head of the Dolphin is turned to the left, whereas that of ours is well known to be turned to the right.[207]

Without any formal intellectual property or copyright laws, piracy was rife. And often it was the printer's device that readers were asked to check as a mark of a book's authenticity. The printers' guilds arose in response to the impunity with which editions could be pirated and counterfeited. In Venice, the Guild of the Venetian Printers dates from 1548; in England the Stationers' Company was granted a royal charter by Philip of Spain and Mary Tudor in 1557. In Milan, a printers' guild was established in 1589. In the case of the Milan guild, membership was only

open to those who had served an eight-year apprenticeship with a printer or bookseller, and regulations stipulated that 'each publication shall bear the imprint of its printer or publisher' and 'no printer or dealer must use for his sign a token identical with or closely similar to that already in use.'[208]

Puns and Parody

Visual puns and play on words were common themes in printers' devices. For example, the rebus of the late sixteenth-century English printer William Norton was a pun on his given and family names; his device was a Sweet William growing through a tun or cask inscribed with the letters *nor*.[209] Another, arguably subtler *jeux de mots* was to be found in the device of Simon de Colines, wherein a family of rabbits are frolicking at the base of a tree. Why rabbits? 'Conil', the old French word for rabbit, is an acoustic anagram for Colines. Moreover, *bouquin*, a French farmer's word for a male hare or rabbit, is also colloquial French for book. Thus the book-hawkers or chapmen of Paris were *bouquinistes* – literally, jack-rabbit dealers.[210]

There were not only puns, but parody too. For example, in Venice, Giovanni Angelo Ruffinelli's device employed three artichokes, a parody of the fleur-de-lys mark of the Florentine Giunti dynasty. (Despite the Giunti family's well-documented history of pirating or imitating Aldine editions, in Lyons the family aggressively defended their own intellectual property, successfully opposing their former partner, Filippo Tinghi, in his legal challenge to the exclusivity of the Giunti's fleur-de-lys device.[211]) In Stefano Zazzera's parody of the Aldine dolphin and anchor mark, the dolphin is replaced by a snake entwined around a garden hoe. Its parodic intent did not go unnoticed and Zazzera was later obliged to alter his mark, thereafter substituting a fox for the snake.[212] One wonders who had the last laugh in that dispute.

In the sixteenth century, printers' devices with animals of all sorts were very popular: from the mythical beasts of classical antiquity, to the elephants of François Regnault in Paris, to wolves, children riding giant frogs, and cats, as in the centrepiece of Melchior Sessa's device.[213] There were many more devices that combined numerous classical and Christian motifs: for example, in mid-sixteenth-century Paris, Andrea Wechello, not satisfied with caduceus, palm trees, coconuts and monograms, crowned his device with the winged stallion Pegasus.

The late nineteenth-century book historian William Roberts claimed that, 'In beauty of design and engraving, the Printer's Mark, like the Title-page, attained its highest point of artistic excellence in the early part of the sixteenth century.'[214] A more wide-reaching assessment would place the best examples of printer's marks coincident with the long cinquecento. From early in the sixteenth century, the burgeoning business of book production underwent significant structural changes: the growing internationalization of the book trade and the changing relationships between investors, publishers, printers, booksellers, distributors and buyers, effected a change in the place of the printer within the publishing hierarchy, a division of labour that very soon saw the printer's mark make way for the publisher's mark.[215] The history of the printer's device reflects the evolution of the printed book. From the simplicity of the orb and cross devices – a reflection of the restrained and uncluttered *mise en page* of the finest fifteenth- and sixteenth-century Italian books – to the baroque and rococo efforts of later centuries, printers' and publishers' devices have been bellwethers or alchemical distillations of prevailing typographic and artistic tastes.

46 Simon de Colines's witty device, used on some title-pages between 1520 and 1527, was a pun on both his own name and also on the French colloquialism for a book.

CHRISTOPHO
RI MORALIS HYSPA
LENSIS, MISSARVM
LIBER PRIMVS.

IACOBVS MODER.

LVGDVNI M. CCCCC. XLVI.

'Here Begynneth a Litl Boke'
The First Title-Pages

> The history of printing is in large measure the history
> of the title-page.
> STANLEY MORISON[216]

THE BOOK IN ITS PRESENT FORM is a product of evolution,
serendipity and design. Its size and proportions are accommodations
to the human form – the length of our arms, for example – and the size
of the type is a concession to our mean visual acuity. Essentially, the
form of the book has changed little in the past 500 years. The very first
printed or typographic books resembled their manuscript forebears,
but as printing spread rapidly throughout fifteenth-century Europe, the
book took on its own, unique characteristics. Page numbers, running
heads, indices, colophons, rubrication, decoration, printing in colour –
appropriations and innovations – soon became common features of
the typographic book.[217]

Today, our first encounter with a book is its cover, usually of heavy
paper or board. Typically, the first text we encounter is the book's title
and the name of its author, running down the spine and across the front
cover. More information, including a publisher's blurb or a précis, often
adorns the back cover when the book is wrapped in a dust jacket (which
first appeared in the 1830s).[218] However, books in the fifteenth century
were seldom sold ready-bound: like other aspects of bookmaking,
bookbinding was hand-work until its mechanization in the nineteenth
century. And only from about the second quarter of the nineteenth
century, as cloth replaced leather as the preferred cover material, do we
begin to observe decorative and textual elements appearing on mass-
produced covers and spines. The earliest printed books were usually sold
unbound and bore no titles, but, like their manuscript counterparts, they
began with an incipit (from the Latin, meaning 'here begins'). When books
were first organized or indexed they were catalogued by the first words

47 The decorative title-page of
Cristobál de Morales's *Missarum
liber primus*, Lyons, 1546, printed by
Jacques Moderne.

of the text, or incipit – many short-title catalogues for manuscripts and printed books are still organized in this way. In fact, many books of the Bible are named by their incipits. Thus, for example, the first book of the Old Testament is named Genesis or 'In the beginning'. Likewise, the last book of the New Testament, Revelation, is named after its original Greek incipit, '*apokalupsis*'. The incipit, in both manuscript and typographic books, was often distinguished from the text proper by the rubricator's pen – a red underline or strikethrough, for example.

Prior to the arrival of the printed book, manuscript books were ostensibly unique copies produced on commission. But the advent of printing and the subsequent proliferation of books, multiple (supposedly) identical copies of a single edition, and a change in the market for books – from commissioned to speculative – necessitated changes to the way books were presented to potential readers or customers. Most early incunabula began with an incipit and sometimes closed with a colophon. Not until 1463 do we witness something resembling a title-page, in Johann Fust and Peter Schoeffer's Papal Bull, *Bulla cruciata contra Turcos*, part of Pope Pius II's efforts to promote a new Crusade against the Ottomans, who a decade earlier had sacked Constantinople (fig. 48).[219] This pamphlet, in two editions, Latin and German, of just six and eight leaves respectively, appeared to be a deliberate attempt on the part of the printers at experimenting with redesigning an element of the typographic

48 Title-page to Johann Fust and Peter Schoeffer's Papal Bull, *Bulla cruciata contra Turcos*, 1463.

book. Seven copies of the Latin edition are extant. The Latin edition copy held in Aschaffenburg, Germany has the nascent title-page set in the large Gothic *textura* type from their 1457 Mainz Psalter, as does the German edition of the Bull held at the John Rylands Library, Manchester, although there the title is presented in four lines rather than two. The copy at the Bibliothèque nationale de France is entirely different in design, with its title-page printed from a single woodcut, whereas the title-page in the other copy in France, at the Musée Condé, is not printed in any form, but is handwritten. In all these copies nothing more than the title and author

is presented. Schoeffer thereafter abandoned the title-page until 1486.[220] The tentative title-page in Arnold Ther Hoernen's 1470 Cologne edition of Rolewinck's 'Sermon' is similar to Schoeffer's early effort, but although it includes the title and date of printing, the author's name is not present. It is the kind of design that Theodore de Vinne describes as a paragraph title, or 'an early bastard title', or label-title.[221]

It was to be in fifteenth-century Venice, the world capital of bookmaking, that three Germans, Ratdolt, Löslein and Maler, produced the first decorative title-page for their 1476 quarto edition of the astronomer Regiomontanus's *Kalendarium* ('Calendar'), which was also the very first book to issue from their press (fig. 49). It was the first title-page to include almost everything one might expect to see in a modern-day title-page: title, author, date and printer and place of publication, details that had hitherto been included partially across incipits, label-titles and colophons. 'It is rare to find dates on title-pages during the incunable period and early sixteenth century. If dates were to appear anywhere in the book, they remained, for the most part, in the colophon.'[222] Although Ratdolt's bordered title-page was presented in verse rather than prose, and the book's title was buried in the third line, the format is instantly recognizable as a title-page.[223] The form of the date too was a novelty, presented in Arabic numerals rather than the traditional roman numerals. The elegant decorative border of the title-page comprised five separate woodcuts printed in outline; i.e., the background or ground was cut away, leaving just the outline. Similar to the short-lived experiments of Fust and Schoeffer and Arnold Ther Hoernen, the title-page of Ratdolt and his two compatriots appeared only in one work, Regiomontanus's *Kalendarium*, albeit in three editions, Latin, Italian and German.[224] Later editions of the calendar – at least a dozen more – printed by Ratdolt alone, were printed without title-pages. The decorative title-page, used only while in partnership with Löslein and Maler, suggests that they had been influential in its adoption. During a career spanning five decades of the fifteenth and sixteenth centuries, Ratdolt produced more than 200 editions, yet the *Kalendarium* is the only one to appear with such a title-page. By the beginning of the sixteenth century, most books were printed with some form of first-page title, whether a label-title or a full title-page. At a time when books were seldom bound prior to sale, the title-page served to make the unbound quires easily identifiable and may have developed from a blank leaf intended to protect the unbound book.

Questa opra da ogni parte e un libro doro .
Non fu piu preciosa gemma mai
Dil kalendario : che tratta cose asai
Con gran facilita : ma gran lauoro
Qui numero aureo : e tutti i segni fuoro
Descripti dil gran polo da ogni lai :
Quando ti sole : e luna eclipsi fai ;
Quante terre se rece a sto thexoro.
In un instanti tu sai qual hora sia :
Qual sara lanno : giorno : tempo : e mexe :
Che tutti ponti son dastrologia .
Ioanne de monte regio questo fexe :
Coglier tal frutto acio non graue sia
In breue tempo: e con pochi penexe .
Chi teme cotal spexe
Scampa uirtu. I nomi di impressori
Son qui da basso di rossi colori .

Venetijs. 1476 .

Bernardus pictor de Augusta
Petrus loslein de Langencen
Erhardus ratdolt de Augusta

The Frontispiece

From about the second quarter of the sixteenth century we observe, notably in France and the Low Countries at first, progressively more ornate and lavishly decorated title-pages, with motifs borrowed from antiquity, the medieval period and early Renaissance art. Architectural motifs, pediments, porticoes, colonnades and pilasters, and figural borders populated by putti and creatures from antique mythology, joined by curlicues, garlands and festoons, were especially popular devices. Some of the more chaotic title-pages, which somehow managed to include just about all of the aforementioned motifs, were offset by the more sober title-pages from the likes of Simon de Colines in Paris and Jean de Tournes in Lyons – whose designs, though highly decorative, were characterized by a graceful restraint and elegance.[225] During the eighteenth century the title-page was often accompanied by a frontispiece, commonly a woodcut or more often an engraving, facing the title-page.[226] Arguably, this development might be described as an appropriation of the practice of medieval scribes, illuminators and miniaturists who similarly sought to emphasize the beginning of the book. In many books throughout the sixteenth and seventeenth centuries, the roles of title-pages and frontispieces often overlapped.[227] This development was undoubtedly responsible for some confusion and the use of the terms interchangeably; however, while the frontispiece was graphic art, the title-page was properly textual and bibliographical.

Books of Pestilence

England's prototypographer, William Caxton, did not use title-pages, but his assistant and heir, Wynkyn de Worde, began to use them upon Caxton's death in 1491. An early example of a label-title in three lines, standing alone in the middle of the recto of the first leaf, is found in Wynkyn de Worde's *The Chastysing of goddes Chyldern*, printed in about 1492–93.[228] However, the very first title-page in England appeared in a popular plague tractate, *Treatise on the Pestilence*, printed by William de Machlinia in London in about 1483.[229] De Machlinia was perhaps a native of the Low Countries who had formerly partnered with John Lettou, the City of London's first printer, with whom he printed only law books. Aftershocks of the fourteenth-century bubonic plague continued to reverberate throughout Europe until the mid-seventeenth century, visiting London several times between 1349 and 1485, including

49 Ratdolt, Löslein and Maler's first decorative title-page for Regiomontanus's *Kalendarium*, printed in Venice, 1476.

50 (below) Frontispiece and
title-page for Anthony Weldon's
A Cat May look upon a King, 'Printed
for William Roybould, at the Unicorn
in Pauls Church-yard' in 1652.

51 (opposite) Elaborate title-page
from Andreas Vesalius, *De humani
corporis fabrica*, printed in Basel
in 1543.

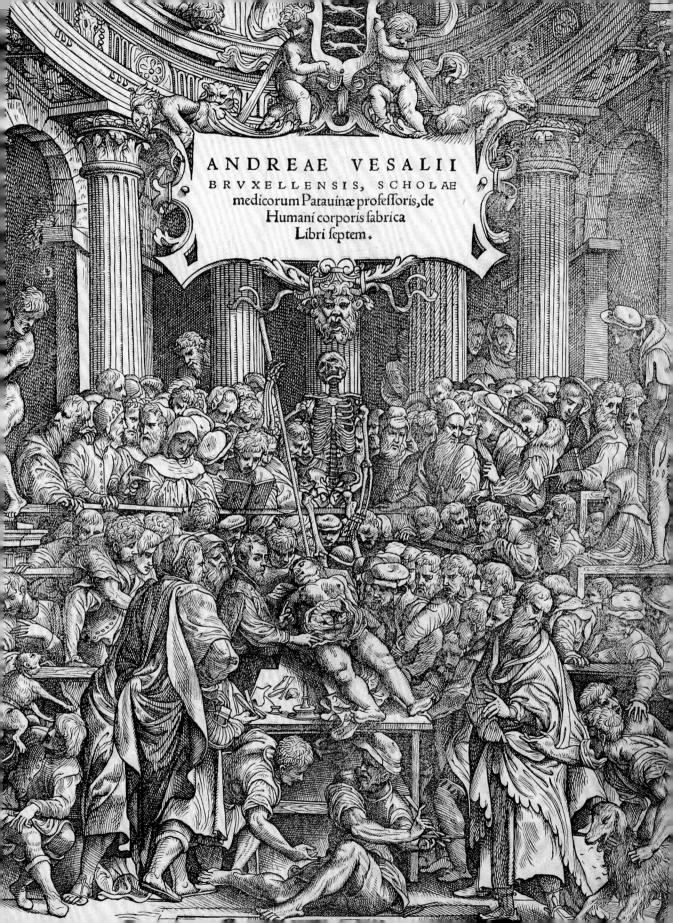

ANDREAE VESALII
BRVXELLENSIS, SCHOLAE
medicorum Patauinæ professoris, de
Humani corporis fabrica
Libri septem.

52 The pared-down typographic
title-page for Virgil's *Bucolica,
Georgica et Aeneis*, printed by
John Baskerville in 1757.

an outbreak in 1479 – outbreaks that doubtlessly prompted de
Machlinia's editions.

In time, the title-page came to include other pieces of biographical
information, including the names of translators and editors. Johann
Amerbach, the celebrated Swiss printer who, incidentally, was responsible
for introducing roman type to Basel in 1486, died on Christmas Day
1513.[230] He had been working on editions of Saint Jerome. Upon his
death, the work of editing was taken up by Erasmus, with the printing
left to his intimate friend, Froben, the famed Basel printer, with the
assistance of Amerbach's three sons. Erasmus's name features promi-
nently on the title-pages, and undoubtedly he had earned it – once
complete, the Jerome edition ran to nine volumes.[231] Erasmus claims in
his quintessential *jeu d'esprit*, 'it cost Jerome less to write his works than
it has me to restore them', remarking elsewhere, 'I have borne in this
such a burden of toil that one could almost say I had killed myself in my
efforts to give Jerome a new lease of life', sentiments not uncommonly
echoed by editors the world over.[232]

By the time books were more regularly sold ready-bound, the
title-page was already commonplace. It appears in almost all books
published today, both paper and digital. Although the origins of the
title-page appear to be somewhat accidental, its survival through the
subsequent 500 years and universal adoption undoubtedly attests to
its utility. In my library I have a number of cloth-bound books from the
late nineteenth century. The titles on their cloth covers have long since
worn away, but their title-pages remain pristine and eloquent. Moreover,
prior to book-cover illustration, a very late innovation, the title-page was
one of the few elements of the book that typographers could really make
their own, and thus the title-page, its history and development has come
to be an accurate index of typographic trends.[233] And whether a lavishly
illustrated sixteenth-century design from Paris, Antwerp or Basel, or
a sparse typographic arrangement (fig. 52) favoured by the likes of
Baskerville and Bodoni in the eighteenth century, the title-page serves
as an invitation to one of humankind's most magnificent achievements,
the typographic book.[234]

PUBLII VIRGILII

MARONIS

BUCOLICA,

GEORGICA,

ET

AENEIS.

BIRMINGHAMIAE:

Typis JOHANNIS BASKERVILLE.

MDCCLVII.

Printed Polyphony

The First Printed Music

10

So it is that without music, no other discipline can be
perfected, for nothing is without music. Indeed, it is
said that the universe itself is composed from a certain
harmony of sounds, and that the very heavens turn to
the modulations of harmony.

ISIDORE OF SEVILLE[235]

TO THIS DAY, IT IS NOT FULLY UNDERSTOOD why music is
such a primal and powerful elicitor of subjective emotion, and yet its
influence on individuals and on popular culture alike is profound and
indubitable. Just as alphabets and writing systems evolved in response
to our desire to record spoken language, so too, musical notation was
invented to solve the challenge of recording what is otherwise ephemeral,
a dilemma summed up in the seventh century by scholar, saint and music
theorist, Isidore of Seville, who wrote that, 'unless sounds are held by the
memory of man, they perish, because they cannot be written down.'[236]
Examples of rudimentary music notation have been found in cuneiform
tablets dating to about 2,000 BCE. The ancient Greeks had devised a
complex system of music notation that was subsequently lost; however,
the ideas of the Greek music theorists were not and were thence transmitted
to the Middle Ages through the writings of Boethius (*c.* 480–524), whose
De Institutione Musica ('The Principles of Music') was based largely on
the first-century work of Nicomachus of Gerasa and Ptolemy.

Prior to the advent of musical notation, music was learned by ear
and performed from memory. At least from the beginning of the Middle
Ages the prayers of the daily Catholic Mass were sung as monophonic
chants or plainchant. Music was the medium in which prayers ascended
to God.[237] The roots of modern musical notation can, to some measure,
be traced back to the medieval Church's efforts at ecclesiastical unity,
to its desire for geographically disparate congregations to, quite literally,
sing from the same hymnbook. During the ninth century, a rudimentary
form of notation began to appear, a kind of shorthand mnemonic aid used
to notate plainchant melodies with symbols known as neumes. Neumes

53 Middle to late fourteenth-century
manuscript antiphonal from Pisa.
The antiphonal was the principal
medieval choir book, and contained
the chants of the Office. The title is
derived from the way the verses of
the service were sung alternately
by the two halves of the choir sitting
opposite one another.

likely originated in the accentuation signs of Greek and Roman literature. Just as the grammarians' *acutus* (´) and *gravis* (`) indicated the respective raising and lowering of the voice, these and their combinations, with additions, were adopted into the system of Gregorian neume notation.[238] The early neumes appeared above the text of the chant. Neumatic or plainchant notation was superseded by stave (or staff) notation, a development usually attributed to the Italian Benedictine monk, Guido d'Arezzo, who, at the very beginning of the eleventh century, introduced a stave of four lines and five spaces, which was regarded as sufficient for the *ambitus*, or range, of the average Gregorian melody.[239] By the late twelfth century most neumatic notation had evolved into square notation on a stave. From the late thirteenth century mensural notation, used for vocal polyphonic music, evolved to meet the challenge of recording complex rhythms that the existing neumatic notation could not do. An early form of mensural notation is described by Franco of Cologne in his *Ars cantus mensurabilis* ('The Art of Measured Chant'). By the fifteenth century, musical notation had developed from those early medieval, rudimentary neumes to an elaborate and comprehensive system of notation that included white and black mensural notation, keyboard and lute tablatures, and Gothic, roman and Ambrosian plainchant notation.[240]

Typographical Music

The printing of music presented a special challenge. Musical notation comprises two principal and overlapping components, the horizontal staves and the perpendicular notes. It was their superimposition that proved the greatest typographic challenge. The most obvious solution was to print the separate components in different runs through the press. Moreover, as there was no desire to break with the colour coding of the manuscript tradition – traditionally, black notes on red staves – then multiple impressions were a natural solution. Some of the earliest printed books simply left space for musical notation to be added in by hand, in much the same way that spaces were left for the addition of manuscript capitals and illuminated initials. Such was the case for Johann Fust and Peter Schoeffer's Mainz Psalter of 1457 (fig. 54), where space was left for the later addition of staves and notes in manuscript. A gradual printed in Southern Germany and surviving in a single copy at the

British Library is perhaps the earliest example of music printing of any kind and, although undated, is tentatively assigned to *c.* 1473. The gradual, in contrast to the missal, was used only by the choir and contains just the musical portions of the Mass. The missal was the most important liturgical book for the celebration of the Mass, and copies of it make up the largest proportion of extant music incunabula.[241] The music is printed in Gothic notation with movable type, in two impressions. The earliest dated book to contain printed music is an edition of *Collectorium super Magnificat* of 1473.[242] However, it contains just five printed notes and no stave, and is described by music historian Alec Hyatt King as 'little more than a curiosity, devoid of significance as music'.[243]

54 *Psalterium Benedictinum* or Mainz Psalter printed by Fust and Schoeffer in 1459 (second edition). Music notation and stave added in by hand.

The first significant music printing and the first dated book to contain both printed music staves and notes from movable type, as well as the first printed roman plainchant, is Ulrich Han's *Missale Romanum*, published in Rome in 1476 (fig. 55).[244] Han had published an earlier, virtually identical, edition in the spring of 1475,[245] in which he had left blank pages for the later addition of music by hand. Mary Kay Duggan suggests that Ulrich Han's '1475 edition of the missal was carefully designed to include the music that did not appear in print until the second edition, eighteen months later.' Moreover, it was not the demands of multiple impressions that had dissuaded Han from printing music in his 1475 missal, for, although leaving space for music to be added in manuscript, it was printed in two impressions: red for rubrics and initials, black for text.[246] Han's 1476 folio missal includes thirty-three pages of roman plainchant, and is the only book of printed music he ever published.[247] The printing of music is explicitly mentioned in Han's colophon: '…printed at Rome. Together with music: which had never been done before.'[248] Although the text is set in Han's Gothic Rotunda

type, the music is not set in Gothic but roman square notation – by no means a departure from convention, but a continuation of scribal tradition for such liturgical books produced south of the Alps.

Within just six months, a *Graduale Romanum* was printed by the brothers Damianus and Bernardus de Moyllis in Parma, with 212 pages of music, compared to Han's thirty-three pages.[249] Within just a quarter of a decade of Han's first experiment in music printing, some sixty-six different printers working in twenty-five different towns and cities had created liturgical works containing music using the double-impression technique.[250]

Ottaviano de Petrucci

Printing of any kind required a considerable capital investment, with relatively slow returns. During the fifteenth and sixteenth centuries numerous privileges were granted to printers. The first such privilege, a monopoly on all printing in Venice, was granted to Johannes da Spira in 1469. Many early privileges, in addition to conferring monopolistic protections, also sought to protect technological inventions and novelties. Privileges were crucially important to the early growth and development of music printing.[251] One such privilege was sought by Ottaviano de Petrucci (1466–1539) in Venice who, in 1498, obtained a twenty-year monopoly privilege for the printing of music in the Venetian Republic. Petrucci again petitioned the Venetian Senate in June 1514 to extend his monopoly privilege, claiming that the war with the League of Cambrai (1508–16) instigated by generous patron of the arts and bellicose 'Warrior Pope', Julius II, had made it all but impossible to take advantage of the initial twenty-year privilege granted in 1498, and that he had been unable to recoup his significant initial capital investment. He was granted a five-year extension.[252] He obtained this impressive privilege as 'he had with great labour and expense executed what many before him, in Italy and elsewhere, had long attempted in vain.'[253] Within three years of being granted the privilege, Petrucci printed the first polyphony in metal type, an anthology of secular songs or chansons, *Harmonice Musices Odhecaton* ('One Hundred Songs') in the spring of 1501 – a book that would prove remarkably influential on the canon of Renaissance music.[254] Petrucci had not invented a new method; in fact, he employed the multiple-impression method that Ulrich Han and the anonymous printer of the *c.* 1473 missal had used more than two decades before. But the

Antiffanarium per circulum anni.
Dominica prima in aduentu domini
Ad vesperas Responsorium.

Ecce dies ve ni et di cit domin⁹

z suscitabo dauid germe

iustum z regna bit rex z sa piens erit z fa ci et

iudicium z iusti ci am in ter ra. Et

hoc est nomen qd vo cabut e u do mi nus

iu stus no ster. V. In dieb⁹ illis saluabit

iu da z israhel habitabit ofiden ter. Et hoc

Gloria patri z fili o z spiri . tui

elegance of Petrucci's *mise en page*, his small, crisp music types and the precision of superimposition was, for a time, without equal. In addition to the Venetian privilege, the recently elected Pope Leo X, profligate patron of the arts, granted Petrucci a fifteen-year monopoly privilege for the printing of music. In 1513, the pope's secretary, Pietro Bembo (of Aldine fame), noted the severe penalties for those choosing to contravene the papal privilege – including the threat of excommunication![255]

Yet even while Petrucci was printing music from movable types with three impressions – once each for staves, music and words – the Italian engraver Andrea Antico, in Rome then in Venice, was still printing music from woodcuts, though he carved trenches for the insertion of metal type so that both could be printed in a single impression. Others experimented with printing music from engraved metal plates.[256] While music printing required multiple impressions, books of music continued to be relatively expensive.

The next watershed in music printing was the invention of the single-impression process, pioneered by John Rastell in London from 1519, although it would be almost two decades before the single-impression method was fully developed and popularized by the Parisian music printer, Pierre Attaingnant.[257] Attaingnant appeared to be the first to realize its full potential, with the publication in 1528 of *Chansons nouvelles en musique à quatre parties* ('New Songs in Four Parts'). In 1537 he became *imprimeur du roi*, benefitting significantly from royal privileges granted by the French king, Francis I. Attaingnant was a prolific printer, focusing almost exclusively on music, and he published as many as fourteen editions a year. His single-impression method of printing music from movable type quickly spread from Paris to Lyons – where it was taken up by the likes of the Italian-born Jacques Moderne – and to Germany and the Low Countries. Within a decade of Attaingnant, the single-impression method had been universally adopted.[258]

By 1538 it had reached Venice where, for the next thirty years, music publishing would be dominated by the two dynastic family firms of Scotto and Gardano, whose combined output was, astoundingly, greater than the sum total output of all other European music printers.[259] The founder of the Scotto publishing dynasty, Ottaviano Scotto (Octavianus Scotus), was the first Italian to print music from movable type. Prior to printing music, he had produced predominantly academic texts, with his most sizeable market in the university town of Padua. His first book to contain

56 Antiphonal printed by Erhard Ratdolt, 23 February 1495. This edition is for the use of Augsburg, and is a fine example of early music printing, showing Gothic neumes printed on a four-line red stave.

PARTHENIA

or

THE MAYDENHEAD

of the first musicke that
euer was printed for the VIRGINALLS.

COMPOSED

By theee famous Masters: William Byrd, D: John Bull, & Orlando Gibbons,
Gentilmen of his Ma:ties most Illustrious Chappell.
Dedicated to all the Masters and Louers of Musick.

Ingrauen
by William Hole.
for

Dorethie Euans.

Cum
Priuilegio.

Printed at London by G: Lowe and are to be soulde
at his howse in Loathberry.

57 Title-page from the first
engraved keyboard music in England:
*Parthenia, or The maydenhead
of the first musicke that ever was
printed for the virginalls*, 1613.

printed music was a folio *Missale Romanum* of 1482 printed with
the double-impression technique, whereby staves were printed first
in red, followed by a second impression of the notes and text in black
ink.[260] A year before he had printed another *Missale Romanum* in
quarto[261] but had left spaces for the inclusion of music by hand.
Venice's pre-eminence in music publishing was maintained throughout
most of the sixteenth century.

The sixteenth century witnessed what Andrew Pettegree describes
as the 'domestication of music',[262] pioneered by music-printing and
publishing luminaries such as Ottaviano de Petrucci in Venice, Pierre
Attaingnant in Paris and Pierre Haultin in Paris and La Rochelle – their
work fostered the growth of musical literacy and spawned a new aspect
of European cultural life that would later pave the way for the likes of
Handel, Bach, Mozart and Chopin. (Petrucci's lute books contained
instruction for those unfamiliar with music notation, demonstrating
a new awareness of a market embracing the amateur musician.) The
history of music printing is woven into the cultural history of music
and our desire to make tangible and permanent that which is otherwise
impalpable and ephemeral, like the 'supremely lovely music of the
wheeling stars'.[263]

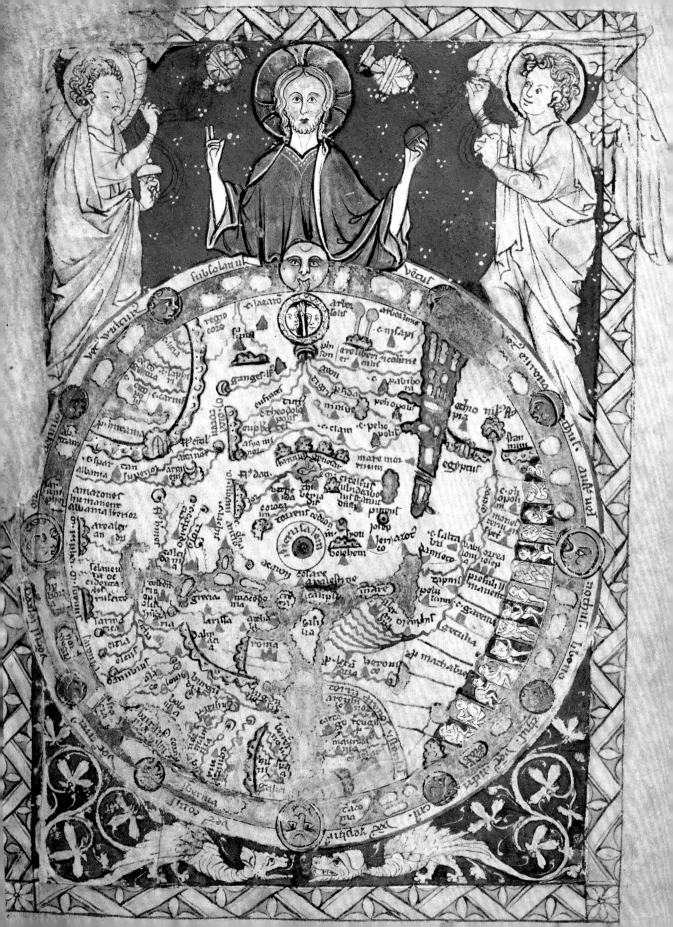

Atlas Printed

The First Maps

> 'Tis a wooded isle, and therein dwells a goddess,
> daughter of Atlas of baneful mind, who knows the
> depths of every sea, and himself holds the tall pillars
> which keep earth and heaven apart.
>
> HOMER[264]

11

TO THE ANCIENT BABYLONIANS, the earth was a flat disc circumscribed by a great briny sea, with distant regions marked as 'a place that winged birds cannot reach' or where 'the sun is hidden and nothing can be seen'. Mythical beasts and heroes surrounded this ancient Mesopotamian world. Similarly, to Homer, the earth, as portrayed on the legendary shield of Achilles, was a disc surrounded by ocean, its centre marked by Delphi. In the fifth century BCE, Homer mocks contemporary portrayals of the earth, perhaps Anaximander's, when he writes, 'I laugh when I see so many men drawing maps of Earth, as none till now have drawn reasonably.'[265] By the fourth century BCE, a spherical earth, supported by Aristotle's proofs, was the consensus among Greek scholars. Nevertheless, from antiquity through to the early Renaissance, maps were anything but commonplace and ancient and medieval cartographers alike were seldom concerned with wayfinding and geographic precision. The medieval mapmaker wished to portray the grandeur of God's creation and 'the significant events in Christian history'.[266] In the Far East, maps were printed at least as early as the twelfth century.[267] In the late fifteenth century, the proliferation of maps throughout Europe was precipitated by the coincident dawn of printing and the Age of Exploration.

Prima Orbis Terrarum

In the West, the first extant printed map is a 'T and O', or T-O, world map (*orbis terrarum*, 'circle of the lands', where the T is inside the O), a schematic design that existed from at least the first half of the seventh century when Isidore of Seville (*c.* 560–636) described it in his popular medieval text *Etymologiae* ('Origins'). The earth is described as a circle

58 Psalter World Map. Westminster, *c.* 1265. This is probably a copy of the lost map which adorned King Henry III's bedchamber in Westminster Palace from the mid-1230s.

with three known continents, Asia, Europe and Africa, centred on Jerusalem and delineated by a T, its stem representing the Mediterranean separating Africa and Europe; its crossbar, the Nile, separating Africa and Asia, and the Tanais (or river Don) dividing Europe and Asia (fig. 60, lower right). The three continents are populated by descendants of Noah's three sons, Sem (Shem), Iafeth (Japheth) and Cham (Ham), and in accordance with medieval practice, east, the direction of the rising sun and of the Biblical Garden of Eden, is placed at the top of the map; the Pillars of Hercules are at the bottom. It is a geographical fusion of cartography, ancient Graeco-Roman mythology, Old Testament theology and New Testament eschatology. Although the world of the T-O map is circular, it does not represent a flat disk, but is a projection of earth's upper hemisphere; the lower hemisphere was thought to be, if not uninhabitable and covered entirely by ocean, then made inaccessible by an impassable equatorial torrid zone.[268] It is Isidore's T-O map that appears as a small woodcut in a 1472 edition of *Etymologiae*, printed by Günther Zainer in Augsburg, Germany, and thus lays claim to being the West's first extant printed map of the world (a map made from a woodcut print in China in 1155 pre-dates it).[269]

fore uitales. ¶Ipfa igitur quatuor flumina ab eodem paradifi fonte:ut noftri affirmant
Theologi omnes eueniunt : & feparantur : Et iterum quædam inter fe comifcentur
atcȝ iterȝ feparant:fæpe etiam abforbentur:& locis rurfus i plurimis emergūt.Inde eſt
cȝ de eoȝ ortu uaria leguntur.Quia gangem dicit Plinius in locis caucafi montis nafci.
Nilum uero procul ab Atlante monte:& Euphratem in armenia.

Paradiſi ſex — ¶Paradifos autė terreftres fex fuiffe inuenimus fcriptū. Vnum uidelicet in occidente
uerfus Zephirum. Alterum in equinoctiali :inter Eurum & Euronothū. Tertium:de
quo Beda meminit:inter cancri Tropicū & circulum Antarcticū. Quartū paradifū ad
orietė uerfus Eurum ultra Eqnoctialė:i quo folis arbores funt.Quintus terreftris pa-
radifus ad polum arcticū eė dicit:de quo Solinus meminit.Inuenit ėt in occidéte alius
uoluptatis & delitiaȝ paradifus : de quo fic habemus : cȝ fenatus:populufcȝ Romanus
mandauit:fummū facroȝ pontifice:nō nifi de Italiæ horto delitiaȝ eligi debere.De pa-
radifo itacȝ terreſti multa a theologis in fecūdo fniacȝ di.xix.tractaṅ. Ex ipfo quippe
loco dn̄s poſtcȝ parétes nr̄os eiecifset:comfeftim eius aditū portis firmifsimis occlufit:
ac ruphea flamæam:atcȝ uertiginé præfidétiū cherubin obfirmauit:quæ ufcȝ ad chri-
fti domini noftri pafsionem obferatæ ftetere: Verū eius fanguis eafdé penitus extinxit:
& effregit ¶Terræ uniuerfæ diftinctio.

¶Orbis terraȝ uniuerfus i ꝗnque diftiguit ptes:quas Zonas uocat:Media folis torret
flammis.Vltias aūt cōtinuū ifeftat gelu.Quæ funt hitabiles:quæ iter exuſtam & rigen
tes funt. Altera a quibus incolatur nullis unꝗ licuit aut licebit agnofcere. Interiecta
autem torrida utricȝ hoium generi cōmertiū ad fe comeādi oīno denegat.Sola ergo fu-
perior icoliſ:uidelicet iter Septétrioné:& Eqnoctialė circulū:uel ut alii uoluerūt : iter
Tropicū æftiuū:& circulū arcticū:ab oī quale fcire pofsum⁹ hoium genere femotum
Hæc ergo ab ortu porrecta:ad occafum longior eſt:ꝗ ubi latifsima . Quo palā fit:qua-
rū hic uapor abftulerit:illic rigor addiderit.Eā igiſ i tres ptes maiores noftri diuifère
Afiam:uidelicet & Aphricam & Europam . Afia a meridie,per orienté ufcȝ ad feptétrio-
né ꝑtédiſ . Europa a feptétrione ufcȝ in occidentem:Et Aphrica ab occidente ufcȝ ad
meridié mediterraeo mari ab Europa difiuncta :Afyæ termini;a meridie Nilus;a feptè-
trione tanais.De quibus latius infra diferemus.

The First Atlas

We move from Günther Zainer's woodcut T-O map to the conical-projection Ptolemaic maps, reconstructed from some of the 8,000 latitude and longitude coordinates recorded in the gazette of Ptolemy's *Geographia* (*c.* 150 CE). For centuries the *Geographia* was all but lost until its translation into Latin in the fourteenth century.[270] Ptolemy's maps first appear in print in 1477, with an edition of his *Geographia* published in Bologna.[271] This was the second edition of Ptolemy's atlas and treatise on cartography, but was the first to be printed with maps and is therefore the first printed atlas. Its importance is even more significant in that its printed maps are not woodcuts, but copper engravings. The following year, in Rome, the *Geographia* was printed by Arnoldus Buckinck.[272] This edition of Ptolemy's atlas is of particular interest as it reintroduces one of Italy's prototypographers, Konrad Sweynheym, who had printed in Subiaco and Rome in partnership with Arnold Pannartz (see p. 40). After printing an edition of Pliny's *Natural History* in May of 1473, they parted company.[273] Pannartz continued to print alone, while Sweynheym set to work on copper-engraved maps for an edition of Ptolemy's *Geographia*. Unfortunately, he died in 1477, shortly before their completion. The atlas comprises twenty-seven maps in total: one world map, ten maps of Europe, four of Africa and twelve of Asia.

The *Nuremberg Chronicle*

In addition to its renown as a centre for art, commerce and precision astronomical instruments (a factor that induced the famed mathematician, astronomer and printer Regiomontanus to settle in the city), Nuremberg became one of the most important centres of mapmaking during the German Renaissance. One of the most familiar incunable world maps is printed in Hartmann Schedel's *Liber chronicarum,* more commonly known after its city of publication, as the *Nuremberg Chronicle.*[274] It is, after Gutenberg's Forty-two-line Bible, arguably the most famous of all incunabula, and for good reason. Not only are there more extant copies of the *Nuremberg Chronicle* than any other incunable, but it is also one of the most typographically sophisticated and lavishly illustrated books of its time, containing more than 1,800 woodcut illustrations, though only 640 woodblocks were used, so many scenes, cityscapes and portraits are repeated: for example, the same woodcut is used to illustrate the cities of Mainz, Naples, Aquila, Bologna and Lyons.[275] The Ptolemaic world

map appears early in the book's second section, *Secunda etas mundi*, recounting the biblical narrative from the Great Flood in Noah's day to the fire and brimstone of Sodom, Gomorrah, Admah and Zeboim. The woodcut map is surrounded by depictions of the twelve winds as twelve curly-haired heads – precursors to the modern compass rose. Appearing again are Noah's three sons, supporting three corners of the map, with the fourth, the bottom left, bearing a caption describing the nature of the twelve winds (fig. 61). The seven unusual characters in the left margin have nothing to do with the map, but are simply a continuation of the previous page with Pliny's narrative of monstrous races – 'in Sicily some people have ears so large that they cover the whole body' and 'In Ethiopia, toward the west, some have four eyes.' It is this relatively seamless flow and integration of text and image that is undoubtedly the *Nuremberg Chronicle*'s most impressive typographic feature. Nuremberg printer-publisher Anton Koberger, who had already been printing in the city for two decades, printed Schedel's *Nuremberg Chronicle* in Latin

61 Ptolemaic world map from Hartmann Schedel's *Nuremberg Chronicle*, 1493. Printed at Nuremberg by Anton Koberger.

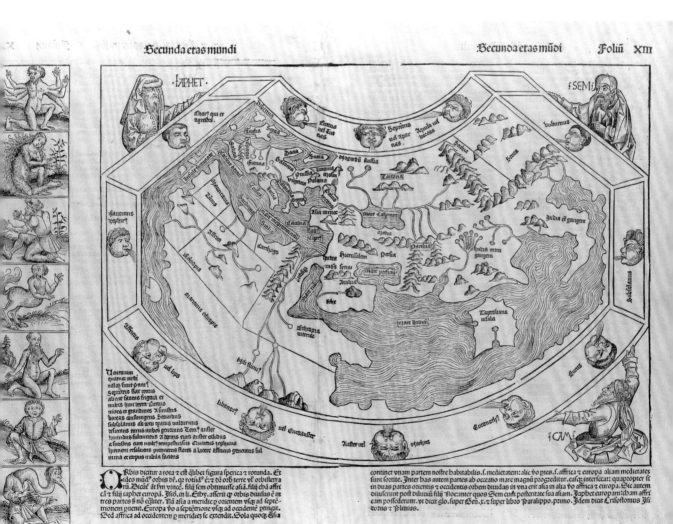

in July 1493,[276] with a German edition following in December.[277] The illustrations are the work of Michael Wolgemut and Wilhelm Pleydenwurff, with some contending that the young Albrecht Dürer, who had been apprenticed to Wolgemut, was also involved in their production at a very early stage.

Post Incunabula

The Age of Exploration began in the last decades of the fifteenth century with the voyages of Vasco da Gama and other Portuguese explorers, the trans-Atlantic voyages of Christopher Columbus between 1492 and 1502, and the first circumnavigation of the globe, a three-year voyage begun in 1519 by Ferdinand Magellan and completed by Juan Sebastián Elcano on 6 September 1522. The world had changed and the Ptolemaic map was all but obsolete.[278] Of about 30,000 incunable editions, only fifty-six included maps.[279] However, the subsequent century witnessed an explosion in their production and use. One of the early sixteenth century's most remarkable maps – intended for display on a wall, not to be bound in a book – was drafted by German cartographer Martin Waldseemüller. This remarkable world map of 1507 comprised twelve woodcut prints, so that when assembled it measured 1.2 by 2.4 metres. It was the first map to recognize the Pacific Ocean as a separate body of water and the first to document the Americas as a distinct and separate landmass or continent. The map included data gathered by the Florentine explorer Amerigo Vespucci during his voyages of 1501–2 and Waldseemüller named the new lands in his honour; the map has been referred to in some quarters as 'America's birth certificate'. In 1538, Gerardus Mercator, in his first world map, *Orbis Imago*, chose to mark both the northern and southern continents, 'America'. Of a purported 1,000 copies, only one copy of Waldseemüller's *Universalis Cosmographia* has survived.[280] The Library of Congress purchased it in 2003 for $10 million.[281]

After Ptolemy of Alexandria, Gerardus Mercator of Flanders is undoubtedly one of the most influential figures in mapmaking history. His eponymous Mercator projection system, first published in 1569, is an interpretation of the world map that is perhaps the most universally familiar: the cylindrical projection is especially useful to navigators as it preserves angles, permitting accurate measurements and allowing

navigators to plot straight-line courses; however, it increasingly distorts landmasses the farther one moves from the equator. Mercator was also the first to call his book of maps an 'atlas' and in 1540 he wrote a typographic manual, *Literarum latinarum*, which advocated the use of italic lettering on maps. Interestingly, Mercator named his book in honour of King Atlas of Mauretania, rather than the Titan Atlas of Greek mythology. However, in editions from the 1630s, the king is replaced by the Titan.

First Printed Tour Guides

Throughout the Middle Ages, pilgrimages to holy sites and relics – to do penance, to win indulgences or in pursuit of spiritual enlightenment – were common among the Christian faithful. Doubtless, many used the pilgrimage as a pretence to satisfy their curiosity and medieval wander-lust in what was otherwise an intensely parochial existence. Pilgrims might have visited one of the many towns that hosted religious relics of local saints and martyrs but a pilgrim's ultimate destination was the biblical Holy Land. For practical reasons, including their safety on such an arduous and hazardous journey, pilgrims frequently chose to travel in groups, often gaining members along the way. In 1483, Bernhard von Breydenbach, Dean of Mainz, set off on such a pilgrimage, accompanied by a large group, including quite a number of knights and barons.[282] Among their number was the Utrecht artist Erhard Reuwich, whom Breydenbach had invited to record their journey. In February 1486 Reuwich published *Peregrinatio in terram sanctam* ('A Pilgrimage to the Holy Land') in Mainz.[283] This was a very early precursor of the guide books popularized in the nineteenth century by the likes of John Murray in England and Karl Baedeker in Germany. Erhard Reuwich's edition is illustrated with fourteen woodcuts, seven of which are foldouts of topographical maps or panoramas of six Mediterranean towns – yet another typographic first. The Bodleian Library copy reproduced here (fig. 64) is hand-coloured in red, blue, green and yellow. The text of the first Mainz edition is set in an especially fine *lettre bâtarde* type from the workshop of Peter Shoeffer. Its translation into German, Dutch, French and Spanish in the fifteenth century alone, and a significant number of surviving copies, is testament to its popularity.

62 (overleaf) Map of Iceland drawn by Gerardus Mercator, 1606.

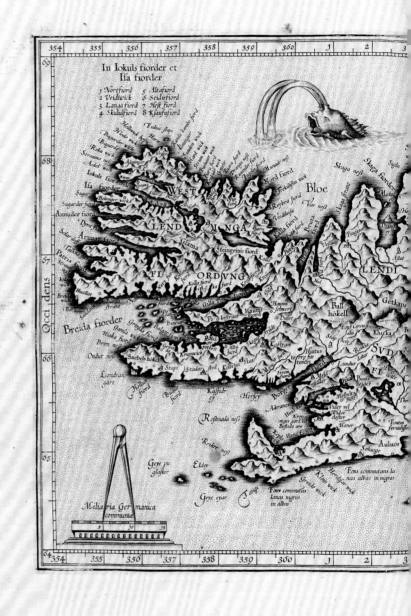

In Iokuls fiorder et
Iſa fiorder

1 Nortfiord 5 Altafiord
2 Veidwick 6 Seidisfiord
3 Lanaa fiord 7 Aleſt fiord
4 Skulisfiord 8 Ksauſusfiord

Occidens

WEST
LEND
ORDVNG
FI
Breida fiorder

Bloe
NGA
Glama
Steingrimis fiord

Nord fiord
Var neß
Skaga neß

LENDI
Ball
hokell
SVD
FI

Rostnala neß
Fons commutans la-
nas albas in nigras

Geye ju
glaſker Elley

Geye eyar Fons commutas
lanas nigras
in albas

Miliaria Germanica
communia
5 10 15

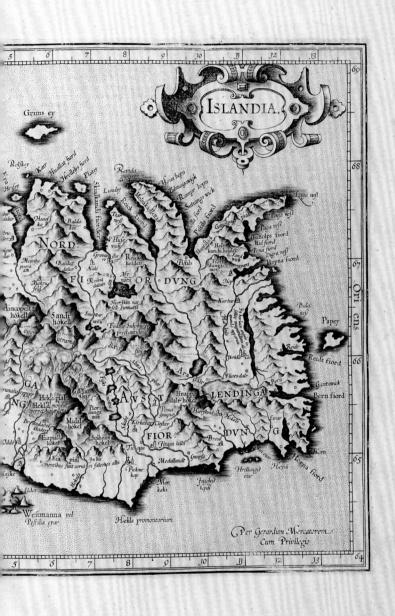

ISLANDIA.

Grims ey

Relfkey

Nord

FI OR DVNG

Ori ens

Papey

GA NG

AWSAT LENDINGA Bern fiord

FIOR DVN G

Westmanna vel Peftilla eyar

Hekla promontorium

Per Gerardum Mercatorem
Cum Privilegio

63 (left) and 64 (below) Bernhard von Breydenbach's *Peregrinatio in terram sanctam* (Mainz: Erhard Reuwich, 11 February, 1486) is perhaps the earliest printed tourist guide.

Goody Two-Shoes and the Fabulist

The First Children's Books

To manage books, and things, and make them act
On infant minds as surely as the sun
Deals with a flower.

WILLIAM WORDSWORTH[284]

PARENTS WELL UNDERSTAND that books are a crucial part of their children's intellectual and social development. They also know that children's books are likely to have relatively short shelf lives. Torn or missing pages, chewed corners and crazed crayoning conspire towards the book's inevitable decline and eventual annihilation. In this respect, fifteenth-century children were no different, and so it is no surprise that most of the very earliest printed children's books, despite being printed in large numbers, have not survived. Of those that have, many bear the hallmarks of accelerated, child-wrought wear and tear.

During the Middle Ages children were seldom exposed to books. Of course, prior to the introduction of printing in the mid-fifteenth century, all books were handwritten. Those manuscript books were unique and expensive – not the kind of item one would typically have placed in the hands of a child. The mere thought of a five-year-old with an illuminated manuscript is likely to bring palaeographers and bibliophiles to tears. There were rare exceptions, manuscripts produced for the children of patrician parents, or the writings of a tutor or parent, later bound, but used more as a teacher's textbook.[285] But until the eighteenth century, and the publishing programmes of educators such as John Newbery (1713–67), the children's books genre simply did not exist. Until then, most books read by children were didactic works: Latin grammars, spelling books and guides to etiquette. One of the fifteenth-century's most popular schoolbooks, Donatus's *Ars minor*, a beginner's guide to Latin grammar that was studied once students had mastered the alphabet and some simple prayers, was required reading for all fifteenth-century

65 Hand-coloured woodcut illustration from Heinrich Knoblochtzer's edition of *Aesop's Fables, c.* 1481, depicting Aesop surrounded by elements of his fables.

schoolboys and was printed in hundreds of editions prior to 1501 – again, most of them have perished, having been used to destruction, or survive only in fragments.[286]

For both entertainment and instruction a child might turn to Aesop's *Fables*, which were among the earliest printed books published in vernacular languages (fig. 65). Johann Zainer, who introduced printing to Ulm in south-west Germany, published a bilingual, illustrated edition of Aesop in Latin and German in about 1476.[287] However, such books, published in large and relatively expensive folio editions, were aimed ostensibly at adult readers, who might on occasion read them aloud to children. The fables themselves, especially from the Renaissance onwards, were seen as valuable education – for who could fail to learn the lesson of 'The Dog and the Bone' or the 'The Wolf and the Crane'. Later, John Locke would recommend illustrated editions of Aesop as 'stories apt to delight and entertain a child … yet afford useful reflections to a grown man'.[288] Locke also recommended *Reynard the Fox*, a collection of medieval satirical tales and allegories, a book explicitly aimed at younger readers, first printed by William Caxton in England. Caxton, the first to print on English soil, also published an English edition of Aesop's *Fables* in 1484[289] and a pamphlet titled *The Book of Curtesey* around 1477;[290] the latter was a children's guide to manners or etiquette, covering everything from morning ablutions to prayer and the importance of reading. This popular book, which had first appeared in Latin in the twelfth century, was later reprinted twice by Caxton's former assistant and later successor, Wynkyn de Worde,[291] the most prolific early British printer. He was also responsible for printing one of the earliest illustrated Latin grammar books, *Lac puerorum* ('Milk for Children')[292] – an elementary text in English by the Tudor schoolmaster and grammarian John Holt – in London in 1505.[293]

Chapbooks, which first appeared in the sixteenth century, were cheap softcover booklets illustrated with woodcuts that often bore absolutely no relation to the text – almanacs, folk tales, ballads, poetry, chivalric romances, religious tracts and sermons and children's literature – often abridged and edited for the mass market and sold by street hawkers.[294] In the eighteenth century chapbooks specifically for children appeared; prior to that time, many chapbooks had been consumed by adults and children alike. William Tyndale's condemnation of children's chapbooks, claiming that Robin Hood and Bevis of Hampton, Hercules, Hector

Fabula·xiij·De aquila et vulpe·

Vm vulpes aquila૩ p₂o rapta p₂ole pūgit
Melle precū p₂eda૩ reddere nescit auis·
P₂eda gemit mōiq૩ cibus timet esse gulosi/
Sed redimit natos vtilis arte parens·
Arbo₂eū ૩onat stipulis et vimine truncum
Instipulam docto po₂rigit o₂e facem·
In pullos aquile consurgit copia fumi?
Hanc tamen vt vulpem p₂ouida placat auis·
Non igitur studeat quis maio₂ obesse mino₂i
Cum bene maio₂i possit obesse mino₂

Otentes metuere debere infimos? hec at
testatur fabula ¶ Vulpinos catulos aqui
la rapuit ac in nidum depo₂tauit /vt pul
lis suis escā darét /p₂osecuta vulpes aqui
lam rogabat / cattulos suos sibi reddi
aquila contēpsit vulpē /quasi iferio₂e૩·vul
pes plena dolo/ ab ara igne૩ rapuit/et ar
bo₂e૩ circumdedit collecta stipula Cunq૩
fumus et flamma perstrepérent? aquila dolo₂e pulsa nato₂um/
ne flammis simul perirét incolumes/vulpinos cattulos suplex
reddidit matri ¶ Docet hec fabula multos ne quis isultet infe
rio₂i ne ab aliqua flamma vindicte incendatur·

67 Palm woodcut from
John Holt's *Lac puerorum*,
an aid to remembering Latin
demonstrative pronouns.

and Troylus would 'corrupt the minds of youth withal', did nothing
to diminish their popularity.[295]

One of the greatest early landmarks in children's books is *Orbis
Sensualium Pictus* ('The Visible World in Pictures'), published in
Nuremberg in 1658 by the Czech social reformer, pedagogue and
advocate of universal literacy, John Comenius (1592–1670). Although
it is frequently referred to as the very first children's picture-book, it is
better described as one of the first illustrated books expressly dedicated
to the education of children.[296] In the following year, after its publication
in Latin and German, it was published in English, going on to become
one of the most popular textbooks in Europe, and remained so for two
centuries. With some 150 illustrations, *Orbis Sensualium Pictus* resembled
an illustrated dictionary or encyclopedia and covered everything from
animal sounds to the nature of the human soul and the Last Judgement.
In addition to its being among the first illustrated books for children,
early editions are of especial typographic interest, skilfully employing
blackletter, roman and italic types.[297]

The Father of Children's Publishing

Seventeenth-century books such as James Janeway's *A Token for
Children: being an exact account of the conversion, holy and exemplary lives,
and joyful deaths of several young children*, which recounted the lives and
untimely deaths of thirteen children, might appear rather macabre for
the younger reader, yet proved incredibly popular on both sides of the
Atlantic, going through numerous reprints, and was viewed at the time
as morally edifying. John Newbery in London published the pithily titled
*A Little Pretty Pocket-Book Intended for the Instruction and Amusement of
Little Master Tommy and Pretty Miss Polly* in 1744. For 2d extra it was sold
with either a small ball (for boys) or a pincushion (for girls), and ten pins;
the author explained that the ball, being red on one side and black on the
other, was to be used to tally good and bad actions respectively. If all ten
pins should populate the red side, then 'I will send you a *Penny*'; however,
'if ever all the *Pins* be found on the *Black Side* of the *Ball*, then I will send
a Rod, and you shall be whipt, as often as they are found there.'

The same year witnessed the publication of *Tommy Thumb's Pretty
Song Book*, the earliest surviving collection of nursery rhymes. Measuring
just over 7.5 centimetres tall, it included the still-familiar 'Bah, Bah,

a Black Sheep' and 'Hickere, Dickere, Dock', although the rhyme about bed-wetting, 'Piss a Bed', never found its way into later collections. The publication of these books reflects Locke's advocacy of education as entertainment or amusement. Newbery, considered the father of children's literature, was also the first to publish a children's periodical, *The Lilliputian Magazine*, and his hugely successful *The History of Little Goody Two-Shoes* (1765), which lays claim to being the first children's novel, and was a more prosaic, less glamorous take on the Cinderella story, with its poor and virtuous protagonist, Margery, 'having Shoes but half a Pair'. Newbery's books held further appeal to children with their brightly coloured floral-print bindings and small format, and measuring approximately 10–12 centimetres tall, they truly were children's pocket books.

Another important factor when considering the introduction of children's books is literacy rates. Although it is very difficult to determine exact rates for literacy among fifteenth-century children, we are able to extrapolate data from extant records. For example, in Florence in 1480, with a total population of about 42,000, approximately 28 per cent of boys aged between ten and thirteen attended formal schools, suggesting a literacy rate of around a third. Though during the Middle Ages and even the Renaissance, the consensus was that girls were not scholastically inclined and that their education should comprise only those subjects conducive to good housekeeping, there were again notable exceptions. Girls who received any formal education were those from wealthy families, taught by private tutors. Among the notable exceptions was Catharinetta, the daughter of a barber, who was the sole female student out of 500 listed in Genoese documents for 1498–1500. I wonder what became of her. Even in Venice during the High Renaissance girls fared little better, with approximate literacy rates of one-third and one-tenth for boys and girls, respectively.

Literacy Via Devotion

Among the very first printed books were psalters, collections of Psalms and prayers in Latin. Psalters originated in sixth-century Ireland and became popular in medieval Europe for learning to read. Of particular interest is an early example of a psalter designed specifically for children and published by the German printer Erhard Ratdolt while he was working in Venice. His *Psalterium puerorum* ('Children's Psalter') was

undoubtedly printed in the hundreds, yet just a single copy has survived in Munich.[298] We know of their early existence through this single surviving copy and reference to them in Venetian bookseller Francesco de Madiis's fifteenth-century sales ledger, or *Zornale*.[299]

Of all Ratdolt's books – and he published some 200 different titles during his long career – this primer is one of my favourites. It opens with an alphabet, including some alternative letterforms (i.e. *d*, *r* and *s*). The final three glyphs are the commonly used tachygraphic signs or abbreviations for the Latin word parts *con* and *rum*, and the character resembling a numeral *4* is a Tironian *et*, or ampersand. The alphabet is preceded by a cross that was known to English children as a 'criss-cross' (from Christ-cross), present to remind its readers to cross themselves before reciting the alphabet, and also commonly appearing in hornbooks (a hornbook was a wooden paddle with an alphabet and prayers attached to it).[300] Below the alphabet is the Latin text of the Pater Noster, or Lord's Prayer, which all children would be expected to memorize. The Gothic Rotunda typeface Ratdolt usually employed only for headings, owing to its large size, is here used for the text – a nice concession to the younger reader.[301] The beautiful vine-leaf border, printed in a magnificent red, first appeared in an edition of *Historia romana* ('Roman History'), printed by Bernhard Maler, Erhard Ratdolt and Peter Löslein in 1477.[302] The woodcut border is, unsurprisingly after a decade of use, showing signs of wear after thousands of impressions.

The most significant typographic concessions to young readers were larger type and smaller page sizes. Besides those attributes, and the later proliferation of illustrations, early children's books differed little from their elders' counterparts. Moreover, type choice, whether roman or Gothic, followed traditional geographic and genre norms throughout the fifteenth century. Of the more than 400 editions of Aelius Donatus's grammar, *Ars minor*, all but thirteen (all printed in the Italian Peninsula) employed Gothic types.[303] Not until the second quarter of the sixteenth century did this begin to change as roman types were more broadly adopted, even for those genres traditionally bound to Gothic scripts and types.

Such books were a far cry from contemporary children's books, yet they yield valuable insights into the culture, learning and literacy of Renaissance and Early Modern Europe. The first children's psalters served a dual purpose, teaching literacy via devotion. The earliest printed Latin grammars were contemporaneous with Gutenberg's

first books. Increasingly, children's books blended instruction with entertainment. Illustrated editions appeared at the very beginning of the sixteenth century, later joined by chapbooks hawked on the streets for a penny that appeared shortly thereafter. By the end of the eighteenth century these were advertised and marketed explicitly to children, flourishing in the subsequent century and helping to give rise to the proliferation of children's literature thereafter.

Aue maria
gra plena
dominus
tecu bene
dicta tu in mulierib'
et benedictus fruct'
uentris tui : ihesus
christus amen.

Gloria laudis resonet in ore
omniu Patri genitoqz proli
spiritui sancto pariter Resul
tet laude perhenni Labori
bus dei vendunt nobis om
nia bona. laus:honor: virtuf
potétia: 7 gratiaz actio tibi
christe. Amen.

Uiue deu sic 7 vines per secula cun/
cta. Prouidet 7 tribuit deus omnia
nobis. Proficit absque deo null9 in
orbe labor. Illa placet tell9 in qua
res parua beatu. Øe facit 7 tenues
luxuriantur opes.

Si fortuna volet fies de rhetore consul.
Si volet hec eadem fies de cosule rhetor.
Quicquid amor iussit no est cotédere tutu
Regnat et in dominos ius habet ille suos
Uita data é vtéda data é sine fenere nobis.
Mutua: nec certa persoluenda die.

Usus 7 ars docuit quod sapit omnis homo
Ars animos frangit 7 firmas dirimit vrbes
Arte cadunt turres arte leuatur onus
Artibus ingenijs quesita est gloria multis
Principijs obsta sero medicina paratur
Cum mala per longas conualuere moras
Sed propera nec te venturas differ in horas
Qui non est hodie cras minus aptus erit.

Non bene pro toto libertas venditur auro
Hoc celeste bonum preterit orbis opes
Precunctis animi est bonis veneranda libertas
Seruitus semper cunctis quoque despicienda
Summa petit liuor perflant altissima uenti
Summa petunt dextra fulmina missa iouis
In loca nonnunqu am siccis arentia glebis
Øe prope currenti flumine man at aqua

Quisquis ades scriptis qui mentem forsitan istis
Ut noscas adhibes proinus istud opus
Nosce: augustensis ratdolt germanus Erhardus
Litterulas istos ordine quasqz facit
Ipse quibus veneta libros impressit in vrbe
Multos 7 plures nunc premit atqz premet
Quique etiam varijs celestia signa figuris
Aurea qui primus nunc monumenta premit
Quin etiam manibus proprijs vbicunqz figuras
Est opus:incidens dedalus alter erit

Nobis benedicat qui i trinitate vinit
7 regnat Amen: Honor soli deo est tribuendu
Aue regina celo 7 mater regis angelo
rum o maria flos virginum velut rosa
velilium o maria : Tua est potentia tu
regnuz domine tu es super omnes gen
tes da pacem domine in dieb' nostris
mirabilis deus in sanctis suis Et glori
osus in maiestate sua oth pantbon kyr

Quod prope sacce diem tibi sum conuia futurus
forsitan ignoras at fore ne dubites
Ergo para cenam non qualem stoicus ambit
Sed lautam sane more cirenaico
Nanque duas mecum florente etate puellas
Adducam quarum balsama cunnus olet
Vernula sola domi sedeat quam nuper habebas
Si nondum cunnus vepribus borruerit
Sunt qui insimulent 7 auari crimen amica
O dicant sacro rumor vtiste cadat Hec Philelphus

Nunc adeas mira quicunqz volumina queris
Arte vel er animo pressa fuisse tuo
Seruiet iste tibi:nobis vre sorores
Incolumem seruet vsqz rogare licet

Est homini uirtus fuluo preciosior auro: xnxas
Ingenium quondam fuerat preciosius auro.
Miramurqz magis quos munera mentis adornát:
Quam qui corporeis emicuere bonis.
Si qua uirtute nites ne despice quenquam
Ex alia quadam forsitan ipse nitet

Nemo sue laudis nimium lętetur honore
Ne uilis factus post sua fata gemat.
Nemo nimis cupide sibi res desiderat ullas
Ne dum plus cupiat perdat & id quod habet.
Ne ue cito uerbis cuiusquam credito blandis
Sed si sint fidei respice quid moneant
Qui bene proloquitur coram sed postea praue
Hic erit inuisus bina φ ora gérat

Pax plenam uirtutis opus pax summa laborum
pax belli exacti præcium est præciumque periclis
Sidera pace uigent consistunt terrea pace
Nil placitum sine pace deo non munus ad aram
Fortuna arbitriis tempus dispensat ubi
Ita rapit iuuenes illa ferit senes

κλιω Τευτερπη τέ θαλεια τέ μελπομένη τέ
Γερψιχόρη τέράτω τέ πολυμνεία τούρανιη
τέ καλλιόπη θέλη προφερεςατη έχιναπα
σαωψ ιεσνσ Χρισούδ μαρια τέλοσ.

Indicis characteτ diuersaτ mane/
rieru impressioni parataru: Finis.

Erhardi Ratdolt Augustensis viri
solertissimi:preclaro ingenio 7 miri
fica arte:qua olim Venetijs excelluit
celebratissimus. In imperiali nunc
vrbe Auguste vindelicoτ laudatissi
me impressioni dedit. Annoqz salu
tis.M.LLLL.LXXXVI.Lalé.
Aprilis Sidere felici compleuit.

Epilogue

So shall the last be first and the first last.[304]

IF WE WERE TO CONSTRUCT a league table of printers based on typographic firsts, arguably the German Erhard Ratdolt would lead it. He introduced the first decorated title-page, although apparently he and his partners, Bernhard Maler and Peter Löslein, were unaware of its novelty. He played a key role in early polychromatic printing and printing in gold. In Venice in late spring 1482 he produced the *editio princeps* of Euclid, a magnificent folio edition containing some of the earliest printed diagrams.[305] On 1 April 1486 Ratdolt printed the first known type specimen, *Index characterum diversarum*. A broadside, printed on one side and measuring 34 × 22 centimetres, it featured a large woodcut initial and specimens of fourteen fonts in all: ten Gothic Rotunda in various sizes, three roman and one Greek. The sole surviving copy is in the Bayerische Staatsbibliothek, Munich, where it was discovered in the late nineteenth century, hidden away in the binding of another book.[306] The specimen may have been printed to advertise the sale of Ratdolt's types or simply to promote his new Augsburg press.[307] In addition to all this, in 1505 Ratdolt was the first to use the fleuron (also called hedera or vine-leaf), a symbol originating in Graeco-Roman antiquity, popularized by the great French Renaissance typographers and still in use today.

Notwithstanding Ratdolt's innovations, no book on early typography would be complete without a discussion of William Caxton. His achievements were all the more remarkable for the fact that he came to printing late in life, at about the age of fifty. Caxton learned to print in Cologne and set up his first press in Bruges, where he published the first English language book, *Recuyell of the historyes of Troye*, in about 1473–74.[308] The

69 *Index characterum diversarum*: the first type specimen, printed by Erhard Ratdolt, 1 April 1486, showing ten Gothic Rotunda in various sizes, three roman and one Greek typeface.

first chess book in English, *The Game and Playe of Chesse*, was published by him in 1474 either in Ghent or Bruges.[309] By 1476, he had returned to England to set up Britain's first press in the precincts of Westminster Abbey, first printing a letter of indulgence in the summer of 1476.[310] A little later, he published the first edition of Chaucer's *The Canterbury Tales* in a Gothic *bastarda* type that he had used previously at his Bruges press.[311] Soon after (*c.* 1477–79), the first printed advertisement in English was issued from Caxton's press,[312] a small poster advertising a book informally known as *Sarum Pie*, an ordinal, used by priests to determine holy days throughout the ecclesiastical year.[313] Caxton used only Gothic typefaces, the high-contrast *bastarda*, in addition to what type historian Daniel Updike called *lettres de forme*, a pointed blackletter that later came to be known as English.[314] It was left to Richard Pynson, a native of Normandy, and printer to the kings of England, to first employ roman type in 1509 at his London press.[315] Thereafter, in England, roman types appeared with increasing frequency and by the mid-seventeenth century were rivalling Gothic.[316] At the behest of James IV, printing was introduced to Scotland via Edinburgh in 1508 by Walter Chepman and Andrew Myllar; license to print was granted by James IV on 15 September 1507 and the first books were printed in 1508.[317] In Ireland, a press was established in 1551 with the publication of *The Boke of the Common Praier*, printed by Humphrey Powell.[318]

Beyond Latin

Millions of books and broadsides were printed in the latter half of the fifteenth century, by more than a thousand presses in over 300 towns and cities throughout Europe, as far north as Stockholm in Sweden (Bartholomaeus Ghotan, from 1483), Odense (Johann Snell, 1482[319]) and Copenhagen in Denmark (Govert van Ghemen, *c.* 1493–95);[320] and as far east as Cracow (1473–74),[321] the then capital of the Polish kingdom; and Constantinople, home to the printing of a single Hebrew incunable from the press of David and Samuel ibn Nahmias in 1493.[322] The printing of Hebrew had been introduced to Europe via Castile, Spain or in Rome, in the 1470s. Among the first books to be printed in Hebrew was Maimonides' *Mishneh Torah*, the first edition of the most important medieval code of Jewish law, printed by Solomon ben Judah and Obadiah ben Moses in Italy, perhaps in Rome.[323] The first dated book in Hebrew

appeared in Reggio di Calabria in Southern Italy, with the publication of *Perush ha-Torah*, a commentary on the Pentateuch, dated February 1475.[324]

Greek was printed earlier, although its first appearance was limited to brief quotations in the first edition of Cicero's treatise, *De officiis* ('On Duties') printed at Mainz by Fust and Schoeffer in 1465.[325] Some of the letters were borrowed from Latin, while others were printed backwards. A better Greek typeface appeared in an edition of the *Opera* ('Works') of Lactantius, issued from the Subiaco press of Sweynheym and Pannartz in 1465, where it was used for longer quotations. Not until about 1474 was the first complete Greek text printed; this is usually attributed to Thomas Ferrandus in Brescia. The first dated and signed text set entirely in Greek belongs to Dionysius Paravisinus, who completed the printing of *Erotemata*, an elementary Greek grammar, in January 1476.[326] Not until 1519 was a book issued in modern or vernacular Greek. Cyrillic types were first used in Cracow for liturgical books printed by the German merchant Swietopolk Fiol in 1491.[327] The Venetian Gregorio de Gregorii set up a press in Fano in 1514, where he issued the first book set in Arabic type – peculiarly, a book of hours commissioned by Pope Julius II, and no doubt intended for export to Christians in the Middle East.[328]

70 Advertisement for *Sarum Pie: Ordinale seu Pica ad usum Sarum*, Westminster, William Caxton, c. 1476–77.

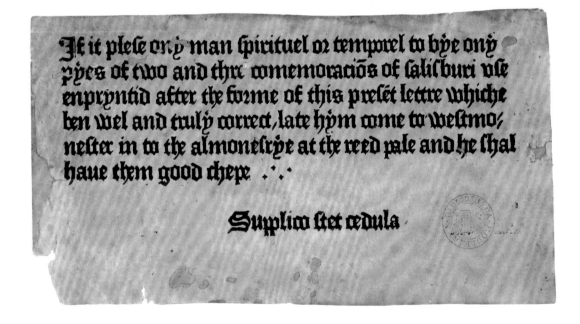

Typographic Conventions

During the late fifteenth century and on into the sixteenth, many now-common aspects of typographic design were set. Invariably these features were not immediately adopted, but in time they came to be established as elements of the typographic canon, such as the introduction of printed foliation (foliation refers to the numbering of folios or leaves on one side only, usually the recto, whereas pagination refers to the consecutive numbering of every page) in 1470 in a book issued from the press of Arnold Ther Hoernen in Cologne.[329] Rather than appearing in the lower margin, here the Arabic numeral 'page numbers' are printed in the recto margins, half-way down the page. Pagination was not broadly adopted until the middle of the sixteenth century. Indices began to appear in printed books from 1470, with one example in the *Epistolae* ('Letters') of Jerome (Hieronymus) printed by one of Rome's earliest printers, Sixtus Riessinger, a priest from Strasbourg.[330] Printed running heads first appeared in 1493, in an edition of *Philosophia pauperum* by the especially learned thirteenth-century philosopher and theologian Albertus Magnus, printed at Brescia by Baptista Farfengus, a priest and doctor of canon law.[331] The first notice of errata appeared in 1478, in a book printed by Gabriele di Pietro at his Venetian press, and this feature appeared with increasing regularity from the 1490s.[332] The same year saw the publication of Rufinus's commentary on the Apostolic Creed, *Expositio symboli apostolorum*, the very first book issued from Oxford's first press.[333]

The first mechanized printing press was Friedrich Koenig's steam-powered cylinder press, first used by *The Times* newspaper in 1814. Within half a decade, rotary presses were printing 10,000 newspapers an hour. Then typecasting and typesetting were mechanized with the introduction of the Pianotyp in 1840, a forerunner of the Linotype and Monotype typecasting machines. The middle of the twentieth century spelled the end of letterpress dominance in printing, with the introduction of offset lithography, phototypesetting and, by the 1980s, digital typesetting, with fonts as software.

Survivals

An estimated 30,000 editions were produced during the incunabula period, in millions of copies.[334] The survival rate of incunable books has been affected by numerous factors. As we have seen, grammar books have survived mostly in fragments, owing to their daily and vigorous use by children. On the other hand, commissioned and expensive editions of books of hours have tended to survive in relatively large numbers, preserved by dint of their value and beauty. Print runs increased steadily from the approximately two to three hundred of the 1460s to editions sometimes numbering in the thousands toward the end of the fifteenth century. Hartmann Schedel's magnificent compendium *Nuremberg Chronicle* (see p. 130) survives in the largest numbers, with some 1,200 extant copies of the Latin edition alone. Other works would be unknown to us but for the improbable survival of a single leaf or fragments of leaves – many discovered only centuries later in the bindings of later books, where they had been reused as binders' waste – even pages of the Gutenberg Bible, both vellum and paper copies, have been discovered used in this way.[335]

Rightly, we have come to associate access to books with certain freedoms, freedoms that extend beyond the realms of intellectual independence and inquiry. The Reformation, the Enlightenment and the Scientific Revolution were fuelled by the printed word. Thanks to the book, authors from beyond antiquity to the present day have voices loud enough to reach the entire world, now and for generations to come. Men and women have risked and given their lives for them, they have been burned at the stake alongside them, shot for owning them. But the book has survived the puritanical, the despots and the dictators. Whether printed on a hand press or mechanical press, or appearing as millions of pixels on a digital screen, the typographic book has triumphed – from the very first editions of the mid-fifteenth century to those of the present day, including the book you have just finished reading.

Glossary

à la poupée inking the selective application of more than one colour of ink to a single printing surface. From the French meaning, 'with a doll', which describes the ball-shaped wad of fabric employed to ink the plate.

bastarda see *lettre bâtarde*.

biting a palaeographical term used to describe the overlapping of bows (the curved parts of letters, e.g. in b, o and p).

Caroline minuscule (also Carolingian minuscule) a product of the Carolingian Renaissance, promoted by Charlemagne: a script that first appeared toward the end of the eighth century containing both majuscule and minuscule forms. Commonly written with word spacing.

colophon an inscription usually appearing at the end of a book or manuscript containing information about its production (imprint). From the Greek *kolophon* meaning 'summit' or 'finishing touch'.

counter the enclosed or partially enclosed white space within letterforms.

counterpunch a steel tool used to create counters in a punch.

folio a relatively large book format where the paper is folded once to produce two leaves, or four pages.

forme (form) the elements to be printed (movable type plus other components such as woodblocks) held in a rectangular frame (chase).

frontispiece illustration facing a book's title-page.

Gothic a generic term for a family of scripts that developed from the twelfth century and are characterized by angularity and lateral compression. In the sixteenth century Gothic scripts were increasingly superseded by roman letterforms.

graver a sharpened steel tool used in engraving letter punches, among other things.

half-uncial a majuscule script employed in Europe from the third to eighth centuries and commonly written without word spacing.

hand mould an adjustable mould for casting type.

historiated initial a decorated or painted capital or initial letter that contains a picture (often illustrative of the narrative). In typography, they first appeared in some copies of the Gutenberg Bible.

illumination originally the application of gold or silver to a manuscript or book. Now more broadly denoting any coloured decoration that supplements the text.

intaglio printing a printing technique whereby a design is engraved or etched into the surface of a plate. Only the ink that fills the grooves is printed (ink on

the surface of the plate is carefully removed). From the Italian *intagliare*, meaning to engrave or cut.

justification the tidying, levelling and squaring of the matrix used in a type mould for casting letters of type.

***lettre bâtarde* (or simply *bâtarde* or *bastarda*)** a form of Gothic script or type, less formal than Textualis Formata. Its name suggests its hybrid parentage of formal and cursive Gothic letterforms.

majuscule a capital letter. In typography, an uppercase letter. From the Latin *majusculus*, meaning 'bigger' or 'rather large'.

matrix a metal die from which a single piece of metal type is cast. Also used formally to describe any block or plate from which an impression is printed.

minuscule a small letter. In typography a lowercase letter. From the Latin *minusculus*, meaning 'smaller' or 'rather small'.

Northern Textualis (or simply Textualis) the most popular medieval Gothic script, commonly used in England, France, Germany, the Low Countries, Central and Eastern Europe and Scandinavia.

octavo a book format where the paper is folded three times to produce eight leaves, or sixteen pages.

punch a hardened steel bar engraved in relief at one end with a single character or glyph. Used to strike or create a matrix.

punchcutter an engraver of steel punches for the creation of metal type.

quarto the most common fifteenth-century book format where the paper is folded twice to produce four leaves, or eight pages.

registration the alignment of superimposed impressions.

relief printing a printing technique whereby the non-printing area is cut away from the matrix, leaving the raised areas to be inked and printed (e.g. letterpress).

Rotunda a form of Gothic script appearing first in Italy and the Iberian Peninsula in the thirteenth century. Generally rounder in appearance than the Gothic forms of Northern Textualis.

rubrication the act of articulating or supplementing text, commonly in red. Includes, but is not limited to titles, initial strokes and underlining. From the Latin *rubricare*, to colour red.

sort a single piece of cast metal type.

Southern Textualis see Rotunda.

Textualis Formata (or *textura*) a narrow, high-contrast Gothic script with short ascenders and descenders, characteristically constructed from mostly straight strokes and angular curves.

uncial a majuscule script employed in Europe from the fourth to eighth centuries and commonly written without word spacing.

Abbreviations

Bod-inc *A Catalogue of Books Printed in the Fifteenth Century now in the Bodleian Library*, 6 vols Oxford, 2005, http://incunables.bodleian.ox.ac.uk

CERL Consortium of European Research Libraries. www.cerl.org

EDIT 16 Censimento nazionale delle edizioni italiane del XVI secolo (The Census of Italian 16th Century Editions), http://edit16.iccu.sbn.it/

ESTC English Short Title Catalogue, http://estc.bl.uk

GW Gesamtkatalog der Wiegendrucke, http://gesamtkatalogderwiegendrucke.de/

ISTC Incunabula Short Title Catalogue, http://data.cerl.org/istc

USTC Universal Short Title Catalogue, www.ustc.ac.uk

VD 16 Verzeichnis der im deutschen Sprachbereich erschienenen Drucke des 16. Jahrhunderts (VD 16) (Catalogue of items published in German-speaking countries in the 16th century), www.vd16.de

Notes

1 Stanley Morison, *Selected Essays on the History of Letter-forms in Manuscript and Print*,
 Cambridge University Press, Cambridge, 2009, p. 25.

2 D. McKitterick, 'The Beginning of Printing', in *The New Cambridge Medieval History*,
 Vol. 7: c. 1415–c. 1500, ed. C. Allmand, Cambridge University Press, Cambridge, 2004,
 pp. 287–98, p. 298.

3 E.L. Eisenstein, *The Printing Press as an Agent of Change*, Cambridge University Press,
 Cambridge, 1979; and E.L. Eisenstein, *The Printing Revolution in Early Modern Europe*
 (second edition), Cambridge University Press, Cambridge, 2005, chapter 5, 'The
 Permanent Renaissance', pp. 123–63, esp. pp. 139–43.

4 Jacques Verger, 'Schools and Universities', in *The New Cambridge Medieval History, Vol. 7:
 c. 1415–c. 1500*, Cambridge University Press, Cambridge, 1998, pp. 220–4, p. 226; and
 E. Buringh and J.L. Van Zanden, 'Charting the "Rise of the West": Manuscripts and
 Printed Books in Europe, a Long-Term Perspective from the Sixth through Eighteenth
 Centuries', *Journal of Economic History*, 69(2), 2009, pp. 409–45, Table 1, p. 416, and
 Table 2, p. 417. See also Eltjo Buringh, *Medieval Manuscript Production in the Latin West*,
 Brill, Leiden and Boston, 2011, Table 5.6, p. 262. On the exhaustive quantitative and
 qualitative historical support for these figures, see chapter 6, pp. 315–95.

5 Christopher de Hamel, *A History of Illuminated Manuscripts*, Phaidon, London, 1994,
 pp. 130–32.

6 Paul Needham, 'Prints in the Early Printing Shops', in *The Woodcut in Fifteenth-Century
 Europe*, ed. P. Parshall, National Gallery of Art, Washington, DC, 2009, pp. 39–91, p. 41.

7 C. McEvedy and R. Jones, *Atlas of World Population History*, Viking, New York, 1978, p. 26.

8 Cf. Margaret Smith, 'The Design Relationship Between the Manuscript and the
 Incunable', in *A Millennium of the Book: Production, Design & Illustration in Manuscript &
 Print 900–1900*, ed. M. Harris and R. Myers, St Paul's Bibliographies, Oak Knoll Press,
 New Castle, DE, 1994, pp. 23–44.

9 Albert Derolez, *The Palaeography of Gothic Manuscript Books: From the Twelfth to the Early
 Sixteenth Century*, Cambridge University Press, Cambridge, 2003, pp. 102–22.

10 B.L. Ullman, *The Origin and Development of Humanistic Script*, Edizioni di Storia e
 Letteratura, Rome, 1960, p. 134.

11 Data from ISTC database, http://data.cerl.org/istc/. Figures approximate.

12 From Martin Lowry, *The World of Aldus Manutius: Business and Scholarship in Renaissance
 Venice*, Cornell University Press, Ithaca, NY, 1979, p. 8. For more on Hervagius, see Peter
 G. Bietenholz (ed.), *Contemporaries of Erasmus: A Biographical Register of the Renaissance and
 Reformation*, University of Toronto Press, Toronto, 2003, pp. 186–7.

13 Foligno, 11 April 1472; ISTC: id00022000; Bod-inc: D-007. Printed in a relatively large
 and somewhat quirky, though not altogether unpleasant, roman typeface. See also Lucien
 Febvre and Henri-Jean Martin, *The Coming of the Book: The Impact of Printing 1450–1800*,
 Verso, New York, 1976, pp. 168–9.

14 Brian Richardson, *Printing, Writers and Readers in Renaissance Italy*, Cambridge University Press, Cambridge, 1999, p. 60.

15 Angela Nuovo, *The Book Trade in the Italian Renaissance*, Brill, Leiden and Boston, 2013, p. 25.

16 Federicus de Comitibus was also known as Federico del Conte of Verona. Victor Scholderer, *Gutenberg-Jahrbuch*, 1932, pp. 110–13 (reprinted in V. Scholderer, *Fifty Essays in Fifteenth- and Sixteenth-Century Bibliography*, Menno Hertzberger and Co., Amsterdam, 1966, pp. 131–4).

17 *La Commedia*, 18 July 1472; ISTC: id00024000.

18 P. Dijstelberge and A.R.A. Croiset van Uchelen (eds), *Dutch Typography in the Sixteenth Century: The Collected Works of Paul Valkema Blouw*, Brill, Leiden and Boston, 2013, p. 68; and C. Clair, *Christopher Plantin*, Cassell, London, 1960, p. 49.

19 Stephan Füssel, *Gutenberg and the Impact of Printing*, Ashgate, Farnham, 2005, pp. 20–21.

20 Robert Bringhurst, *The Elements of Typographic Style*, Hartley & Marks, Dublin, 2005, p. 11.

21 John Milton, *Areopagitica*, Clarendon Press, Oxford, 1874, p. 6.

22 For more on manuscript indulgences, see K.M. Rudy, 'Indulgences', in K.M. Rudy, *Rubrics Images and Indulgences in Late Medieval Netherlandish Manuscripts*, Brill, Leiden and Boston, 2016, pp. 30–51; J.A. Hobson, *God and Mammon: The Relations of Religion and Economics*, Routledge Revivals, New York, 2011, p. 18; Jan van Herwaarden, *Between Saint James and Erasmus: Studies in Late-Medieval Religious Life – Devotion and Pilgrimage in the Netherlands*, Brill, Leiden and Boston, 2003, pp. 108–9. For information on numbers printed, see Janet Ing, 'The Mainz Indulgences of 1454/5: A Review of Recent Scholarship', *British Library Journal*, 9(1), 1983, pp. 14–31, pp. 29–30, note 19. Between 1498 and 1500 a printer in Barcelona was commissioned to print some 200,000 letters of indulgence. See A. Pettegree, *The Book Trade in the Renaissance*, Yale University Press, New Haven, CT, 2010, p. 94.

23 See Kenneth M. Setton, *The Papacy and the Levant, 1204–1571, Vol. 2: The Fifteenth Century*, American Philosophical Society, Philadelphia, 1976, p. 158 and note 65.

24 The earliest extant handwritten example of the Cyprus indulgence is dated 4 January 1454. See Ernst Braches and Anna E.C. Simoni, 'Gutenberg's "scriptorium"', *Quaerendo*, 21(2), 1991, pp. 83–98, p. 94. R.W. Shaffern, 'The Medieval Theology of Indulgences', in R.N. Swanson (ed.), *Promissory Notes on the Treasury of Merits: Indulgences in Late Medieval Europe*, Brill, Leiden and Boston, 2006, pp. 11–36, p. 12.

25 Paul Needham, 'Copy-specifics in the Printing Shop', in *Early Printed Books as Material Objects*, ed. B. Wagner and M. Reed, De Gruyter Saur, Berlin and New York, 2010, pp. 9–20.

26 See Füssel, *Gutenberg and the Impact of Printing*, pp. 26–7; and Stan Knight, *Historical Types from Gutenberg to Ashendene*, Oak Knoll Press, New Castle, DE, 2012, pp. 14–15, p. 27. Nicolas Barker also postulates the involvement of Cusa: N. Barker, 'Aldus Manutius: Mercantile Empire of the Intellect', *Occasional Papers*, 3, UCLA, Los Angeles, 1989, pp. 1–25, pp. 13–14. See also an excellent summary in Ing, 'The Mainz indulgences of 1454/5', pp. 14–31.

27 From Norman Housley, 'Indulgences for Crusading, 1417–1517', in *Promissory Notes on the Treasury of Merits: Indulgences in Late Medieval Europe*, ed. R.N. Swanson, Brill, Leiden and Boston, 2006, p. 278.

28 See H.D.L. Vervliet, 'Gutenberg or Diderot: Printing as a Factor in World History', *Quaerendo*, 8(1), 1978, pp. 3–28, pp. 22–3.

29 E.g. ISTC: id00316450.

30 G.D. Painter, 'Gutenberg and the B36 Group. A Re-consideration', in *Essays in Honour of Victor Scholderer*, ed. D.E. Rhodes, Karl Pressler, Mainz, 1970, pp. 292–322, p. 297.

31 ISTC: it00503500. Simon Eckehar, *The 'Türkenkalender' (1454) Attributed to Gutenberg and the Strasbourg Lunations Tracts*, Medieval Academy of America, Cambridge, MA, 1988.

32 The fragment is also known as *Fragment vom Weltgericht*; ISTC: is00492500. See D.C. McTurtie, *Some Facts Concerning the Invention of Printing,* Chicago Club of Printing House Craftsmen, 1939. See also Margaret B. Stillwell, *The Beginning of the World of Books, 1450 to 1470: A Chronological Survey of the Texts Chosen for Printing During the First Twenty Years of the Printing Art*, Bibliographical Society of America, New York, 1972, pp. 3–4; and M.W. Browne, 'A Beam of Protons Illuminates Gutenberg's Genius: A New Examination Reveals Details of the Earliest Use of Movable Type', *New York Times*, 12 May 1987.

33 See Laura Light, 'The Thirteenth Century and the Paris Bible', in *The New Cambridge History of the Bible, Vol. 2: From 600 to 1450*, ed. R. Marsden and E.A. Matter, Cambridge University Press,Cambridge, 2012, pp. 380–91. On the differences between twelfth- and thirteenth- century Bibles, see Christopher de Hamel, *The Book: A History of the Bible*, Phaidon, London, 2001, p. 114. On Stephen Langton, however, compare Paul Saenger, 'The Twelfth-century Reception of Oriental Languages and the Graphic *Mise en Page* of Latin Vulgate Bibles Copied in England', in *Form and Function in the Late Medieval Bible*, ed. E. Poleg and L. Light, Brill, Leiden and Boston, 2013, pp. 31–66, who attributes this innovation, not to Langton in Paris, but to a Benedictine monastery in Saint Albans, England, after *c.* 1180 (p. 31). For the form of the Bible from the early thirteenth century, see E. Poleg and L. Light (eds), *Form and Function in the Late Medieval Bible*. For the Bible in the fifteenth century, see Paul Needham, 'The Changing Shape of the Vulgate Bible in Fifteenth-Century Printing Shops', in *The Bible as Book: The First Printed Editions*, ed. Paul Saenger and Kimberley van Kampen, British Library, London, 1999, pp. 53–70; and Kristian Jensen, 'Printing the Bible in the Fifteenth Century: Devotion, Philology and Commerce', in *Incunabula and their Readers: Printing, Selling and Using Books in the Fifteenth Century*, ed. K. Jensen, British Library, London, 2003, pp. 115–38.

34 A. Pettegree, 'Publishing in Print: Technology and Trade' in *The New Cambridge History of the Bible, Vol. 3: From 1450 to 1750*, ed. E. Cameron, Cambridge University Press, Cambridge, 2016, pp. 159–86.

35 Paul Needham, 'The Paper Supply of the Gutenberg Bible', *Papers of the Bibliographical Society of America*, 79, 1985, pp. 303–74. See R.N. Schwab, T.A. Cahill, A. Thomas, B.H. Kusko, and D.L. Wick, 'Cyclotron Analysis of the Ink in the 42-Line Bible', *Papers of the Bibliographical Society of America*, 77(3), 1983, pp. 285–315; and R.N. Schwab, T.A. Cahill, R.A. Eldred, B.H. Kusko and D.L. Wick, 'New Evidence on the Printing of the Gutenberg Bible: The Inks in the Doheny Copy', *Papers of the Bibliographical Society of America*, 79, 1985, pp. 375–410. R.N. Schwab, 'New Clues About Gutenberg in the Huntington 42-line Bible: What the Margins Reveal', *Huntington Library Quarterly*, 51(3), 1988, pp. 177–210; on the pinholes alone, see pp. 182–93.

36 Translation from Martin Davies, 'Juan de Carvajal and Early Printing: The 42-line Bible and the Sweynheym and Pannartz Aquinas', *The Library*, 18(3), 1996, pp. 193–215, p. 196.

37 See Setton, *The Papacy and the Levant*, chapter 5, esp. pp. 151–4; and Nancy Bisaha, 'Pope Pius II and the Crusade', in N. Housley (ed.), *Crusading in the Fifteenth Century: Message and Impact*, Palgrave Macmillan, New York, 2004, pp. 39–52. On the twice-yearly Frankfurt trade fair, see Pettegree, *The Book Trade in the Renaissance*, pp. 78–82; and John L. Flood, 'Omnium totius emporiorum compendium: The Frankfurt Fair in the Early

Modern Period', in *Fairs, Markets and the Itinerant Book Trade*, ed. R. Myers, M. Harris, G. Mandelbrote, Oak Knoll, New Castle, DE, 2007, p. 10.

38 See Davies, 'Juan de Carvajal and Early Printing', p. 199.

39 Füssel, *Gutenberg and the Impact of Printing*, p. 20.

40 See Needham, 'Copy-specifics in the Printing Shop', p. 17. On the text of the Forty-two-line Bible's *tabula rubricarum,* see the appendix, 'The Text of the Rubric Table', in Paul Needham, 'A Gutenberg Bible Used as Printer's Copy by Heinrich Eggestein in Strasbourg, ca. 1469', *Transactions of the Cambridge Bibliographical Society*, 9, 1986, pp. 36–75, pp. 71–2.

41 See Needham, 'Copy-specifics in the Printing Shop', pp. 13–17.

42 Paul Needham, 'Division of Copy in the Gutenberg Bible: Three Glosses on the Ink Evidence', *Papers of the Bibliographical Society of America*, 79, 1985, pp. 411–26, p. 425 and note 10. The word breaks across columns are located at: vol. 1, 310r and vol. 2, 276r.

43 Füssel, *Gutenberg and the Impact of Printing*, p. 21.

44 Recently challenged by McCarthy, who suggests that the Bible's paper was made elsewhere in the Duchy of Savoy or in Basel. See Isabel Feder McCarthy, 'Ad Fontes: A New Look at the Watermarks on Paper Copies of the Gutenberg Bible', *The Library,* 17(2), 2016, pp. 115–37.

45 Needham, 'The Paper Supply of the Gutenberg Bible', pp. 303–74.

46 Füssel, *Gutenberg and the Impact of Printing*, pp. 20–1. See also Mary Kay Duggan, 'Bringing Reformed Liturgy to Print at the New Monastery at Marienthal', *Church History and Religious Culture*, 88, 2008, pp. 415–36, p. 416 note 1; and Leonhard Hoffmann, 'Der Preis Der Gutenberg-Bibel. Zum Kauf Der "Biblia De Molde Grande" in Burgos. Un Memoriam Horst Kunze', *Gutenberg-Jahrbuch*, 2002, pp. 50–6. On Gutenberg's solvency upon his split with Fust, see Stillwell, *The Beginning of the World of Books, 1450 to 1470*, p. 85.

47 Volume 1: Arch. B b.10; volume 2: Arch. B b.11.

48 Provenance information gleaned from the MEI (Material Evidence in Incunabula) database, hosted and maintained by CERL, http://data.cerl.org/mei/.

49 From the colophon of the Mainz first edition of *Catholicon*, 1460. Quoted from John L. Flood, 'Nationalistic Currents in Early German Typography', *The Library*, s6-15(2), June 1993, p. 131.

50 Sohn Pow-Key, 'Printing Since the 8th Century in Korea', *Koreana*, 7(2), summer 1993, pp. 4–9; and 'Early Korean Printing', *Journal of the American Oriental Society*, 79(2), 1959, pp. 96–103, p. 103.

51 Füssel, *Gutenberg and the Impact of Printing*, p. 16.

52 See Warren Chappell, *A Short History of the Printed Word*, Hartley & Marks, 1999, pp. 43–57.

53 Fred Smeijers, *Counterpunch: Making Type in the Sixteenth Century, Designing Typefaces Now*, Hyphen Press, London, 1996, pp. 124–5.

54 Ibid., pp. 120–2, esp. fig. 15.2. See also Harry Carter, *A View of Early Typography up to about 1600*, Oxford University Press, Oxford, 1969, p. 9.

55 Such a type-mould is first described in detail in 1683 in Joseph Moxon's *Mechanick Exercises*. For more detail, see the annotated edition by Herbert Davis and Harry Carter, Oxford University Press, London, 1958; and Alan May, 'Making Moxon's Type-mould', *Journal of the Printing Historical Society*, 22, spring 2015, pp. 5–22 for a fascinating and informative account of an attempted modern-day reconstruction.

56 On whether the very earliest printers, including Gutenberg, used metal or temporary matrices (e.g. casting in sand), see Blaise Agüera y Arcas, 'Temporary Matrices and

Elemental Punches in Gutenberg's DK type', in *Incunabula and Their Readers: Printing, Selling and Using Books in the Fifteenth Century*, ed. Kristian Jensen, British Library, London, 2003, pp. 1–12. Also see the convincing arguments for permanent matrices in Stephen Pratt, 'The Myth of Identical Types: A Study of Printing Variations from Handcast Gutenberg Type', *Journal of the Printing Historical Society*, new series, 6, 2003, pp. 7–17.

57 Füssel, *Gutenberg and the Impact of Printing*, p. 20.

58 Rolf Schmidt, 'Die Klosterdruckerei von St. Ulrich und Afra in Augsburg (1472 bis 1474)', *Augsburger Buchdruck und Verlagswesen von den Anfängen bis zur Gegenwart*, ed. Helmut Gier and Johannes Janota, Harrassowitz, Wiesbaden, 1997, pp. 141–53.

59 Derolez, *The Palaeography of Gothic Manuscript Books*, pp. 73, 101.

60 On the manuscript origins of the Gothic cursive and *bastarda*, see B. Bischoff, *Latin Palaeography: Antiquity and the Middle Ages*, Cambridge University Press, Cambridge, 1990, pp. 136–45. On the two indulgence types, see Ing, 'The Mainz Indulgences of 1454/5', pp. 18–19.

61 ISTC: is00492500. George D. Painter concluded that 'primitive imperfections' in the typeface of the *Sibyllenbuch* fragment indicate that it was the earliest of the fragments printed in the DK type; see Stillwell, *The Beginning of the World of Books, 1450 to 1470*, p. 4. Likewise, Paul Needham describes the DK type of the earliest editions of Donatus and the *Sibyllenbuch* fragment as a 'conspicuously crude and imperfect state'; see Parshall, *The Woodcut in Fifteenth-Century Europe*, p. 43.

62 ISTC: ib00527000. On the identification of the printer and evolution of the DK types, see Painter, 'Gutenberg and the B36 Group. A Reconsideration', pp. 292–322. From 1461, Albrecht Pfister in Bamberg used the B36 type.

63 *Vocabularius ex quo*, Eltville: [Nicolaus Bechtermüntze], 12 March 1472, ISTC: iv00361900; and Thomas Aquinas's *De articulis fidei et ecclesiae sacramentis*, [Eltville: Nicolaus Bechtermüntze, between June 1469 and March 1472], ISTC: it00272800.

64 An indulgence for promoting the war against the Ottoman Turks and the defence of Rhodes; ISTC: ij00273260.

65 ISTC: im0008293.

66 Braches, 'Gutenberg's "scriptorium"', p. 95 notes 43 and 44.

67 D. Ganz, 'Book Production in the Carolingian Empire and the Spread of Caroline Minuscule', in *The New Cambridge Medieval History, Vol. 2: c. 700–c. 900*, ed. R. McKitterick, Cambridge University Press Cambridge, 1995, pp. 786–808.

68 Erik Kwakkel, 'Kissing, Biting and the Treatment of Feet: The Transitional Script of the Long Twelfth Century', in *Turning Over a New Leaf: Change and Development in the Medieval Book*, ed. Erik Kwakkel, Rosamond McKitterick and Rodney Thomson, Leiden University Press, Leiden, 2012, pp. 79–126.

69 See Derolez, *The Palaeography of Gothic Manuscript Books*, p. 68.

70 Stan Knight outlines four broad principles that affect the evolution and development of scripts. See *Historical Scripts: from Classical Times to the Renaissance*, Oak Knoll Press, New Castle, DE, 2009, pp. 9–11.

71 'Humanistic script was, then, inspired by Coluccio Salutati, invented by Poggio Bracciolini, encouraged by Niccolò Niccoli, preferred by the Medici…': Ullman, *The Origin and Development of Humanistic Script*, p. 134.

72 Jacob Burckhardt, *The Civilization of the Renaissance in Italy*, Penguin, London, 1990, p. 135.

73 '…Conradus Sweynheym et Arnoldus Pannartz clerici Maguntine et Coloniensis diocesis…': Scholderer, *Fifty Essays in Fifteenth- and Sixteenth-Century Bibliography*, p. 72.

Papal records corroborate this provenance: '…den päpstlichen Registern hervorgeht Pannartz als Inhaber einer Altarstelle am Dom von Köln, die er vertreten lassen konnte, Sweynheym als Inhaber einer Präbende an St. Viktor vor Mainz': Uwe Israel, 'Romnähe und Klosterreform oder: Warum die erste Druckerpresse Italiens in der Benediktinerabtei Subiaco stand', *Archiv für Kulturgeschichte*, 88, 2006, p. 284.

74 G.D. Hargreaves, 'Florentine Script, Paduan Script, and Roman Type', *Gutenberg-Jahrbuch*, 1992, p. 22 note 24.

75 Stanley Morison, 'Early Humanistic Script and the First Roman Type', *The Library*, 24(1–2), 1943, pp. 1–29, p. 21.

76 Lotte Hellinga, *Texts in Transit: Manuscript to Proof and Print in the Fifteenth Century*, Brill, Leiden and Boston, 2014, pp. 157, 166–7.

77 From Lotte Hellinga, 'The Rylands Incunabula: An International Perspective', *Bulletin du bibliophile*, 1, 1989, pp. 34–52, pp. 48–9.

78 ISTC ip00147000.

79 See A. Hind, *An Introduction to a History of Woodcut*, vol. 1, Dover reprint, New York, 1963, pp. 193–4; K. Haebler, *Die italienischen Fragmente vom Leiden Christi, das älteste Druckwerk Italiens*, J. Rosenthal, Munich, 1927; and Parshall, *The Woodcut in Fifteenth-Century Europe*, pp. 69–70. For a synopsis of the arguments, see Christie's, King Street, London, Sale 6055, 23 November 1998, lot 18, https://goo.gl/yruldn.

80 From the dedication of Aldus Manutius's Juvenal of 1501, addressed to his friend Scipio Carteromachus. Translation from Daniel Berkeley Updike, *Printing Types, Their History, Forms and Use: A Study in Survivals*, vol. 1, Harvard University Press, Cambridge, MA, 1937, p. 126.

81 See Martin Davies, *Aldus Manutius: Printer and Publisher of Renaissance Venice*, British Library, London, 1995, p. 13

82 *Institutiones grammaticae*, ISTC: im00226500. See Lamberto Donati (ed.), *Miscellanea bibliografica in memoria di don Tommaso Accurti*, vols 15–16, Edizioni di Storia e Letteratura, Rome, 1947, pp. 193–203.

83 ISTC: ic00767000. For more on this unusual book, see H. Szépe, 'Desire in the Printed Dream of Poliphilo' *Art History*, 19(3), 1996, pp. 370–92.

84 See Davies, *Aldus Manutius*, p. 46. On the comparative and per-sheet costs, see Stanley Boorman, *Ottaviano Petrucci: Catalogue Raisonné*, Oxford University Press, Oxford, 2005, p. 355, esp. Table 10-2.

85 ISTC: ic00281000; Bod-inc C-120.

86 See A.C. de la Mare and Laura Nuvoloni's excellent *Bartolomeo Sanvito: The Life and Work of a Renaissance Scribe*, Association Internationale de Bibliophilie, London, 2009; for an example of Sanvito's humanist cursive script, see James Wardrop, *The Script of Humanism, Some Aspects of Humanistic Script, 1460–1560*, Clarendon Press, Oxford, 1963, Fig. 38.

87 See L.V. Gerulaitis, *Printing and Publishing in Fifteenth-Century Venice*, American Library Association, Chicago, 1976, pp. 40, 44.

88 See Will Kemp, 'Counterfeit Aldines and Italic-Letter Editions Printed in Lyons 1502–1510: Early Diffusion in Italy and France', *Papers of The Bibliographical Society of Canada*, 35(1), 1997; and David Shaw, 'The Lyons Counterfeit of Aldus's Italic Type: A New Chronology', in *The Italian Book 1465–1800*, ed. Denis V. Reidy, British Library, London, 1993, pp. 117–33; and H. George Fletcher, *In Praise of Aldus Manutius: A Quincentenary Exhibition*, exhibition catalogue, Pierpont Morgan Library, New York, 1995, pp. 55–9.

89 Translation from Kemp, 'Counterfeit Aldines', p. 56.

90 Paul J. Angerhofer, et al., *In Aedibus Aldi: The Legacy of Aldus Manutius and his Press*, Brigham Young University Library, Provo, UT, 1995, pp. 2–3.

91 See Lowry, *The World of Aldus Manutius*, p. 156.

92 'Italic' appears to have been used first to describe these types by the Paris publisher Denis Roce in 1512 (although the term had been used before – but to describe roman types). See H.D.L. Vervliet, *The Palaeotypography of the French Renaissance: Selected Papers on Sixteenth-Century Typefaces*, vol. 1, Brill, Leiden and Boston, 2008, p. 288.

93 For example, Granjon's First Long Primer Italic of 1545. See ibid., pp. 289, 314.

94 Ibid., p. 322.

95 See Kay Amert and R. Bringhurst, *The Scythe and the Rabbit*, RIT Press, Rochester, NY, 2012, pp. 21–5.

96 Soncino attributes Hebrew types to Griffo: 'un nobilissimo sculptore de littere, graece et hebraice, chiamato M. Francesco, da Bologna': G. Manzoni, *Annali tipografici dei Soncino*, Romagnoli, Bologna, 1886, pt. 2, p. 27.

97 Praise omitted from later editions. Soncino had briefly collaborated with Aldus on a polyglot Bible (Hebrew, Greek and Latin) that, unfortunately, never went to press.

98 See Davies, *Aldus Manutius*, p. 55.

99 Petrarch's *Canzonier*: USTC: 847791; ibid., p. 52.

100 *De rerum natura*, January 1515 (USTC: 838803). Previously published in December 1500 by Aldus in quarto (ISTC: il00335000; Bod-inc L-184).

101 'Omnis cum in tenebris praesertim vita laboret': Book II, l. 54.

102 A paraphrase of Virginia Woolf, from *A Room of One's Own* (Hogarth Press, London, 1929): 'I would venture to guess that Anon … was often a woman.'

103 Sherrill Cohen, *The Evolution of Women's Asylums Since 1500*, Oxford University Press, Oxford, 1992, p. 13; Sherrin Marshall (ed.), *Women in Reformation and Counter-reformation Europe*, Indiana University Press, Bloomington, IN, 1989, p. 170.

104 J.H. Plumb, *The Italian Renaissance*, Houghton Mifflin, Boston and New York, 2001, p. 132.

105 Malcolm Gaskill, *Witchcraft: A Very Short Introduction*, Oxford University Press, Oxford, 2010, p.76. Some authors cite much higher figures.

106 L. Hurtado and C. Keith, 'Book Writing and Production in the Hellenistic and Roman Period', in *New Cambridge History of the Bible: From the Beginnings to 600*, ed. James Carleton-Paget and Joachim Schaper, Cambridge University Press, Cambridge, 2013, p. 71 note 15.

107 See Alison Beach, *Women as Scribes: Book Production and Monastic Reform in Twelfth-Century Bavaria*, Cambridge University Press, Cambridge, 2004.

108 Martin Lowry, 'Aldus Manutius and Benedetto Bordon: In Search of a Link', *Bulletin of the John Rylands University Library of Manchester*, 66, 1984, pp. 173–97, pp. 186–8.

109 Cynthia J. Cyrus, *The Scribes for Women's Convents in Late Medieval Germany*, Toronto Press, Toronto, Buffalo and London, 2009, p. 55.

110 ISTC: ip01123500.

111 *Behinat Olam*: ISTC: ij00218520; Bod-inc Heb-47. On the dating, see A.K. Offenberg: 'The Chronology of Hebrew Printing at Mantua in the Fifteenth Century: A Re-examination', *Library*, s6-16, 1994, pp. 298–315. See A. Rosenthal, 'Some Remarks on "The Daily Performance of a Printing Press in 1476"', *Gutenberg-Jahrbuch*, 1979, pp. 39–50, p. 40. The first dated Hebrew printed book is Rashi's commentary on the Torah, *Perush ha-Torah*, 17 February 1475 (ISTC: is00625180).

112 Translation from Hebrew from David Werner Amram, *The Makers of Hebrew Books in Italy: Being Chapters in the History of the Hebrew Printing Press*, Edward Stern and Co. Inc., Philadelphia, PA, 1909, p. 32.

113 Sheila Edmunds, 'Anna Rügerin Revealed', *Journal of the Early Book Society for the Study of Manuscripts and Printing History*, 2, 1999, pp. 179–81, p. 180.

114 Helen Smith, '"Print[ing] Your Royal Father Off": Early Modern Female Stationers and the Gendering of the British Book Trades', *Text*, 15, 2003, pp. 163–86, p. 163.

115 D. Parker, 'Women in the Book Trade in Italy, 1475–1620', *Renaissance Quarterly* 49(3), 1996, pp. 509–41, p. 527.

116 Ibid., p. 509.

117 Beech, Beatrice. 'Charlotte Guillard: A Sixteenth-Century Business Woman', *Renaissance Quarterly*, 36(3), 1983, pp. 345–67.

118 Leonardo da Vinci, *Trattato della pittura*, Brancato, Catania, 1990, p. 19. Translation from Paola Spinozzi, 'Interarts and Illustration: Some Historical Antecedents, Theoretical Issues, and Methodological Orientations', *Journal of Illustration Studies*, December 2007, www.jois.ua.no.

119 On the dating of blockbooks, see Nigel F. Palmer, 'Junius's Blockbooks: Copies of the "Biblia pauperum" and "Canticum canticorum" in the Bodleian Library and their Place in the History of Printing', *Renaissance Studies*, 9(2), 1995, pp. 137–65.

120 William Young Ottley, *An Inquiry into the Origin and Early History of Engraving upon Copper and in Wood, with an Account of Engravers and Their Works*, John and Arthur Arch, London, 1816, pp. 111–37. For books based on a tenth- and eleventh-century manuscript tradition of illustrated Apocalypses, see: Suzanne Lewis, *Reading Images: Narrative Discourse and Reception in the Thirteenth-Century Illuminated Apocalypse*, Cambridge University Press, Cambridge, 1995; R.K. Emmerson and Suzanne Lewis, 'Census and Bibliography of Medieval Manuscripts Containing Apocalypse Illustrations, Ca. 800–1500: II', *Traditio*, 41, 1985, pp. 367–409.

121 See H. Schulz, 'Albrecht Pfister and the Nürnberg Woodcut School', *Gutenberg-Jahrbuch*, 1953, pp. 39–49.

122 ISTC: ib00974500.

123 See A. Hyatt Mayor, *Prints & People: A Social History of Printed Pictures*, Metropolitan Museum of Art, New York, 1971, p. 24. See also Samuel Weller Singer, *Researches into the History of Playing Cards*, R. Triphook, London, 1816, pp. 23–4.

124 *Apocalypsis cum figuris*, ISTC: ij00226000.

125 USTC: 683073 (VD16: S 4587); Bodleian Library: Douce D subt. 41. Hind, *An Introduction to a History of Woodcut*, 1963, p. 384.

126 E.g. Bod-inc: B-504, B-506, B-512, B-513.

127 Jonathan J.G. Alexander (ed.), *The Painted Page: Italian Renaissance Book Illumination, 1450–1550*, Prestel-Verlag, Munich, 1994, pp. 174–6; ISTC: ip00801000; Bod-inc: P-372(2); Arch. G b.6.

128 Attributed to Michelangelo. Quoted from R.J. Clements, *Michelangelo's Theory of Art*, New York University Press, New York, 1961, pp. 311–12.

129 For example, the *Book of the Dead of the Goldworker of Amun, Sobekmose, c.* 1500–1480 BCE. Papyrus, ink, paint, 14 × 293 in. (35.6 × 744.2 cm). Brooklyn Museum, Charles Edwin Wilbour Fund, 37.1777E.

130 See Bischoff, *Latin Palaeography: Antiquity and the Middle Ages*, pp. 187–8.

131 On medieval pigments, grounds, binding media and painting practices, see D.V. Thompson, *The Materials and Techniques of Medieval Painting*, Dover Publications,

New York, 1956, esp. pp. 74–187 on pigments and colours; and Janet L. Ross, *Pigments Used in Late Medieval Western European Manuscript Illumination*, University of Texas Press, Austin, 1971. See also the monumental, four-volume work, R. Ashok, et al., *Artists' Pigments: A Handbook of their History and Characteristics*, 4 vols, National Gallery of Art, Washington, DC, 1987, 1994, 1997, 2007.

132 See N. Eastaugh, V. Walsh, T. Chaplin and R. Siddall, *Pigment Compendium: A Dictionary of Historical Pigments*, Elsevier, Oxford, 2007, pp. 219 (ultramarine), 233–5 (lead white), 385 (red lead), 105 (vermilion), 285 (yellows).

133 See Richard S. Field, *Fifteenth-Century Woodcuts and Metalcuts from the National Gallery of Art*, National Gallery of Art, Washington, DC, 1965, p. 71 note 2. On the dating and provenance of the Buxheim St Christopher, see Hind, *An Introduction to a History of Woodcut*, pp. 104–13.

134 Parshall, *The Woodcut in Fifteenth-Century Europe*, pp. 300–1.

135 On the use of pigments in fifteenth- and sixteenth-century prints, see Thomas Primeau, 'The Materials and Technology of Renaissance and Baroque Hand-Colored Prints', in S. Dackerman, *Painted Prints: The Revelation of Color in Northern Renaissance & Baroque Engravings, Etchings, & Woodcuts*, Penn State Press, University Park, PA, 2002, pp. 49–78.

136 Margaret Smith, *The Title-Page: Its Early Development, 1460–1510*, British Library, London, and Oak Knoll Press, New Castle, DE, 2000, p. 36 note 3. See also Hellmut Lehmann-Haupt, *Peter Schoeffer of Gernsheim and Mainz*, Printing House of L. Hart, Rochester, NY, 1950, p. 53.

137 See Margaret M. Smith, 'Red as a Textual Element During the Transition from Manuscript to Print' (Critical essay), *Essays and Studies*, 2010, pp. 187–200. See also Scholderer, *Fifty Essays in Fifteenth- and Sixteenth-Century Bibliography*, pp. 265–70. Margaret Smith estimates (from a relatively large sample of 4,194 editions) that about 13.4 per cent of incunabula contain text printed in red. Excluding breviaries, the figure drops to between 6 and 7 per cent: Margaret Smith, 'From Manuscript to Print: Early Design Changes', in *Archiv für Geschichte des Buchwesens*, ed. M. Estermann, U. Rautenberg and R. Wittmann, Band 59, De Gruyter, Saur, 2005, p. 5 and notes 22–3. See also M. Smith and A. May, 'Early Two-Colour Printing', *Bulletin of the Printing Historical Society*, 44, winter 1997, pp. 1–4, p. 1. Margaret Smith, 'Patterns of Incomplete Rubrication in Incunables and What They Suggest about Working Methods', in *Medieval Book Production: Assessing the Evidence*, ed. L.L. Brownrigg, Anderson-Lovelace, Los Altos Hills, CA, 1990, pp. 133–46, p. 133.

138 On the importance of the articulatory nature of red in manuscripts, see Smith, 'From Manuscript to Print: Early Design Changes', pp. 3–6. 'Red was one of the foundations of manuscript textual articulation, present in the humblest of professionally produced books, and often even in those produced by non-professionals', p. 4.

139 Ad Stijnman and Elizabeth Savage (eds), *Printing Colour 1400–1700: Histories, Techniques, Functions and Receptions*, Brill, Leiden and Boston, 2015, pp. 24–5.

140 Mayumi Ikeda, 'The Fust and Schöffer Office and the Printing of the Two-Coloured Initials in the 1457 Mainz Psalter', in Stijnman and Savage, *Printing Colour 1400–1700*, pp. 65–75.

141 Peter Shoeffer, *Psalterium Benedictinum cum canticis et hymnis*, Mainz, 31 August 1490. ISTC: ip01062500.

142 Henry Meier, 'Woodcut Stencils of 400 Years Ago', *Bulletin of the New York Public Library*, 42, 1938, pp. 10–19; reprinted, without an introduction and bibliography, in *Print Collector's Quarterly*, 25(1), 1938, pp. 9–31.

143 On the history and much later use of stencils in liturgical books, see Eva Judd O'Meara, 'Notes on Stencilled Choir-Books: With Seven Figures', *Gutenberg-Jahrbuch*, 1933, pp. 169–85, p. 170.

144 Thomas Primeau, 'Coloring within the Lines: The Use of Stencil in Early Woodcuts', *Art in Print* 3(3), 2013.

145 On the role of the professional print colourist, or *Briefmaler*, see Dackerman, *Painted Prints*, pp. 17–25; and W. Schreiber, 'Die Briefmaler und ihre Mitarbeiter', *Gutenberg-Jahrbuch*, 1932, pp. 53–4. With the spread of printing and a concomitant proliferation of printed illustrations, the number of *Briefmaler* increased. 'Between c. 1550 and 1750, at least 260 *Briefmaler* were active in Augsburg alone': J. Paas, 'Georg Kress, a "Briefmaler" in Augsburg in the Late Sixteenth and Early Seventeenth Centuries', *Gutenberg-Jahrbuch*, 1990, p. 177.

146 Translation from Dackerman, *Painted Prints*, p. 17.

147 Ibid., p. 68.

148 Elizabeth Savage, 'New Evidence of Erhard Ratdolt's Working Practices: The After-life of Two Red Frisket-sheets from the Missale Constantiense (c. 1505)', *Journal of the Printing Historical Society*, Spring 2015, pp. 81–97; and Elizabeth Upper, 'Red Frisket Sheets, c. 1490–1700: The Earliest Artifacts of Color Printing in the West', *Papers of the Bibliographical Society of America*, 108(4), 2014, pp. 477–522.

149 See Joseph A. Dane, 'An Early Red-Printed Correction Sheet in the Huntington Library', *Papers of the Bibliographical Society of America*, 110(2), 2016, pp. 227–36, p. 231.

150 ISTC: ib00296700; see A. Stijnman and E. Upper, 'Color Prints before Erhard Ratdolt: Engraved Paper Instruments in Lazarus Beham's *Buch von der Astronomie* (Cologne: Nicolaus Götz, c. 1476)', *Gutenberg-Jahrbuch*, 2014, pp. 86–105.

151 See A. Stijnman and E. Savage, 'Materials and Techniques for Early Colour Printing', in Stijnman and Savage, *Printing Colour 1400–1700*, pp. 11–22, p. 12.

152 The process is described in Stijnman and Upper, 'Color Prints before Erhard Ratdolt', pp. 91–2.

153 See Ignaz Schwarz, *Die Memorabilien des Augsburger Buchdruckers Erhard Ratdolt (1462–1523)*, K.F. Koehler, Leipzig, 1924.

154 9 August 1482; ISTC: ir00094000; Bod-inc: R-034.

155 30 April 1485; ISTC: ib01146900.

156 [Before 4 November] 1485; ISTC: ij00406000; Bod-inc: J-182. See G.R. Redgrave, *Erhard Ratdolt and His Work at Venice*, Chiswick Press, London, 1894, p. 57.

157 ISTC: ib01030000; Bod-inc: B-482. On the schoolmaster printer, see Nicolas Barker, 'The St. Albans Press: The First Punch-Cutter in England and the First Native Typefounder', *Transactions of the Cambridge Bibliographical Society*, 7(3), 1979, pp. 257–78.

158 Joseph A. Dane, 'Two-Color Printing in the Fifteenth Century as Evidenced by Incunables at the Huntington Library', *Gutenberg-Jahrbuch*, 1999, p. 142.

159 Stijnman and Savage, *Printing Colour 1400–1700*, p. 220.

160 *Glossa magistralis Psalterii*, 12 February 1478, ISTC: ip00477000; Bod-inc: P-220. See Stijnman and Savage, *Printing Colour 1400–1700*, p. 25 and note 12.

161 De Hamel, *The Book: A History of the Bible*, 2001, p. 205.

162 J.K. Sowards (ed.), *Collected Works of Erasmus*, vol. 2, University of Toronto Press, Toronto, 1985, p. 399. See also John Gage, *Color and Culture: Practice and Meaning from Antiquity to Abstraction*, University of California Press, Berkeley, 1999, pp. 33–4; and Gregory Jecmen and Freyda Spira, *Imperial Augsburg: Renaissance Prints and Drawings, 1475–1540*, Ashgate Publishing, Farnham, 2012, pp. 67–8.

163 Ad Stijnman, 'Jacob Christoff Le Blon and the Invention of Trichromatic Colour Printing, c.1710', in Stijnman and Savage, *Printing Colour 1400–1700*, pp. 216–18.

164 Ibid., p. xvi.

165 An early sixteenth-century recipe for powdered gold for use in gold pigments. From D.T. Rodgers, B. Raman and H. Reimitz (eds), *Cultures in Motion*, Princeton University Press, Princeton, NJ, 2013, pp. 115–16.

166 R. Zorach and M.W. Phillips, *Gold: Nature and Culture*, Reaktion Books, London, 2016, p. 74.

167 De Hamel, *A History of Illuminated Manuscripts*, p. 105.

168 *Elementa geometriae*, ISTC: ie00113000; Bod-inc: E-036 (shelfmarks: Auct. K 3.19 and Byw. E 1.6.) In the Bodleian copies the dedication is not printed in gold.

169 V. Carter, L. Hellinga, et al., 'Printing With Gold in the Fifteenth Century', *British Library Journal*, 9(1), 1983, pp. 1–13. Zacharias Callierges (*c.* 1473–*c.* 1524) began printing in Venice in 1499. By 1515 he had transferred his press to Rome. See Deno Geanakoplos, *Byzantium and the Renaissance: Greek Scholars in Venice: Studies in the Dissemination of Greek Learning from Byzantium to Western Europe*, Archon Books, Hamden, CT, 1973, pp. 201–2.

170 ISTC: ie00112000; Bod-inc: E-034. See Nicolas Barker, *Aldus Manutius and the Development of Greek Script and Type in the Fifteenth Century*, Fordham University Press, New York, NY, 1985, pp. 69–72.

171 R. Proctor, *The Printing of Greek in the Fifteenth Century*, Bibliographical Society at the Oxford University Press, Oxford, 1900, p. 119.

172 ISTC: it00361000; Bod-inc: T-204; Carter, Hellinga, et al., 'Printing With Gold in the Fifteenth Century', pp. 1–13, p. 13 note 19.

173 USTC: 691414.

174 E.P. Goldschmidt, *The Printed Book of the Renaissance: Three Lectures on Type, Illustration and Ornament*, Cambridge University Press, Cambridge, 1950, p. 19.

175 *La Commedia*, ISTC: id00022000; Bod-inc: D-007.

176 *De officiis*, ISTC: ic00575000; Bod-inc: C-307.

177 Jecmen and Spira, *Imperial Augsburg* pp. 74, 76–7.

178 See Elizabeth Savage, 'Jost de Negker's Woodcut Charles V (1519): An Undescribed Example of Gold Printing', *Art in Print*, (July–August) 2015, pp. 9–15, p. 9.

179 D. Hunter, *Papermaking: The History and Technique of an Ancient Craft*, Dover Publications, New York, 1978, p. 495.

180 Primeau, 'The Materials and Technology of Renaissance and Baroque Hand-Colored Prints', pp. 70–1. Joseph Moxon, *Mechanick Exercises: Or, the Doctrine of Handy-works. Applied to the Art of Printing*, vol. 2, J. Moxon, London, 1683, pp. 331–3, 428.

181 Parshall, *The Woodcut in Fifteenth-Century Europe*, p. 288 and note 55.

182 A recipe for the preparation of mosaic gold is found in the early fourth-century Chinese alchemical manual, *Baopuzi*. Helaine Selin (ed.), *Encyclopaedia of the History of Science, Technology, and Medicine in Non-Westen Cultures*, Springer Science & Business Media, Dordrecht, 2013, p. 186.

183 J. Elkins and R. Williams, *Renaissance Theory*, Routledge, New York and London, 2008, pp. 438–42.

184 From the preface to Aldus's Livy of 1518, translation from Edward S. Rogers, 'Some Historical Matter Concerning Trade-Marks', *Michigan Law Review*, 9(1), 1910, pp. 29–43.

185 Markus Schiegg, 'Scribes' Voices: The Relevance and Types of Early Medieval Colophons', *Studia Neophilologica*, 88(2), 2016, pp. 129–47, p. 129.

186 'Heu male finivi quia scribere non bene scivi': Schiegg, 'Scribes' Voices', p. 135.

187 Cyrus, *The Scribes for Women's Convents in Late Medieval Germany*, pp. 97, 122.

188 Translation of Mainz Psalter colophon from Alfred W. Pollard, *An Essay on Colophons, with Specimens and Translations*, Caxton Club, Chicago, 1905, p. 12.

189 See F.I. Schechter, 'Early printers' and publishers' devices', *Papers of the Bibliographical Society of America*, 19(1), 1925, pp. 11–22; and William Roberts, *Printers' Marks: A Chapter in the History of Typography*, Chiswick Press, London, 1893, pp. 42–3.

190 ISTC: ib00529000; Bod-inc: B-239. This was the fourth edition of the Latin Vulgate Bible, set from a copy of the Gutenberg Bible. The colophon exists in three variants. See Paul Needham, 'The 1462 Bible of Johann Fust and Peter Schöffer (GW 4204): A Survey of its Variants', *Gutenberg-Jahrbuch*, 2006, pp. 19–49.

191 See Stijnman and Savage, *Printing Colour 1400–1700*, pp. 24–5, esp. note 10.

192 Thomas D. Walker, 'The Cover Design', *Library Quarterly: Information, Community, Policy*, 68(1), 1998, pp. 80–81.

193 Pollard, *An Essay on Colophons, with Specimens and Translations*, pp. 21–4.

194 Thirty such devices, mostly Italian, are reproduced in Roberts, *Printers' Marks*, pp. 25, 209 note 1. See also the facsimile reproductions of early printers' devices in P.A. Orlandi, *Origine e progressi della stampa*, Pisarius, Bologna, 1722, p. 228; and J. Ames, *Typographical Antiquities...*, W. Faden, London, 1749.

195 *Rosarium decretorum* (ISTC: ib00288000), Guido de Baysio's commentary on Gratian's *Decretum*.

196 For example, the printers' devices of early sixteenth-century Paris printers, Simon Vostre, Félix Baligault and Thielman Kerver. For fine facsimile reproductions, see Theodore Low De Vinne, *The Practice of Typography: A Treatise on Title-Pages*, Century Co., New York, 1902, pp. 26–9.

197 For the Naples device, see ISTC: ib00742000; for the Rome device, see ISTC: ib01288500 and ib00230500.

198 '...de Argentina': an archaic Latin reference to the city of Strasbourg. For a facsimile of the smaller device, see Vassar College Library, *A list of the printers' marks in the windows of the Frederick Ferris Thompson Memorial Library*, Vassar College, Poughkeepsie, NY, 1917, p. 6.

199 See Marian Harman, *Printer's and Publisher's Devices in Incunabula in the University of Illinois Library*, 1983, no. 5.

200 See Lotte Hellinga, 'William Caxton, Colard Mansion, and the Printer in Type 1', *Bulletin du bibliophile*, 1, 2011, p. 102 note 3.

201 ISTC: im00719200; Bod-inc: M-271 (2 fragments). Caxton commissioned Guillermus Maynyal in Paris to print this work, though Caxton's printer's device was stamped into copies upon their arrival in Westminster. See G.D. Painter, *William Caxton: A Biography*, Putnam, New York, 1977, p. 195.

202 See R.B. McKerrow, *Printers' & Publishers' Devices in England & Scotland, 1485–1640*, Chiswick Press, London, 1913, p. xi.

203 William Blades suggests that the stylized *74* marks the publication of *Recuyell of the historyes of Troye* (ISTC: il00117000), the translation of which into English Caxton had begun in Bruges and completed while exiled in Cologne. See William Blades, *The Biography and Typography of William Caxton, England's First Printer*, Trübner & Co., London, 1877, pp. 137–8. Lotte Hellinga suggests that Caxton's *Recuyell* was published toward the end of 1473 or perhaps very early in 1474. See Hellinga, 'William Caxton, Colard Mansion, and the Printer in Type 1', p. 88.

204 For a brief survey of the Aldine dolphin and anchor device, see Fletcher, *In Praise of Aldus Manutius*, pp. 25–34.

205 From EDIT 16, a database of sixteenth-century printers' and publishers' devices, which lists forty-eight versions of the Aldine dolphin and anchor device.

206 USTC: 838283; Bodleian Library: Auct. 2 R 5.16-19.

207 Quoted from Rogers, 'Some Historical Matter Concerning Trade-Marks', p. 36. See also J. Kostylo, 'Commentary on Aldus Manutius's Warning against the Printers of Lyon (1503)', in 'Primary Sources on Copyright (1450–1900)', ed. L. Bently and M. Kretschmer, 2008, www.copyrighthistory.org; Schechter, 'Early printers' and publishers' devices', p. 3; and Nuovo, *The Book Trade in the Italian Renaissance*, p. 150 note 15.

208 George Putnam, *Books and their Makers during the Middle Ages*, Putnam, London, 1896, pp. 450–3.

209 Reproduced in Charles H. Timperley, *A Dictionary of Printers and Printing: With the Progress of Literature; Ancient and Modern*, ed. H. Johnson, London, 1839, p. 416.

210 Amert and Bringhurst, *The Scythe and the Rabbit*, p. 17.

211 See Nuovo, *The Book Trade in the Italian Renaissance*, p. 153–4; and Ian Maclean, *Learning and the Market Place: Essays in the History of the Early Modern Book*, Brill, Leiden and Boston, 2009, p. 233 note 21.

212 Nuovo, *The Book Trade in the Italian Renaissance*, p. 157 note 37.

213 A Griffin used from 1532 in Lyons by the German printer Sébastien Gryphius (EDIT 16: CNCE 597). The printer's device of the Swiss printer, Christopher Froschover, shows a child astride a rather large frog, alluding to the printer's name Froschover – 'Frosch' being the German for 'frog'.

214 Roberts, *Printers' Marks*, p. 48.

215 Goldschmidt, *The Printed Book of the Renaissance*, p. 79.

216 Stanley Morison, *First Principles of Typography*, Macmillan, New York, 1936.

217 For this chapter I am especially indebted to Smith, *The Title-Page: Its Early Development, 1460–1510*.

218 'The earliest known printed dust jacket was issued in London in 1832 for *The Keepsake*': M.F. Suarez and H.R. Woudhuysen (eds), *The Oxford Companion to the Book*, Oxford University Press, Oxford and New York, 2010, pp. 152, 684.

219 ISTC: ip00655750 (Latin); ISTC: ip00655800 (German). Latin edition in six leaves; German edition, eight leaves. Smith, *The Title-Page: Its Early Development*, p. 38.

220 *Coronatio Maximiliani*, ISTC: im00384000. The title-page is again presented as a paragraph title.

221 *The Practice of Typography*, p. 97; Smith, *The Title-Page: Its Early Development*, p. 40. Or 'label "title-page"': A.W. Pollard, *Last Words on the History of the Title-Page*, Chiswick Press, London, 1891, p. 15.

222 Smith, *The Title-Page: Its Early Development*, p. 97: 'Even at the end of the [fifteenth century], well over 40% of the editions still had their dates printed nowhere in the book.'

223 Ibid., p. 44 note 18.

224 Latin (ISTC: ir00093000) and Italian editions (ISTC: ir00103000) dated 1476; and a German edition dated 1478 (ISTC: ir00100500). See also Redgrave, *Erhard Ratdolt and His Work at Venice*, pp. 6, 7, 28, 31.

225 For examples representative of their style, see Stanley Morison, *Four Centuries of Fine Printing*, second edition, Ernest Benn Ltd, London, 1949, p. 120 (USTC: 146801) and p. 170 (USTC: 11321).

226 Mayor, *Prints & People*, 1971, pp. 211–14. For the differentiation of its use in bibliography and in art history, see the entry in Smith, *The Title-Page: Its Early Development*, Glossary, p. 147.

227 See M. Corbett and R.W. Lightbown, *The Comely Frontispiece: The Emblematic Title-page in England, 1550–1660*, Routledge and Kegan Paul, London, 1979.

228 ISTC: ic00430000; Bod-inc: C-171; ESTC: S106568. GW assigns to 'about 1494.' See Blades, *The Biography and Typography of William Caxton*, 1877, p. 45. For Wynkyn de Worde's title-page, see ibid., pp. 355–6. On the contents of this title, see T.F. Dibdin, *Bibliotheca Spenceriana*, vol. 4, Shakspeare Press, Northampton, England, 1815, pp. 336–9.

229 Three editions (ESTC: S91355; S111592; S111595) of this book were printed at about the same time by William de Machlinia. Only the edition held by the British Library (ISTC: ij00013600; ESTC: S111595) bears a label-title on a separate page. A photograph of the label-title is reproduced in W.T. Berry and H.E. Poole, *Annals of Printing: A Chronological Encyclopaedia from the Earliest Times to 1950*, Blandford Press, London, 1966, p. 58. On the dating and for a full facsimile reproduction of one of the other editions (ISTC: ij00013200; ESTC: S91355), see G. Vine, *The John Rylands Facsimiles, No. 3, 'A litl boke for the Pestilence'*, Manchester University Press, Manchester, 1910.

230 *Novum epistolarium*, ISTC: ip00617000; Bod-inc: P-280; See A.F. Johnson, *The First Century of Printing at Basle*, Charles Scribner's Sons, New York, NY, 1926, p. 7.

231 Erasmus's name appears in the 'half-title', title-page and the paragraph-title above the opening text. For example, in the *Opera* of 1516 (VD 16: H3482; USTC: 679364).

232 Sowards, *Collected Works of Erasmus*. As cited in B.C. Halporn, *The Correspondence of Johann Amerbach*, University of Michigan Press, Ann Arbor, MI, 2000, pp. 362–3.

233 B.H. Bronson, *Facets of the Enlightenment: Studies in English Literature and its Contexts*, University of California Press, Berkeley and Los Angeles, 1968, pp. 343–55.

234 See the title-pages reproduced in F.E. Pardoe, *John Baskerville of Birmingham: Letter-Founder & Printer*, F. Muller, London, 1975, pp. 49, 85, 86.

235 Isidore of Seville, *The Etymologies of Isidore of Seville*, translated with introduction and notes by Stephen A. Barney, et al., Cambridge University Press, Cambridge and New York, NY, 2006, III.xvi.1, p. 95.

236 Ibid., III.xiv.2, p. 95.

237 Jeremy Yudkin, *Music in Medieval Europe*, Prentice Hall, Englewood Cliffs, NJ, 1989, p. 16.

238 See Carl Parrish, *The Notation of Medieval Music*, Pendragon Press, New York, NY, 1978, pp. 4–5.

239 Joseph Otten, 'Guido of Arezzo', *The Catholic Encyclopedia*, vol. 7, Robert Appleton Co., New York, 1910.

240 Jane A. Bernstein, *Print Culture and Music in Sixteenth-century Venice*, Oxford University Press, Oxford, 2001, p. 20.

241 ISTC: ig00329700. On the dating, provenance and significance of the Southern German gradual, see Alec Hyatt King, 'The 500th Anniversary of Music Printing: The Gradual of c1473', *Musical Times*, 114(1570), 1973, pp. 1220–3. Ohly makes a case for Heinrich Eggestein as the printer of the *c*. 1474 gradual: see K. Ohly, 'Eggestein, Fyner, Knoblochtzer. Zum Problem des deutschsprachigen Belial mit Illustrationen', *Gutenberg-Jahrbuch*, 1962, pp. 122–35. Scholderer, however, assigns the work to an anonymous printer in Strasbourg, 'maintaining close relations with Eggestein': Scholderer, *Fifty Essays in Fifteenth- and Sixteenth-century Bibliography*, pp. 224–8. On the Early Modern

printing of graduals, see R.J. Agee, 'The Printed Dissemination of the Roman Gradual in Italy during the Early Modern Period', *Notes*, 64(1), 2007, pp. 9–42.

242 ISTC: ig00199000; Bod-inc: G-112.

243 King, 'The 500th Anniversary of Music Printing: The Gradual of c1473', p. 1220 note 1.

244 12 October 1476, ISTC: im00689000.

245 ISTC: im00688500; Bod-inc: M-266.

246 Mary Kay Duggan, *Italian Music Incunabula, Printers and Type*, University of California Press, Berkeley, CA, 1992, p. 45. Early music printing also included examples of printed staves (awaiting the later addition of notes in manuscript); see, for example, Bartholomaeus Ramus's *Musica practica*, printed at Bologna in 1482; and conversely examples of notes printed without staves, or *in campo aperto* (literally, 'in an open field'), as in Franciscus Niger's quarto format *Grammatica* of 1480 (ISTC: in00226000; Bod-inc: N-104).

247 Ulrich Han's successor, Stephan Planck, used Han's music type from 1482, with the publication of a folio *Missale Romanum* (ISTC: im00692400).

248 Translation of Ulrich Han's colophon from Duggan, *Italian Music Incunabula, Printers and Type*, p. 80.

249 10 April 1477; ISTC: ig00329800.

250 James Haar (ed.), *European Music, 1520–1640*, Boydell & Brewer Ltd, Woodbridge, 2014, p. 282.

251 For an overview of the Venetian privilege system, see Horatio F. Brown, *The Venetian Printing Press 1469–1800*, J.C. Nimmo, London, 1891, pp. 51–9: 'Monopolies, copyrights, patents, and all other special concessions from the government on the subject of books and of printing are known under the generic name of privileges (*privilegii*)', p. 51. On music printing privileges, see R.J. Agee, 'The Venetian Privilege and Music-printing in the Sixteenth Century', *Early Music History*, 3, 1983, pp. 1–42.

252 Boorman, *Ottaviano Petrucci* 2005, pp. 77–8. See Jane A. Bernstein, *Music Printing in Renaissance Venice: The Scotto Press (1539–1572)*, Oxford University Press, Oxford and New York, 1998, pp. 36–7; and Bernstein, *Print Culture and Music in Sixteenth-century Venice*, p. 120. For an excellent and comprehensive discussion of the 1498 privilege granted to Petrucci, see J. Kostylo, 'Commentary on Ottaviano Petrucci's music printing patent (1498)', in 'Primary Sources on Copyright (1450–1900)', ed. L. Bently and M. Kretschmer, www.copyrighthistory.org.

253 William Cummings, 'Music Printing', *Proceedings of the Musical Association*, 11th Sess. (1884–1885), 1885, p. 103.

254 Stanley Boorman, 'The "First" Edition of the Odhecaton A', *Journal of the American Musicological Society*, 30(2), 1977, pp. 183–207.

255 Pietro Bembo's letter of 1513 is reproduced in full, in English translation, in Cummings, 'Music Printing', pp. 103–4.

256 Perhaps the earliest example of printed music from metal engravings is Francesco da Milano's *Intabolatura di liuto de diversi*, c. 1536 (EDIT 16: 43606). Printing from metal engraving was not popularized until the late sixteenth-century invention of the rolling press.

257 Only fragmentary evidence of Rastell's single-impression music printing has survived, including a three-voice song, 'Tyme to pas with goodly sport' that is part of a play-text; and a cropped broadside that contains just thirty notes of a polyphonic song. Reproduced in J. Milsom, 'Songs and Society in Early Tudor London', *Early Music History*, 1997, 16, pp. 242–4. See also Samuel F. Pogue, 'The Earliest Music Printing in France', *Huntington Library Quarterly*, 50(1), 1987, pp. 35–57, p. 36; and A. King, 'The Significance of

John Rastell in Early Music Printing', *The Library*, 26(3), 1971, pp. 197–214. On earlier experiments with single-impression printing of plainchant, see Stanley Boorman, 'The Salzburg Liturgy and Single-Impress Music Printing', in *Music in the German Renaissance: Sources, Styles, and Contexts*, ed. J. Kmetz, Cambridge University Press, Cambridge, 1994, pp. 235–53. Daniel Heartz, *Pierre Attaingnant, Royal Printer of Music: A Historical Study and Bibliographical Catalogue*, University of California Press, Berkeley, 1969.

258 Daniel Heartz, 'Typography and Format in Early Music Printing: With Particular Reference to Attaingnant's First Publications', *Notes*, 23(4), 1967, pp. 702–6, pp. 704–5.

259 Bernstein, *Music Printing in Renaissance Venice*, pp. 27–8.

260 ISTC: im00692700.

261 ISTC: im00691000.

262 Pettegree, *The Book Trade in the Renaissance*, 2010, p. 173.

263 John Milton, 'On the Music of the Spheres' (publ. 1674).

264 Homer, *Odyssey*, English translation by A.T. Murray. Harvard University Press Cambridge, MA, and William Heinemann, Ltd, London, 1919, Book 1.

265 Wayne Horowitz, *Mesopotamian Cosmic Geography*, Eisenbrauns, Winona Lake, IN, 1998, p. 41.

266 J.B. Harley and David Woodward (eds), *The History of Cartography, Vol. 1: Cartography in Prehistoric, Ancient, and Medieval Europe and the Mediterranean*, University of Chicago Press, Chicago, IL, 1987, pp. 286, 342. J. Harley, about European cartography since the seventeenth century, writes, 'The map-maker is often as busy recording the contours of feudalism, the shape of a religious hierarchy, or the steps in the tiers of social class, as the topography of the physical and human landscape': J. Harley, 'Deconstructing the Map', in *Classics in Cartography: Reflections on Influential Articles from Cartographica*, ed. Martin Dodge, John Wiley & Sons, Chichester, 2010, pp. 273–94, p. 276. On religion's influence on medieval mapmaking, see Pauline Moffitt Watts, 'The European Religious Worldview and Its Influence on Mapping' in *The History of Cartography, Vol. 3: Cartography in the European Renaissance*, ed. David Woodward, pp. 382–400.

267 In China, the *Dili zhi tu* dates to the early twelfth century. For discussion and a reproduction, see Woodward, *The History of Cartography, Vol. 3: Cartography in the European Renaissance*, pp. 591–2.

268 See Evelyn Edson, *Mapping Time and Space: How Medieval Mapmakers Viewed Their World*, British Library, London, 1997, pp. 41–2.

269 ISTC: ii00181000; Bod-inc: I-035; woodcut diameter: 65 mm. A more elaborate version of Isidore's T-O map was issued in a *c.* 1476 edition of *Etymologiae*, printed in Cologne (ISTC: ii00183000). Some two decades later, in Florence, appeared the first polychromatic T-O map, printed full-page in red and black (*Orbis breviarium*. 1493; ISTC: il00218000).

270 See Patrick Gautier Dalché, 'The Reception of Ptolemy's Geography (End of the Fourteenth to Beginning of the Sixteenth Century)', in *The History of Cartography, Vol. 3: Cartography in the European Renaissance*, ed. David Woodward, pp. 285–364. On manuscript exemplars for the earliest printed editions of Ptolemy's *Geographia*, see Chet Van Duzer, 'Ptolemy from Manuscript to Print: New York Public Library's Codex Ebnerianus (MS MA 97)', *Imago Mundi*, 67:1, 2015, pp. 1–11.

271 ISTC: ip01082000; Bod-inc: P-531. The first, and unillustrated, edition of Ptolemy's work was printed by Hermannus Liechtenstein in Vicenza, 13 September 1475 (ISTC: ip01081000; Bod-inc: P-526).

272 ISTC: ip01083000; Bod-inc: P-527. The twenty-seven copper plates for this edition were used again for an edition of 1490, put out by Petrus de Turre in Rome (ISTC: ip01086000; Bod-inc: P-530).

273 *Historia naturalis*, Rome, 7 May 1473. ISTC: ip00789000; Bod-inc: P-361.

274 See Adrian Wilson and J. Lancaster Wilson, *The Making of the Nuremberg Chronicle*, Nico Israel, Amsterdam, 1976; and D.C. Duniway, 'A Study of the Nuremberg Chronicle', *Papers of the Bibliographic Society of America*, 35, 1941, pp. 17–34.

275 See Füssel, *Gutenberg and the Impact of Printing*, pp. 118–20.

276 *Liber chronicarum*, 12 July 1493 (ISTC: is00307000; Bod-inc: S-108).

277 *Das Buch der Croniken und Geschichten*, 23 December 1493 (ISTC: is00309000; Bod-inc: S-110).

278 Ptolemy's *Geographia* continued to be printed in the first decades of the sixteenth century with revised maps; for example, a Venetian edition, printed for Giacomo Penzio in 1511 (USTC: 851475; Bodleian Library: Vet. F1 b.6); its full title, *Liber geographiae cum tabulis et universali figura et cum additione locorum quae a recentioribus reperta sunt diligenti cura emendatus et impressus*, stated that it incorporated recent discoveries into Ptolemy's maps. These woodcut maps, with metal type for place-names, are notable for their printing in two colours (red and black).

279 See Tony Campbell, *The Earliest Printed Maps 1472–1500*, University of California Press, Berkeley, 1987.

280 Its full title was *Universalis cosmographia secunda Ptholemei traditionem et Americi Vespucci aliorum que lustrationes* ('A drawing of the whole earth following the tradition of Ptolemy and the travels of Amerigo Vespucci and others'). For an enlightening and entertaining introduction to the 1507 Waldseemüller map, see chapter 5 of Jerry Brotton's *A History of the World in Twelve Maps*, Penguin, New York, 2012.

281 See Library of Congress, 'Library of Congress Completes Purchase of Waldseemüller Map', www.loc.gov/item/prn-03-110/.

282 One source notes that once they had reached Jerusalem they numbered about 150 persons in all. See Hugh William Davies, *Bernhard von Breydenbach and his Journey to the Holy Land 1483–4. A Bibliography*, J. & J. Leighton, London, 1911, p. v.

283 ISTC: ib01189000; Bod-inc: B552; shelfmark: Arch. B c.25; GW: 5075.

284 Wordsworth, *The Prelude*, Book 5, 1805.

285 For examples see Kathryn Rudy, 'An Illustrated Mid-Fifteenth-Century Primer for a Flemish Girl: British Library, Harley MS 3828*', *Journal of the Warburg and Courtauld Institutes*, 69, 2006, pp. 51–94.

286 Füssell, *Gutenberg and the Impact of Printing*, pp. 30–31. Some early editions of Donatus (surviving only in fragments) date to the 1450s. On their early printing, see: W.O. Schmitt, 'Die Ianua (Donatus): Ein Beitrag zur lateinischen Schulgrammatik des Mittelalters und der Renaissance', *Beiträge zur Inkunabelkunde*, 3(4), 1969, pp. 43–80.

287 ISTC: ia00116000; Bod-inc A-053. Translation by Heinrich Steinhöwel, the town doctor of Ulm. Reprinted by Günther Zainer in Augsburg, *c.* 1477–78 (ISTC: ia00119000) with some 190 woodcuts; and by Anton Sorg, *c.* 1479 (ISTC: ia00120000). The woodcut designs were much copied, finding their way to England, France and the Low Countries. On the Ulm Aesop, see Füssel, *Gutenberg and the Impact of Printing*, pp. 124–6; and Martin Davies, 'A Tale of Two Aesops', *The Library*, 7(3), 2006, pp. 257–88.

288 John Locke, *Some Thoughts Concerning Education*, n.p., London, 1693, §156.

289 ISTC: ia00117500; Bod-inc: A-054; shelfmark: Arch. G d.13(4). Translated by Caxton, from the French collection made by Julien Macho.

290 ISTC: ib01029500. See Alessandra Petrina, 'Young Man, Reading: Caxton's Book of Curtesye', in *MedieVaria. Un liber amicorum per Giuseppe Brunetti*, ed. A. Petrina, Unipress, Padua, 2011, pp. 115–34.

291 Wynkyn de Worde dominated the market for grammars, with 30 per cent of his output devoted to grammars by John Stanbridge and Robert Whittinton alone. See V. Gillespie and S. Powell, *A Companion to the Early Printed Book in Britain, 1476–1558*, Boydell & Brewer Ltd, Woodbridge, 2014, p. 32.

292 R.C. Alston, *A Bibliography of the English Language from the Invention of Printing to the Year 1800. Volume XV: Greek, Latin to 1650*, E. J. Arnold & Son, Leeds, 2001.

293 USTC: 516129; ESTC: S124868. Thanks to Peter Kilpe for bringing this edition to my attention.

294 M. Grenby, 'Chapbooks, Children, and Children's Literature', *The Library*, 8(3), 2007, pp. 277–303.

295 Ibid., p. 283. Printed editions of Robin Hood appear in London and York in England at the very beginning of the sixteenth century. See Bod-inc: R-080 (ISTC: ir00209000) and Bod-inc: R-081 (ISTC: ir00208950).

296 See H.G. Good, 'The "First" Illustrated School-Books', *Journal of Educational Research*, 35(5), 1942, pp. 338–43.

297 See the spread reproduced in facsimile in Berry and Poole, *Annals of Printing*, p. 133.

298 See also Ernst Schulz, *Das erste Lesebuch an den Lateinschulen des späten Mittelalters*, Verlag der Gutenberg-Gesellschaft, Mainz, 1929, pp. 18–30.

299 For a discussion of de Madiis's *Zornale*, see M. Walsby and N. Constantinidou, *Documenting the Early Modern Book World: Inventories and Catalogues in Manuscript and Print*, Brill, Leiden and Boston, 2013, chapter 14 and p. 401.

300 Rudy, 'An Illustrated Mid-Fifteenth-Century Primer', pp. 51–94, p. 60.

301 Type 9:130G (Typenrepertorium der Wiegendrucke).

302 ISTC: ia00928000; Bod-inc A-363.

303 Figures obtained from a search of the incunabula catalogue, Gesamtkatalog der Wiegendrucke.

304 Matthew 20:16.

305 *Elementa geometriae*, ISTC: ie00113000; Bod-inc: E-036(1 & 2), shelfmarks: Auct. K 3.19. & Byw. E 1.6. Renzo Baldasso, 'La stampa dell'editio princeps degli Elementi di Euclide (Venezia, Erhard Ratdolt, 1482)', in *The Books of Venice/Il libro veneziano*, ed. Lisa Pon and Craig Kallendorf, La Musa Talìa, Venice and Oak Knoll Press, New Castle, DE, 2009, pp. 61–100. Baldasso proposes that Ratdolt employed thin metal strips, or printer's rules, set in plaster, to print the geometrical figures accompanying the text.

306 ISTC: ir00029840.

307 R. Hirsch, *Printing, Selling and Reading, 1450–1550*, Harrassowitz, Wiesbaden, 1967, p. 118 note 18.

308 ISTC: il00117000; Bod-inc: L-060.

309 ISTC: ic00413000; Bod-inc: C-168 (shelfmark: Arch. G d.2.). On its place of printing, see Hellinga, 'William Caxton, Colard Mansion, and the Printer in Type 1', pp. 86–114.

310 P. Needham, *The Printer & the Pardoner: An Unrecorded Indulgence Printed by William Caxton for the Hospital of St. Mary Rounceval, Charing Cross*, Library of Congress, Washington, DC, 1986, pp. 32, 61.

311 *Circa* 1476–7, ISTC: ic00431000; Bod-inc: C-172 (shelfmark: Douce Fragm. e.3.). See also Knight, *Historical Types*, pp. 20–1.

312 ISTC: ic00355700; Bod-inc: C-155 (shelfmark: Arch. G e.37). Printed in Caxton's Type 3:136G.

313 *Ordinale seu Pica ad usum Sarum*, surviving only in fragments. ISTC: io00087500
(dates 1476/77); STC: 16228 (dates 1477); GW 8455 (dates 1477/78). Paul Needham
assigns the ordinal and advertisement to 1477. See Needham, *The Printer & the Pardoner*,
p. 82. 'Pie' (or Pica) alludes to the size of the type.

314 Updike, *Printing Types, Their History, Forms, and Use*, pp. 116–17.

315 STC: 12413. J.B. Trapp, 'The Humanist Book', in *The Cambridge History of the Book in Britain*,
ed. L. Hellinga and J.B. Trapp, Cambridge University Press, Cambridge, 1999, p. 290.

316 Specifically on the rise of roman type in the latter half of sixteenth-century England,
see W.C. Ferguson, *Pica Roman Type in Elizabethan England*, Bower Publishing Co.,
Brookfield, VT, 1989.

317 On the early history of typography and type-founding in Scotland, see A J. Mann,
'The Anatomy of the Printed Book in Early Modern Scotland', *Scottish Historical Review*,
80(210), 2001, pp. 181–200; A. J. Mann, *The Scottish Book Trade 1500 to 1720: Print
Commerce and Print Control in Early Modern Scotland*, Tuckwell Press, East Linton, 2000;
and A.F. Johnson 'Type Designs and Type-founding in Scotland', in *Selected Essays on
Books and Printing*, ed. P. Muir, Van Gendt & Co., Amsterdam, 1970, pp. 312–26. See
also J. Hinks, 'The Book Trade in Early Modern Britain', in *Print Culture and Peripheries
in Early Modern Europe*, ed. B.R. Costas, Brill, Leiden and Boston, 2013: 'Printing was
deliberately introduced to Scotland in 1507 by James IV "for nationalistic, cultural
and patriotic reasons"', p. 120. One of the first, if not the first book, to be issued by
Chepman and Myllar's press was *The mayng or disport of Chaucer*, dated 4 April 1508.
ESTC: S114461; USTC: 501013.

318 USTC: 517883; ESTC: S93748. Raymond Gillespie and Andrew Hadfield (eds),
The Oxford History of the Irish Book, Vol. 3: The Irish Book in English, 1550–1800, Oxford
University Press, Oxford, 2006, p. 63.

319 *Breviarium Othoniense* (Odense), ISTC: ib01173400.

320 During the incunabula period only two Scandinavian nations printed books, Denmark
and Sweden, with about twenty-three editions produced between 1482 and 1500. See
Wolfgang Undorf, *From Gutenberg to Luther: Transnational Print Cultures in Scandinavia
1450–1525*, Brill, Leiden and Boston, 2014, p. 11.

321 A broadside almanac for the year 1474, ISTC: ia00491550. The first book in the Polish
language appeared in 1475 from the press of Caspar Elyan in Breslau (Wrocław);
ISTC: is00755300.

322 13 December 1493; ISTC: ij00000300; Bod-inc: Heb-44, shelfmark: Opp.fol.724.
See A.K. Offenberg, 'The Printing History of the Constantinople Hebrew Incunable
of 1493: A Mediterranean Voyage of Discovery', *British Library Journal*, 22(2), 1996,
pp. 221–35. On the dating of this edition, see A.K Offenberg, *A Choice of Corals: Facets
of Fifteenth- Century Hebrew Printing*, De Graaf, Nieuwkoop, 1992, pp. 102–32.

323 ISTC: im00079400; Bod-inc: Heb-58. Bibliothèque nationale du Canada and Brad
Sabin Hall, *Incunabula, Hebraica & Judaica*, exhibition catalogue, National Library of
Canada, 1981, p. 3. On the date and place of printing, see A.K. Offenberg, review of
'David Goldstein, *Hebrew Incunables in the British Isles: A Preliminary Census*, London
1985', *The Library*, sixth series, 8(1), 1986, p. 72.

324 ISTC: is00625180. 'The earliest dated Rashi of Reggio, was finished on the 10th of
Adar, 1475, which is the 18th, not the 5th, of February': Alexander Marx, 'Hebrew
Incunabula', *Jewish Quarterly Review*, 11(1), 1920, pp. 98–119, p. 101.

325 ISTC: ic00575000; Bod-inc: C-307. On the early history of Greek printing types,
see Proctor, *The Printing of Greek in the Fifteenth-century*.

326 ISTC: ih00065000 (Bod-Inc: L-038) and ih00300800. E. Layton, 'The Earliest Printed Greek Book', *Journal of the Hellenic Diaspora*, 5(4), 1979, pp. 63–79, pp. 69–70.

327 ISTC: ih00484300 and i000022250.

328 Philip K. Hitti, 'The First Book Printed in Arabic', *Princeton University Library Chronicle*, 4(1), 1942, pp. 5–9, p. 9. Miroslav Krek, 'The Enigma of the First Arabic Book Printed from Movable Type', *Journal of Near Eastern Studies*, 3, 1979, pp. 203–12.

329 *Sermo in festo praesentationis beatissimae Mariae virginis*, ISTC: ir00303000. On printed foliation, see Margaret M. Smith, 'Printed Foliation: Forerunner to Printed Page-Numbers?', *Gutenberg-Jahrbuch*, 1988, pp. 54–7.

330 ISTC: ih00160800. Bod-inc: H-081. ISTC assigns to 'not after 1467'. On the dating of this edition, see D.E. Rhodes, review of Bennett Gilbert, '*A Leaf from the Letters of St. Jerome, First Printed by Sixtus Reissinger, Rome, c. 1466–1467*, London, 1981,' *The Library*, 6th series, 5, 1983, pp. 68–71. Colin Clair, *A Chronology of Printing*, Praeger, New York and Washington, DC, 1969, p. 13.

331 ISTC: ia00297000. E.E. Willoughby, 'The Cover Design', *Library Quarterly: Information, Community, Policy*, 22(3), 1952, p. 302.

332 *Enarrationes Satyrarum Juvenalis*, ISTC: im00501000; Bod-inc: M-200.

333 ISTC: ir00352000; Bod-inc: R-148. The work of an anonymous printer preceding Theodoric Rood. Some have tentatively attributed to Rood. See Ian Gadd (ed.) *History of Oxford University Press, Vol. 1: Beginnings to 1780*, Oxford University Press, Oxford, 2013, pp. 41–4. Rood's press was 'completely distinct from its precursor', p. 41; and Lotte Hellinga, 'the Rufinus edition…was certainly not the product of a full-fledged printing house, such as that set up in Oxford by Theodericus Rood a few years later': L. Hellinga, *Texts in Transit*, p. 221 (based on an earlier work published in 1978, see p. 218 note 1).

334 The British Library's ISTC, now hosted by CERL, records 30,523 editions as of March 2017. http://data.cerl.org/istc/_stats (accessed 8 October 2017).

335 E.M. White, 'The Gutenberg Bibles that Survive as Binders' Waste', in *Early Printed Books as Material Objects*, ed. B. Wagner and M. Reed, De Gruyter Saur, Berlin and New York, 2010, pp. 21–38.

Further Reading

Agee, R.J., 'The Venetian Privilege and Music-Printing in the Sixteenth Century', *Early Music History*, 3, 1983, pp. 1–42

Agee, R.J., 'The Printed Dissemination of the Roman Gradual in Italy during the Early Modern Period', *Notes*, 64(1), 2007, pp. 9–42

Alexander, J.J.G. (ed.), *The Painted Page: Italian Renaissance Book Illumination, 1450–1550*, Prestel-Verlag, Munich, 1994

Allmand, C., and R. McKitterick, *The New Cambridge Medieval History, Vol. 2: c. 700–c. 900*, Cambridge University Press, Cambridge, 1995

Allmand, C., and R. McKitterick, *The New Cambridge Medieval History, Vol. 7: c. 1415–c. 1500*, Cambridge University Press, Cambridge, 1998

Alston, R.C., *A Bibliography of the English Language from the Invention of Printing to the Year 1800 Vol. XV: Greek, Latin to 1650*, E.J. Arnold & Son, Leeds, 2001

Amert, K., and R. Bringhurst, *The Scythe and the Rabbit*, RIT Press, Rochester, NY, 2012

Ames, J., *Typographical Antiquities…*, W. Faden, London, 1749

Amram, D.W., *The Makers of Hebrew Books in Italy: Being Chapters in the History of the Hebrew Printing Press*, Edward Stern and Co. Inc., Philadelphia, PA, 1909

Angerhofer, P.J., et al., *In Aedibus Aldi: The Legacy of Aldus Manutius and his Press*, Brigham Young University Library, Provo, UT, 1995

Ashok, R., et al., *Artists' Pigments: A Handbook of their History and Characteristics*, 4 vols, National Gallery of Art, Washington, DC, 1987, 1994, 1997, 2007

Barker, N., 'The St. Albans Press: The First Punch-Cutter in England and the First Native Typefounder', *Transactions of the Cambridge Bibliographical Society*, 7(3), 1979, pp. 257–78

Barker, N., 'Aldus Manutius: Mercantile Empire of the Intellect', *Occasional Papers*, 3, UCLA, Los Angeles, CA, 1989, pp. 1–25

Barker, N., *Aldus Manutius and the Development of Greek Script and Type in the Fifteenth Century*, Fordham University Press, New York, NY, 1992

Barker, N. (ed.), *A Potencie of Life: Books in Society*, Oak Knoll Press, New Castle, DE, 2001

Batchelor, D., *Chromophobia*, Reaktion Books, London, 2000

Baurmeister, U., 'Clement de Padoue, enlumineur et premier imprimeur italien?', *Bulletin du Bibliophile*, 1, 1990

Beach, A., *Women as Scribes: Book Production and Monastic Reform in Twelfth-Century Bavaria*, Cambridge University Press, Cambridge, 2004

Beech, B., 'Charlotte Guillard: A Sixteenth-Century Business Woman', *Renaissance Quarterly*, 36(3), 1983, pp. 345–67

Bently, L., and M. Kretschmer (eds), 'Primary Sources on Copyright (1450–1900)', www.copyrighthistory.org

Bernstein, J.A., *Music Printing in Renaissance Venice: The Scotto Press (1539–1572)*, Oxford University Press, Oxford and New York, 1998

Bernstein, J.A., *Print Culture and Music in Sixteenth-century Venice*, Oxford University Press, Oxford, 2001

Berry, W.T., and H.E. Poole, *Annals of Printing: A Chronological Encyclopaedia from the Earliest Times to 1950*, Blandford Press, London, 1966

Bibliothèque nationale du Canada and Brad Sabin Hall, *Incunabula, Hebraica & Judaica*, exhibition catalogue, National Library of Canada, 1981

Bietenholz, P.G. (ed.), *Contemporaries of Erasmus: A Biographical Register of the Renaissance and Reformation*, University of Toronto Press, Toronto, 2003

Bischoff, B., *Latin Palaeography: Antiquity and the Middle Ages*, Cambridge University Press, Cambridge, 1990

Blades, W., *The Biography and Typography of William Caxton, England's First Printer*, Trübner & Co., London, 1877

Boorman, S., 'The "First" Edition of the Odhecaton A', *Journal of the American Musicological Society*, 30(2), 1977, pp. 183–207

Boorman, S., 'The Salzburg Liturgy and Single-Impress Music Printing', in *Music in the German Renaissance: Sources, Styles, and Contexts*, ed. J. Kmetz, Cambridge University Press, Cambridge, 1994, pp. 235–53

Boorman, S., *Ottaviano Petrucci: Catalogue Raisonné*, Oxford University Press, Oxford, 2005

Braches, E., and A.E.C. Simoni, 'Gutenberg's "scriptorium"', *Quaerendo*, 21(2), 1991, pp. 83–98

Bringhurst, R., *The Elements of Typographic Style*, Hartley & Marks, Dublin, 2005

Bronson, B.H., *Facets of the Enlightenment: Studies in English Literature and its Contexts*, University of California Press, Berkeley and Los Angeles, 1968

Broomhall, S., *Women and the Book Trade in Sixteenth-Century France*, Ashgate, Farnham, 2002

Brotton, J., *A History of the World in Twelve Maps*, Penguin, New York, NY, 2012

Brown, H.F., *The Venetian Printing Press 1469–1800*, J.C. Nimmo, London, 1891

Browne, M.W., 'A Beam of Protons Illuminates Gutenberg's Genius: A New Examination Reveals Details of the Earliest Use of Movable Type', *New York Times*, 12 May 1987

Brownrigg, L.L. (ed.), *Medieval Book Production: Assessing the Evidence*, Anderson-Lovelace, Los Altos Hills, CA, 1990

Burckhardt, J., *The Civilization of the Renaissance in Italy*, Penguin, London, 1990

Buringh, E., *Medieval Manuscript Production in the Latin West*, Brill, Leiden and Boston, 2011

Buringh, E., and J.L. van Zanden, 'Charting the "Rise of the West": Manuscripts and Printed Books in Europe, a Long-Term Perspective from the Sixth through Eighteenth Centuries', *Journal of Economic History*, 69(2), 2009, pp. 409–45

Cameron, E. (ed.), *The New Cambridge History of the Bible, Vol. 3: From 1450 to 1750*, Cambridge University Press, Cambridge, 2016

Camille, M., *Image on the Edge: The Margins of Medieval Art*, Reaktion Books, London, 2004

Campbell, T., *The Earliest Printed Maps 1472–1500*, University of California Press, Berkeley, 1987

Carleton-Paget, J., and Joachim Schaper (eds), *New Cambridge History of the Bible, Vol. 1: From the Beginnings to 600*, Cambridge University Press, Cambridge, 2013

Carter, H., *A View of Early Typography up to about 1600*, Oxford University Press, Oxford, 1969

Carter, V., L. Hellinga, et al., 'Printing with Gold in the Fifteenth Century', *British Library Journal*, 9(1), 1983, pp. 1–13

Chappell, W., *A Short History of the Printed Word*, Hartley & Marks, Vancouver, 1999

Christian, J., 'Toward a Cultural History of Cartography', *Imago Mundi*, 48, 1996, pp. 191–8

Clair, C., *Christopher Plantin*, Cassell, London, 1960

Clair, C., *A Chronology of Printing*, Praeger, New York and Washington, DC, 1969

Clemens, R., and T. Graham, *Introduction to Manuscript Studies*, Cornell University Press, Ithaca, NY, and London, 2007

Cohen, S., *The Evolution of Women's Asylums Since 1500: From Refuges for ex-Prostitutes to Shelters for Battered Women*, Oxford University Press, Oxford, 1992

Corbett, M., and R.W. Lightbown, *The Comely Frontispiece: The Emblematic Title-page in England, 1550–1660*, Routledge and Kegan Paul, London, 1979

Costas, B.R. (ed.), *Print Culture and Peripheries in Early Modern Europe*, Brill, Leiden and Boston, 2013

Cummings, W.H., 'Music Printing', *Proceedings of the Musical Association*, 11th Sess. (1884–1885), 1885, pp. 99–116

Cyrus, C.J., *The Scribes for Women's Convents in Late Medieval Germany*, University of Toronto Press, Toronto, Buffalo and London, 2009

Dackerman, S., *Painted Prints: The Revelation of Color in Northern Renaissance and Baroque Engravings, Etchings, & Woodcuts*, Penn State Press, University Park, PA, 2002

Dane, J.A., 'Two-Color Printing in the Fifteenth Century as Evidenced by Incunables at the Huntington Library', *Gutenberg-Jahrbuch*, 1999, pp. 131–45

Dane, J.A., *Out of Sorts: On Typography and Print Culture*, University of Pennsylvania Press, Philadelphia and Oxford, 2011

Dane, J.A., 'An Early Red-Printed Correction Sheet in the Huntington Library', *Papers of the Bibliographical Society of America*, 110(2), 2016, pp. 227–36

Davies, H.W., *Bernhard von Breydenbach and his Journey to the Holy Land 1483–4. A Bibliography*, J. & J. Leighton, London, 1911

Davies, M., *Aldus Manutius: Printer and Publisher of Renaissance Venice*, British Library, London, 1995

Davies, M., 'Juan de Carvajal and Early Printing: The 42-line Bible and the Sweynheym and Pannartz Aquinas', *The Library*, 18(3), 1996, pp. 193–215

Davies, M., 'A Tale of Two Aesops', *The Library*, 7(3), 2006, pp. 257–88

De Hamel, C., *A History of Illuminated Manuscripts*, Phaidon, London, 1994

De Hamel, C., *The Book: A History of the Bible*, Phaidon, London, 2001

De la Mare, A.C., and L. Nuvoloni, *Bartolomeo Sanvito: The Life and Work of a Renaissance Scribe*, Association Internationale de Bibliophilie, London, 2009

Derolez, A., *The Palaeography of Gothic Manuscript Books: From the Twelfth to the Early Sixteenth Century*, Cambridge University Press, Cambridge, 2003

De Vinne, T., *The Practice of Typography: A Treatise on Title-Pages*, Century Co., New York, 1902

Dibdin, T.F., *Bibliotheca Spenceriana*, vol. 4, Shakspeare Press, Northampton, England, 1815

Dijstelberge, P., and A.R.A. Croiset van Uchelen (eds), *Dutch Typography in the Sixteenth Century: The Collected Works of Paul Valkema Blouw*, Brill, Leiden and Boston, 2013

Dodge, M. (ed.), *Classics in Cartography: Reflections on Influential Articles from Cartographica*, John Wiley & Sons, Chichester, 2010

Donati, L. (ed.), *Miscellanea bibliografica in memoria di don Tommaso Accurti*, vols 15–16, Edizioni di Storia e Letteratura, Rome, 1947

Drogin, M., *Medieval Calligraphy: Its History and Technique*, Dover Publications, New York, NY, 1989

Duggan, M.K., *Italian Music Incunabula, Printers and Type*, University of California Press, Berkeley, CA, 1992

Duggan, M.K., 'Bringing Reformed Liturgy to Print at the New Monastery at Marienthal', *Church History and Religious Culture*, 88, 2008, pp. 415–36

Duniway, D.C., 'A Study of the Nuremberg Chronicle', *Papers of the Bibliographic Society of America*, 35, 1941, pp. 17–34

Eastaugh, N., V. Walsh, T. Chaplin and R. Siddall, *Pigment Compendium: A Dictionary of Historical Pigments*, Elsevier, Oxford, 2007

Eckehar, S., *The 'Türkenkalendar' (1454) Attributed to Gutenberg and the Strasbourg Lunation Tracts*, Medieval Academy of America, Cambridge, MA, 1988

Edmunds, S., 'Anna Rügerin Revealed', *Journal of the Early Book Society for the Study of Manuscripts and Printing History*, 2, 1999, pp. 179–181

Edson, E., *Mapping Time and Space: How Medieval Mapmakers Viewed their World*, British Library, London, 1997

Eisenstein, E.L., *The Printing Press as an Agent of Change*, Cambridge University Press, Cambridge, 1979

Eisenstein, E.L., *The Printing Revolution in Early Modern Europe*, second edition, Cambridge University Press, Cambridge, 2005

Elkins, J., and R. Williams, *Renaissance Theory*, Routledge, New York and London, 2008

Emmerson, R.K., and S. Lewis, 'Census and Bibliography of Medieval Manuscripts Containing Apocalypse Illustrations, Ca. 800–1500: II', *Traditio*, 41, 1985, pp. 367–409

Estermann, M., U. Rautenberg and R. Wittmann (eds), *Archiv für Geschichte des Buchwesens*, Band 59, De Gruyter Saur, Berlin and Boston, 2005

Farmer Jr, N.K., review of 'The Comely Frontispiece: The Emblematic Title-Page in England, 1550–1660, Margery Corbett Ronald Lightbown', *Renaissance Quarterly*, 33(3), 1980, pp. 464–6

Febvre, L., and H.-J. Martin, *The Coming of the Book: The Impact of Printing 1450–1800*, Verso, New York, NY, 1976

Ferguson, W.C., *Pica Roman Type in Elizabethan England*, Bower Publishing Co., Brookfield, VT, 1989

Fernandez-Armesto, F., *Columbus and the Conquest of the Impossible*, Saturday Review Press, New York, NY, 1974

Field, R.S., *Fifteenth Century Woodcuts and Metalcuts from the National Gallery of Art*, National Gallery of Art, Washington, DC, 1965

Fletcher, H.G., *In Praise of Aldus Manutius: A Quincentenary Exhibition*, exhibition catalogue, Pierpont Morgan Library, New York, NY, 1995

Flood, J.L., 'Nationalistic Currents in Early German Typography', *The Library*, 6th series, 15(2), June 1993, p. 131

Füssel, S., *Gutenberg and the Impact of Printing*, Ashgate, Farnham, 2005

Gadd, J. (ed.), *History of Oxford University Press, Vol. 1: Beginnings to 1780*, Oxford University Press, Oxford, 2013

Gage, J., *Color and Culture: Practice and Meaning from Antiquity to Abstraction*, University of California Press, Berkeley, 1999

Gaskill, M., *Witchcraft: A Very Short Introduction*, Oxford University Press, Oxford, 2010

Geanakoplos, D.J., *Byzantium and the Renaissance: Greek Scholars in Venice: Studies in the Dissemination of Greek Learning from Byzantium to Western Europe*, Archon Books, Hamden, CT, 1973

Gerulaitis L.V., *Printing and Publishing in Fifteenth-Century Venice*, American Library Association, Chicago, IL, 1976

Gillespie, R., and A. Hadfield (eds), *The Oxford History of the Irish Book, Vol. 3: The Irish Book in English, 1550–1800*, Oxford University Press, Oxford, 2006

Gillespie, V., and S. Powell, *A Companion to the Early Printed Book in Britain, 1476–1558*, Boydell & Brewer Ltd, Woodbridge, 2014

Goldschmidt, E.P., *The Printed Book of the Renaissance: Three Lectures on Type, Illustration and Ornament*, Cambridge University Press, Cambridge, 1950

Good, H.G., 'The "First" Illustrated School-Books', *Journal of Educational Research*, 35(5), 1942, pp. 338–43

Grenby, M., 'Chapbooks, Children, and Children's Literature', *The Library*, 8(3), 2007, pp. 277–303

Haar, J. (ed.), *European Music, 1520–1640*, Boydell & Brewer Ltd, Woodbridge, 2014

Haebler, K., *Die italienischen Fragmente vom Leiden Christi, das älteste Druckwerk Italiens*, J. Rosenthal, Munich, 1927

Halporn, B.C., *The Correspondence of Johann Amerbach*, University of Michigan Press, Ann Arbor, MI, 2000

Hargreaves, G.D., 'Florentine Script, Paduan Script, and Roman Type' *Gutenberg-Jahrbuch*, 1992, pp. 15–34

Harley, J.B., and D. Woodward (eds), *The History of Cartography*, vols. 1–6, University of Chicago Press, Chicago, IL, 1987–

Harman, M., *Printer's and Publisher's Devices in Incunabula in the University of Illinois Library*, n.p., Urbana, IL, 1983

Harris M., and R. Myers (eds), *A Millennium of the Book: Production, Design & Illustration in Manuscript & Print, 900–1900*, St. Paul's Bibliographies, Oak Knoll Press, New Castle, DE, 1994

Heartz, D., 'Typography and Format in Early Music Printing: With Particular Reference to Attaingnant's First Publications', *Notes*, 23(4), 1967, pp. 702–6

Heartz, D., *Pierre Attaingnant, Royal Printer of Music: A Historical Study and Bibliographical Catalogue*, University of California Press, Berkeley, 1969

Hellinga, L., 'The Rylands Incunabula: An International Perspective', *Bulletin du bibliophile*, 1, 1989, pp. 34–52

Hellinga, L., 'William Caxton, Colard Mansion, and the Printer in Type 1', *Bulletin du bibliophile*, 1, 2011, pp. 86–114

Hellinga, L., *Texts in Transit: Manuscript to Proof and Print in the Fifteenth Century*, Brill, Leiden and Boston, 2014

Hellinga, L., and J.B. Trapp (eds), *The Cambridge History of the Book in Britain*, Cambridge University Press, Cambridge, 1999

Herwaarden, J. van, *Between Saint James and Erasmus: Studies in Late-Medieval Religious Life – Devotion and Pilgrimage in the Netherlands*, Brill, Leiden and Boston, 2003

Hind, A.M., *An Introduction to a History of Woodcut*, 2 vols, Dover reprint, New York, NY, 1963

Hirsch, R., *Printing, Selling and Reading, 1450–1550*, Harrassowitz, Wiesbaden, 1967

Hitti, P.K., 'The First Book Printed in Arabic', *Princeton University Library Chronicle*, 4(1), 1942, pp. 5–9

Hobson, J.A., *God and Mammon: The Relations of Religion and Economics*, Routledge Revivals, New York, NY, 2011

Hoffmann, L., 'Der Preis Der Gutenberg-Bibel. Zum Kauf Der "Biblia De Molde Grande" in Burgos. Un Memoriam Horst Kunze', *Gutenberg-Jahrbuch*, 2002, pp. 50–56

Hooper, N., and M. Bennett, *Cambridge Illustrated Atlas: Warfare, the Middle Ages, 768–1487*, Cambridge University Press, Cambridge, 1996

Horowitz, W., 'The Babylonian Map of the World', *Iraq*, 50, 1988

Horowitz, W., *Mesopotamian Cosmic Geography*, Eisenbrauns, Winona Lake, IN, 1998

Housley, N. (ed.), *Crusading in the Fifteenth Century: Message and Impact*, Palgrave Macmillan, New York, NY, 2004

Hunter, D., *Papermaking: The History and Technique of an Ancient Craft*, Dover Publications, New York, NY, 1978

Hurtado L., and C. Keith, 'Book Writing and Production in the Hellenistic and Roman Period', in *New Cambridge History of the Bible, Vol. 1: From the Beginnings to 600*, ed. James Carleton-Paget and Joachim Schaper, Cambridge University Press, Cambridge, 2013

Ing, J., 'The Mainz Indulgences of 1454/5: A Review of Recent Scholarship', *British Library Journal*, 9(1), 1983, pp. 14–31

Ing, J., *Johann Gutenberg and His Bible: A Historical Study*, Typophiles, New York, NY, 1988

Isidore of Seville, *The Etymologies of Isidore of Seville*, translated with introduction and notes by Stephen A. Barney, et al., Cambridge University Press, Cambridge and New York, NY, 2006

Israel, U., 'Romnähe und Klosterreform oder Warum die erste Druckerpresse Italiens in der Benediktinerabtei Subiaco stand', *Archiv für Kulturgeschichte*, 88(2), 2006, pp. 279–96

Jecmen, G., and F. Spira, *Imperial Augsburg: Renaissance Prints and Drawings, 1475–1540*, Ashgate Publishing, Farnham, 2012

Jensen, K. (ed.), *Incunabula and Their Readers: Printing, Selling and Using Books in the Fifteenth Century*, British Library, London, 2003

Johnson, A.F., *The First Century of Printing at Basle*, Charles Scribner's Sons, New York, NY, 1926

Kemp, W., 'Counterfeit Aldines and Italic-Letter Editions Printed in Lyons 1502–1510: Early Diffusion in Italy and France', *Papers of The Bibliographical Society of Canada*, 35(1), 1997, pp. 75–100

King, A.H., 'The Significance of John Rastell in Early Music Printing', *The Library* 26(3), 1971, pp. 197–214

King, A.H., 'The 500th Anniversary of Music Printing: The Gradual of c1473', *Musical Times*, 114(1570), 1973, pp. 1220–23

Knight, S., *Historical Scripts from Classical Times to the Renaissance*, Oak Knoll Press, New Castle, DE, 2009

Knight, S., *Historical Types from Gutenberg to Ashendene*, Oak Knoll Press, New Castle, DE, 2012

Krek, M., 'The Enigma of the First Arabic Book Printed from Movable Type', *Journal of Near Eastern Studies*, 3, 1979, pp. 203–12

Künast, H.-J., and H. Zäh, 'The Revival of a Great German Library', *German Research*, 25, 2003

Kwakkel, E., R. McKitterick and R. Thomson, *Turning Over a New Leaf: Change and Development in the Medieval Book*, Leiden University Press, Leiden, 2012

Layton, E., 'The Earliest Printed Greek Book', *Journal of the Hellenic Diaspora*, 5(4), 1979, pp. 63–79

Lehmann-Haupt, H., *Peter Schoeffer of Gernsheim and Mainz: With a List of his Surviving Books and Broadsides*, Printing House of L. Hart, Rochester, NY, 1950

Lewis, S., *Reading Images: Narrative Discourse and Reception in the Thirteenth-Century Illuminated Apocalypse*, Cambridge University Press, Cambridge, 1995

Locke, J., *Some Thoughts Concerning Education*, n.p., London, 1693

Logeswaran, N., and J. Bhattacharya, 'Crossmodal Transfer of Emotion by Music', *Neuroscience Letters*, 455(2), 2009

Lowry, M., *The World of Aldus Manutius: Business and Scholarship in Renaissance Venice*, Cornell University Press, Ithaca, NY, 1979

Lowry, M., 'Aldus Manutius and Benedetto Bordon: In Search of a Link', *Bulletin of the John Rylands University Library of Manchester*, 66, 1984, pp. 173–97

Lucretius, *De Rerum Natura* [On the Nature of Things], trans. W.H.D. Rouse, Harvard University Press, Cambridge, MA, 1992

Maclean, I., *Learning and the Market Place: Essays in the History of the Early Modern Book*, Brill, Leiden and Boston, 2009

Mann, A. J., *The Scottish Book Trade 1500 to 1720: Print Commerce and Print Control in Early Modern Scotland*, Tuckwell Press, East Linton, 2000

Mann, A.J., 'The Anatomy of the Printed Book in Early Modern Scotland', *Scottish Historical Review*, 80(210), 2001, pp. 181–200

Manzoni, G., *Annali tipografici dei Soncino*, Romagnoli, Bologna, 1886

Marsden, R., and E. Matter, *The New Cambridge History of the Bible, Vol. 2: From 600 to 1450*, Cambridge University Press, Cambridge, 2012

Marshall, S. (ed.), *Women in Reformation and Counter-reformation Europe*, Indiana University Press, Bloomington, IN, 1989

Marx, A., 'Hebrew Incunabula', *Jewish Quarterly Review*, 11(1), 1920, pp. 98–119

May, A., 'Making Moxon's Type-mould', *Journal of the Printing Historical Society*, 22, spring 2015, pp. 5–22

Mayor, A.H., *Prints & People: A Social History of Printed Pictures*, Metropolitan Museum of Art, New York, NY, 1971

McCarthy, I.F., 'Ad Fontes: A New Look at the Watermarks on Paper Copies of the Gutenberg Bible', *The Library*, 17(2), 2016, pp. 115–37

McEvedy, C., and R. Jones, *Atlas of World Population History*, Viking, New York, NY, 1978

McKerrow, R.B., *Printers' & Publishers' Devices in England & Scotland, 1485–1640*, Chiswick Press, London, 1913

McTurtie, D.C., *Some Facts Concerning the Invention of Printing*, Chicago Club of Printing House Craftsmen, Chicago, IL, 1939

Meier, H., 'Woodcut Stencils of 400 Years Ago', *Bulletin of the New York Public Library*, 42, 1938, pp. 10–19

Milsom, J., 'Songs and Society in Early Tudor London', *Early Music History*, 16, 1997, pp. 235–93

Morison, S., *First Principles of Typography*, Macmillan, New York, NY, 1936

Morison, S., 'Early Humanistic Script and the First Roman Type', *The Library*, 24(1–2), 1943, pp. 1–29

Morison, S., *Four Centuries of Fine Printing*, second edition, Ernest Benn Ltd, London, 1949

Morison, S., *Selected Essays on the History of Letter-forms in Manuscript and Print*, Cambridge University Press, Cambridge, 2009

Moxon, J., *Mechanick Exercises: Or, the Doctrine of Handy-works. Applied to the Art of Printing*, 2 vols, J. Moxon, London, 1683

Moxon, J., *Mechanick Exercises on the Whole Art of Printing*, ed. H. Davis and H. Carter, Oxford University Press, London, 1958

Muir, P. (ed.), *Selected Essays on Books and Printing*, Van Gendt & Co., Amsterdam, 1970

Myers, R., M. Harris and G. Mandelbrote (eds), *Fairs, Markets and the Itinerant Book Trade*, Oak Knoll Press, New Castle, DE, 2007

Needham, P., 'Division of Copy in the Gutenberg Bible: Three Glosses on the Ink Evidence', *Papers of the Bibliographical Society of America*, 79, 1985, pp. 411–26

Needham, P., 'The Paper Supply of the Gutenberg Bible', *Papers of the Bibliographical Society of America*, 79, 1985, pp. 303–74

Needham, P., 'A Gutenberg Bible Used as Printer's Copy by Heinrich Eggestein in Strasbourg, ca. 1469', *Transactions of the Cambridge Bibliographical Society*, 9, 1986, pp. 36–75

Needham, P., *The Printer & the Pardoner: An Unrecorded Indulgence Printed by William Caxton for the Hospital of St. Mary Rounceval, Charing Cross*, Library of Congress, Washington, DC, 1986

Needham, P., 'The 1462 Bible of Johann Fust and Peter Schöffer (GW 4204): A Survey of its Variants', *Gutenberg-Jahrbuch*, 2006, pp. 19–49

Nuovo, A., *The Book Trade in the Italian Renaissance*, Brill, Leiden and Boston, 2013

Offenberg, A.K., review of 'David Goldstein, *Hebrew Incunables in the British Isles: A Preliminary Census*, London 1985', *The Library*, sixth series, 8(1), 1986, pp. 70–76

Offenberg, A.K., *A Choice of Corals: Facets of Fifteenth-Century Hebrew Printing*, De Graaf, Nieuwkoop, 1992

Offenberg, A.K., 'The Chronology of Hebrew Printing at Mantua in the Fifteenth Century: A Re-examination', *The Library*, sixth series, 16(4), 1994, pp. 298–315

Offenberg, A.K., 'The Printing History of the Constantinople Hebrew Incunable of 1493: A Mediterranean Voyage of Discovery', *British Library Journal*, 22(2), 1996, pp. 221–35

Ohly, K., 'Eggestein, Fyner, Knoblochtzer. Zum Problem des deutschsprachigen Belial mit Illustrationen', *Gutenberg-Jahrbuch*, 1962, pp. 122–35

O'Meara, E.J., 'Notes on Stencilled Choir-Books: With Seven Figures', *Gutenberg-Jahrbuch*, 1933, pp. 169–85

Orlandi, P.A., *Origine e progressi della stampa*, Pisarius, Bologna, 1722

Otten, J., 'Guido of Arezzo', *The Catholic Encyclopedia*, vol. 7, Robert Appleton Co., New York, NY, 1910

Ottley, W.Y., *An Inquiry into the Origin and Early History of Engraving upon Copper and in Wood, with an Account of Engravers and Their Works*, John and Arthur Arch, London, 1816

Paas, J., 'Georg Kress, a "Briefmaler" in Augsburg in the Late Sixteenth and Early Seventeenth Centuries', *Gutenberg-Jahrbuch*, 1990, pp. 177–204

Painter, G.D., *William Caxton: A Biography*, Putnam, New York, NY, 1977

Palmer, N.F., 'Junius's Blockbooks: Copies of the "Biblia pauperum" and "Canticum canticorum" in the Bodleian Library and their Place in the History of Printing', *Renaissance Studies*, 9(2), 1995, pp. 137–65

Pardoe, F.E., *John Baskerville of Birmingham: Letter-Founder & Printer*, F. Muller, London, 1975

Parker, D., 'Women in the Book Trade in Italy, 1475–1620', *Renaissance Quarterly* 49(3), 1996, pp. 509–41

Parrish, C., *The Notation of Medieval Music*, Pendragon Press, New York, NY, 1978

Parshall, P. (ed.), *The Woodcut in Fifteenth-Century Europe*, National Gallery of Art, Washington, DC, 2009

Petrina, A., 'Young Man, Reading: Caxton's Book of Curtesye', in MedieVaria Un liber amicorum per Giuseppe Brunetti, ed. A. Petrina, Unipress, Padua, 2011, pp. 115–34

Pettegree, A., *The Book Trade in the Renaissance*, Yale University Press, New Haven, CT, 2010

Plumb, J.H., *The Italian Renaissance*, Houghton Mifflin, Boston, MA, and New York, NY, 2001

Pogue, S.F., 'The Earliest Music Printing in France', *Huntington Library Quarterly*, 50(1), 1987, pp. 35–57

Poleg, E., and L. Light (eds), *Form and Function in the Late Medieval Bible*, Brill, Leiden and Boston, 2013

Pollard, A.W., *Last Words on the History of the Title-Page*, Chiswick Press, London, 1891

Pollard, A.W., *An Essay on Colophons, with Specimens and Translations*, Caxton Club, Chicago, IL, 1905

Pon, L., and C. Kallendorf (eds), *The Books of Venice/Il libro veneziano*, La Musa Talìa, Venice and Oak Knoll Press, New Castle, DE, 2009

Pratt, S., 'The Myth of Identical Types: A Study of Printing Variations from Handcast Gutenberg Type', *Journal of the Printing Historical Society*, new series, 6, 2003, pp. 7–17

Primeau, T., 'Coloring within the Lines: The Use of Stencil in Early Woodcuts', *Art in Print*, 3(3), 2013, pp. 11–16

Proctor, R., *The Printing of Greek in the Fifteenth Century*, Bibliographical Society at the Oxford University Press, Oxford, 1900

Putnam, G., *Books and Their Makers During the Middle Ages*, Putnam, New York, NY, 1896

Redgrave, G.R., *Erhard Ratdolt and His Work at Venice*, Chiswick Press, London, 1894

Reidy, D.V. (ed.), *The Italian Book 1465–1800*, British Library, London, 1993

Rhodes, D.E. (ed.), *Essays in Honour of Victor Scholderer*, Karl Pressler, Mainz, 1970

Rhodes, D.E., Bennett Gilbert, '*A Leaf from the Letters of St. Jerome, First Printed by Sixtus Reissinger, Rome, c. 1466–1467*, London, 1981', *The Library*, sixth series, 5, 1983, pp. 68–71

Rhodes, D.E., 'The Career of Thomas Ferrandus of Brescia', *Bulletin of the John Rylands University Library of Manchester*, 67(1), 1984

Richardson, B., *Printing, Writers and Readers in Renaissance Italy*, Cambridge University Press, Cambridge, 1999

Roberts, W., *Printers' Marks: A Chapter in the History of Typography*, Chiswick Press, London, 1893

Rodgers, D.T., B. Raman and H. Reimitz (eds), *Cultures in Motion*, Princeton University Press, Princeton, NJ, 2013

Rogers, E.S., 'Some Historical Matter Concerning Trade-Marks', *Michigan Law Review*, 9(1), 1910, pp. 29–43

Rosenthal, A., 'Some Remarks on "The Daily Performance of a Printing Press in 1476"', *Gutenberg-Jahrbuch*, 1979, pp. 39–50

Ross, J.L., *Pigments Used in Late Medieval Western European Manuscript Illumination*, University of Texas Press, Austin, 1971

Rudy, K., 'An Illustrated Mid-Fifteenth-Century Primer for a Flemish Girl, British Library, Harley MS 3828*', *Journal of the Warburg and Courtauld Institutes*, 69, 2006, pp. 51–94

Rudy, K.M., *Rubrics Images and Indulgences in Late Medieval Netherlandish Manuscripts*, Brill, Leiden and Boston, 2016

Saenger, P., and K. van Kampen (eds), *The Bible as Book: The First Printed Editions*, British Library, London, 1999

Savage, E., 'New Evidence of Erhard Ratdolt's Working Practices: The After-life of Two Red Frisket-sheets from the Missale Constantiense (c. 1505)', *Journal of the Printing Historical Society*, Spring 2015, pp. 81–97

Savage, E., 'Jost de Negker's Woodcut Charles V (1519): An Undescribed Example of Gold Printing', *Art in Print*, July–August 2015, pp. 9–15

Scapecchi, P., 'An Example of Printer's Copy used in Rome, 1470', *The Library*, 6th series, 12, 1990

Schechter, F.I., 'Early Printers' and Publishers' Devices', *Papers of the Bibliographical Society of America*, 19(1), 1925, pp. 11–22

Schiegg, M., 'Scribes' Voices: The Relevance and Types of Early Medieval Colophons', *Studia Neophilologica*, 88(2), 2016, pp. 129–47

Schmidt, R., 'Die Klosterdruckerei von St. Ulrich und Afra in Augsburg (1472 bis 1474)', *Augsburger Buchdruck und Verlagswesen von den Anfängen bis zur Gegenwart*, ed. H. Gier and J. Janota, Harrassowitz, Wiesbaden, 1997, pp. 141–53

Schmitt, W.O., 'Die Ianua (Donatus). Ein Beitrag zur lateinischen Schulgrammatik des Mittelalters und der Renaissance', *Beiträge zur Inkunabelkunde*, 3(4), 1969, pp. 43–80

Scholderer, V., *Fifty Essays in Fifteenth- and Sixteenth-Century Bibliography*, Menno Hertzberger and Co., Amsterdam, 1966

Schreiber, W., 'Die Briefmaler und ihre Mitarbeiter', *Gutenberg-Jahrbuch*, 1932, pp. 53–4

Schulz, E., *Das erste Lesebuch an den Lateinschulen des späten Mittelalters*, Verlag der Gutenberg-Gesellschaft, Mainz, 1929

Schulz, H.C., 'Albrecht Pfister and the Nürnberg Woodcut School', *Gutenberg-Jahrbuch*, 1953, pp. 39–49

Schwab, R.N., 'New Clues About Gutenberg in the Huntington 42-line Bible: What the Margins Reveal', *Huntington Library Quarterly*, 51(3), 1988, pp. 177–210

Schwab, R.N., T.A. Cahill, A. Thomas, B.H. Kusko and D.L. Wick, 'Cyclotron Analysis of the Ink in the 42-Line Bible', *Papers of the Bibliographical Society of America*, 77(3), 1983, pp. 285–315

Schwab, R.N., T.A. Cahill, R.A. Eldred, B.H. Kusko and D.L. Wick, 'New Evidence on the Printing of the Gutenberg Bible: The Inks in the Doheny Copy', *Papers of the Bibliographical Society of America*, 79, 1985, pp. 375–410

Schwarz, I., *Die Memorabilien des Augsburger Buchdruckers Erhard Ratdolt (1462–1523)*, K.F. Koehler, Leipzig, 1924

Selin, H., (ed.), *Encyclopaedia of the History of Science, Technology, and Medicine in Non-Western Cultures*, Springer Science & Business Media, Dordrecht, 2013

Setton, K.M., *The Papacy and the Levant, 1204–1571, Vol. 2: The Fifteenth Century*, American Philosophical Society, Philadelphia, PA, 1976

Sharpe, L., *The Cambridge Companion to Goethe*, Cambridge University Press, Cambridge, 2002

Singer, S.W., *Researches into the History of Playing Cards*, R. Triphook, London, 1816

Smeijers, F., *Counterpunch: Making Type in the Sixteenth Century, Designing Typefaces Now*, Hyphen Press, London, 1996

Smith, C.D., 'Imago Mundi's Logo the Babylonian Map of the World', *Imago Mundi*, 48, 1996, pp. 209–11

Smith H., '"Print[ing] Your Royal Father Off": Early Modern Female Stationers and the Gendering of the British Book Trades', *Text*, 15, 2003, pp. 163–86

Smith, M., 'Printed Foliation: Forerunner to Printed Page-Numbers?', *Gutenberg-Jahrbuch*, 1988, pp. 54–7

Smith, M., *The Title-Page: Its Early Development, 1460–1510*, British Library, London, and Oak Knoll Press, New Castle, DE, 2000

Smith, M., 'Red as a Textual Element During the Transition From Manuscript to Print' (Critical essay), *Essays and Studies*, 2010, pp. 187–200

Smith, M., and A. May, 'Early Two-Colour Printing', *Bulletin of the Printing Historical Society*, 44, winter 1997, pp. 1–4

Sohn Pow-Key, 'Early Korean Printing', *Journal of the American Oriental Society*, 79(2), 1959, pp. 96–103

Sohn Pow-Key, 'Printing Since the 8th Century in Korea', *Koreana*, 7(2), summer 1993, pp. 4–9

Sowards, J.K. (ed.), *Collected Works of Erasmus*, University of Toronto Press, Toronto, 1974–1985

Stijnman, A., and E. Savage (eds), *Printing Colour 1400–1700: Histories, Techniques, Functions and Receptions*, Brill, Leiden and Boston, 2015

Stijnman, A., and E. Upper, 'Color Prints before Erhard Ratdolt: Engraved Paper Instruments in Lazarus Beham's *Buch von der Astronomie* (Cologne: Nicolaus Götz, c. 1476)', *Gutenberg-Jahrbuch*, 2014, pp. 86–105

Stillwell, M.B., *The Beginning of the World of Books, 1450 to 1470: A Chronological Survey of the Texts Chosen for Printing During the First Twenty Years of Printing Art*, Bibliographical Society of America, New York, NY, 1972

Suarez, M.F., and H.R. Woudhuysen (eds), *The Oxford Companion to the Book*, Oxford University Press, Oxford and New York, 2010

Swanson, R.N. (ed.), *Promissory Notes on the Treasury of Merits: Indulgences in Late Medieval Europe*, Brill, Leiden and Boston, 2006

Szépe, H., 'Desire in the Printed Dream of Poliphilo', *Art History*, 19(3), 1996, pp. 370–92

Taitz, E., S. Henry and C. Tallan, *The JPS Guide to Jewish Women: 600 BCE to 1900 CE*, Jewish Publication Society, Philadelphia, PA, 2003

Thompson, D.V., *The Materials and Techniques of Medieval Painting*, Dover Publications, New York, NY, 1956

Timperley, C.H., *A Dictionary of Printers and Printing: With the Progress of Literature; Ancient and Modern*, ed. H. Johnson, London, 1839

Torrell, J.-P., *Saint Thomas Aquinas: The Person and his Work*, vol. 1, CUA Press, Washington, DC, 2005

Uhlendorf, B.A., 'The Invention of Printing and its Spread till 1470: With Special Reference to Social and Economic Factors', *The Library Quarterly: Information, Community, Policy*, 2(3), 1932, pp. 179–231

Ullman, B.L., *The Origin and Development of Humanistic Script*, Edizioni di Storia e Letteratura, Rome, 1960

Undorf, W., *From Gutenberg to Luther: Transnational Print Cultures in Scandinavia 1450–1525*, Brill, Leiden and Boston, 2014

Updike, D.B., *Printing Types, Their History, Forms, and Use: A Study in Survivals*, 2 vols, Harvard University Press, Cambridge, MA, 1937

Upper, E., 'Red Frisket Sheets, c. 1490–1700: The Earliest Artifacts of Color Printing in the West', *Papers of the Bibliographical Society of America*, 108(4), 2014, pp. 477–522

Van Duzer, C., 'Ptolemy from Manuscript to Print: New York Public Library's Codex Ebnerianus (MS MA 97)', *Imago Mundi*, 67(1), 2015, pp. 1–11

Vassar College Library, *A List of the Printers' Marks in the Windows of the Frederick Ferris Thompson Memorial Library*, Vassar College, Poughkeepsie, NY, 1917

Veltri, G. and G. Miletto (eds), *Rabbi Judah Moscato and the Jewish Intellectual World of Mantua in the 16th–17th Centuries*, Brill, Leiden and Boston, 2012

Vervliet, H.D.L., 'Gutenberg or Diderot: Printing as a Factor in World History', *Quaerendo*, 8(1), 1978, pp. 3–28

Vervliet, H.D.L., *The Palaeotypography of the French Renaissance: Selected Papers on Sixteenth-Century Typefaces*, vol. 1, Brill, Leiden and Boston, 2008

Vervliet, H.D.L., *Vine Leaf Ornaments in Renaissance Typography: A Survey*, Oak Knoll Press, New Castle, DE, 2012

Vine, G., *The John Rylands Facsimiles, No. 3, 'A litl boke for the Pestilence'*, Manchester University Press, Manchester, 1910

Wagner, B., and M. Reed (eds), *Early Printed Books as Material Objects: Proceedings of the Conference Organized by the IFLA Rare Books and Manuscripts Section, Munich, 19–21 August 2009*, De Gruyter Saur, Berlin and New York, 2010

Walker, T.D., 'The Cover Design', *Library Quarterly: Information, Community, Policy*, 68(1), 1998, pp. 80–81

Walsby, M., and N. Constantinidou, *Documenting the Early Modern Book World: Inventories and Catalogues in Manuscript and Print*, Brill, Leiden and Boston, 2013

Wardrop, J., *The Script of Humanism, Some Aspects of Humanistic Script, 1460–1560*, Clarendon Press, Oxford, 1963

Willoughby, E.E., 'The Cover Design', *Library Quarterly: Information, Community, Policy*, 22(3), 1952, p. 302

Wilson, A., and J. Lancaster Wilson, *The Making of the Nuremberg Chronicle*, Nico Israel, Amsterdam, 1976

Wunder, H., *He is the Sun, She is the Moon: Women in Early Modern Germany*, Harvard University Press, Cambridge, MA, 1998

Yudkin, J., *Music in Medieval Europe*, Prentice Hall, Englewood Cliffs, NJ, 1989

Zorach, R., and M.W. Phillips, *Gold: Nature and Culture*, Reaktion Books, London, 2016

Picture Credits

35 H. Wallau, 'Die zweifarbigen Initialen der Psalterdrucke von Johann Fust und
 Peter Schöffer', *Festschrift zum fünfhundertjährigen Geburtstage von Johann Gutenberg*,
 ed. Otto Hartwig, 1900), p. 327

36 Dover Publications, Inc, 1973

37 Oxford, Bodleian Library, Broxb. 97.40

38 National Gallery of Art, Washington, DC, Rosenwald Collection 1943.3.757

39 Oxford, Bodleian Library, MS. Canon. Liturg. 287, fols. 62v–63r

40 Bayerische Staatsbibliothek, München, Rar. 292, fol. aI verso

41 © The Trustees of the British Museum

42 © The Trustees of the British Museum

43 Oxford, Bodleian Library, Auct. 2 R 1.12

44 Author

45 Universitäts- und Landesbibliothek Darmstadt, Inc-II-353

46 Author

47 From the collection of John J. Burns Library, Boston College

48 Courtesy of Staatsbibiothek Berlin, from Veröffentlichungen der Gesellschaft für
 Typenkunde, 1907–39, Tab. 2401

49 Oxford, Bodleian Library, Douce 207, title-page

50 Oxford, Bodleian Library, (OC) 55 c.159

51 Oxford, Bodleian Library, B 1.16 Med, title-page

52 Oxford, Bodleian Library, Don. D.185

53 Oxford, Bodleian Library, MS. Don. a. II, fol. 5v

54 Oxford, Bodleian Library, Arch. B a.I, fol. 6r

55 Vatican Library, Sta.Maria.Magg. 105, fol. 105r

56 Oxford, Bodleian Library, Inc. c.G5.1495.I, Sig. A3r (I)

57 Oxford, Bodleian Library, Arch. A c.II

58 © British Library Board, Add MS 28681. All Rights Reserved / Bridgeman Images

59 Harry Ransom Center, University of Texas at Austin, Kraus Map Collection 13

60 Cornell University Library, PJ Mode Collection of Persuasive Cartography, 1003.01

61 Cornell University Library, PJ Mode Collection of Persuasive Cartography, 1002.02

62 Oxford, Bodleian Library, Map Res. 105

63 Oxford, Bodleian Library, Arch. B c.25, fol. 76

64 Oxford, Bodleian Library, Arch. B c.25, map of Venice

65 © Universitätsbibliothek Heidelberg, GW 00348

66 Oxford, Bodleian Library, Douce 226, fol. 28r

67 R.C. Alston, *Bibliography of the English language from invention of printing*, vol 15, 2001

68 Bayerische Staatsbibliothek, München, Rar. 863, fol. A1r

69 Author

70 Oxford, Bodleian Library, Arch. G e.37

Index

Pages with illustrations are denoted by numbers in *italic* type.